THE ART OF

D0128838

THE ART OF RAW CONVERSION

HOW TO PRODUCE ART-QUALITY PHOTOS WITH ADOBE PHOTOSHOP CS2 AND LEADING RAW CONVERTERS

UWE STEINMUELLER & JÜRGEN GULBINS

NO STARCH
PRESS

THE ART OF RAW CONVERSION:

How to Produce Art-Quality Photos with Adobe Photoshop CS2 and Leading RAW Converters

© 2006 by Uwe Steinmueller and Jürgen Gulbins

Printed in Canada

1 2 3 4 5 6 7 8 9 10 – 09 08 07 06

Publisher: William Pollock
Managing Editor: Elizabeth Campbell
Cover, Interior Design, and Layout: Octopod Studios
Developmental Editor: Jim Compton
Copyeditor: Kathy Grider-Carlyle
Proofreader: Nancy Riddiough, Stephanie Provines
Indexer: Nancy Guenther

For information on book distributors or translations, please contact No Starch Press, Inc. directly:

No Starch Press, Inc.
555 De Haro Street, Suite 250, San Francisco, CA 94107
phone: 415.853.9900; fax: 415.853.9950; info@nostarch.com; www.nostarch.com

LIBRARY OF CONGRESS CATALOGUING-IN-PUBLICATION DATA:

Steinmueller, Uwe.
 The art of raw conversion : how to produce art-quality photos with Adobe Photoshop CS2 and leading raw converters / Uwe Steinmueller and Jürgen Gulbins.
 p. cm.
 ISBN 1-59327-067-4
 1. Adobe Photoshop. 2. Photography, Artistic. 3. File conversion (Computer science) 4. Raw file formats (Digital photography) 5. Photography--Digital techniques. 6. Image processing--Digital techniques. I. Gulbins, Jürgen. II. Title.

 TR267.5.A3.S74 2005
 775--dc22

 2005024986

==

Acknowledgments

==

Thanks to our many influencers and friends, but especially to: Bill Atkinson, Paul Caldwell, Jim Collum, Charles Cramer, Antonio Dias, Katrin Eismann, Jack Flesher, Mac Holbert, Michael Jonsson (creator of RawShooter), Thomas Knoll (original creator of Photoshop and Camera Raw), Phil Lindsay, Daniel Stephens, and Ben Willmore.

Last but not least we want to thank Bill Horton for correcting our somewhat German English.

Uwe Steinmueller, *San Jose (California)*
Jürgen Gulbins, *Keltern (Germany)*
April 2006

Table of Contents

Introduction

Literally thousands of books on digital photography are currently in print. Both authors Uwe Steinmueller and Jürgen Gulbins (whose work has until now been available only in German) have contributed to this growing list. These books mostly cover various aspects of shooting photographs or of image processing. In the latter category you can find hundreds of books on Photoshop.

The Art of RAW Conversion, however, focuses on an important step that, for demanding photographers both amateur and professional, occurs in between shooting and image processing or manipulation. It deals with the conversion of images shot using RAW format into images in a standardized image format, such as TIFF or JPEG. For anyone with a DSLR or other high-end digital camera that can save images in RAW, we strongly recommend shooting photographs using THAT format. Doing so allows you to get the highest quality images from your camera. It frees you from the need to decide on many image settings at the moment you take a photo and reduces the effects that can result from pressure and haste as you shoot. For many camera settings, RAW processing lets you reconsider and even revise settings made during shooting. This ability need not encourage sloppy photography, yet it gives you substantially more control of your pictures.

RAW CONVERSION AND IMAGE PROCESSING

In this book, we focus mostly on the process of RAW conversion: what you should consider when shooting RAW, how to prepare files for conversion, and how to set up an efficient conversion workflow as part of your total image workflow.

We don't go as deeply into image processing and image manipulation in Photoshop, but we do discuss some image enhancements that can be done either in the camera, in the RAW converter, or perhaps later in Photoshop.

The king of all image editors is Photoshop. It may not be the best solution for all image operations, but it provides an overall high level of functionality and an excellent integration of those various functions. It is also definitely the trendsetter for these kinds of applications. We believe these qualities justify its hefty price. Adobe Camera Raw, an excellent RAW converter, is provided as part of Photoshop CS. Of all the RAW converters, Camera Raw supports one of the broadest ranges of RAW formats, and it is updated regularly in order to support newly released RAW camera formats. For this reason, we delve deeper into the details of Adobe Camera Raw and RawShooter Essentials than we do other RAW converters.

Be aware that there are a number of RAW converters available, and some of them are quite good concerning resulting image quality and workflow integration. It may well be worth evaluating other RAW converters as well, and you may even decide to use different converters for different situations and workflows. We focus on those we judge the best and most often used.

A PROVEN WORKFLOW

In learning about working with RAW files, you've probably heard the term "digital photography workflow" quite often. What is a digital photography workflow, and why should you care about it? All you want is to take a picture and get great output. Well, a workflow is a method, a process. As with anything else you do, following a tried-and-true method may not guarantee perfect results, but *not* following such a method is guaranteed to produce poor results. The process should be fast, at reasonable cost, and should produce optimal quality.

Digital workflow includes everything that happens from the moment you take a picture until you print and archive it. Unfortunately there is no magic bullet to guarantee success in all of these areas. This book will not presume to sell you this illusion. What we can do is present a proven workflow that enables you to:

- Improve your output quality
- Save you time by avoiding costly personal exploration

Our goal is to present the essential information as simply as possible, but no simpler. The workflow we present is based on practical work with thousands of real-world RAW photographs. We're not trying to make you a great master in Photoshop or similar tools. Instead, we hope to teach you how to use all necessary imaging tools in a way that allows you to create the images you want without undue trial and error.

We've included some of our own photographic artwork to remind you that it is all about good pictures and not just technique. We prefer a great vision imperfectly executed over a technically perfect but boring picture. We trust you understand what we mean by this. In the end, your eyes are the most important tool for success in photography.

HOW TO USE THIS BOOK

This book is not intended as a substitute for the program's manual. Some of the programs covered here would very likely be worth books of their own. Instead, you will receive a thoughtful overview, plus hints and recommendations designed to help you set up your own RAW workflow and adapt it to your personal preferences and the kind of work that you do. We focus on getting the best possible images from the RAW files your camera produces.

This book is quite technical and deals with many aspects of various programs and techniques. But remember: The goal is to take good photographs. Don't get so lost in technique that you spend all your time fiddling with programs and settings. You can be more productive if you shoot good photographs and focus on being creative, looking for appropriate light, and finding the right angle of view and optimal settings. What we hope to show you in this book is how, in the "digital darkroom," to make the most of the creative work you've already done with your digital camera.

HOW THIS BOOK IS ORGANIZED

The first two chapters are intended to prepare you for implementing a RAW conversion workflow. Chapter 1 explains what RAW files are, how they differ from JPEG files created by in-camera processing, and some of the advantages of doing that processing in a RAW converter instead. Chapter 2 covers the basics of color management, including color models and color spaces, and shows how to create an accurately calibrated profile of your computer monitor.

The next four chapters focus on the RAW conversion process and the software you'll use to implement it. Chapter 3 outlines a general workflow for RAW conversion. Chapter 4 shows how to implement that workflow using Adobe Camera Raw, the converter most directly integrated with Photoshop; and Chapter 5 takes the same detailed approach with Pixmantec's RawShooter, a powerful RAW converter that's available free of charge, and RawShooter Premium. Chapter 6 covers Apple's new RAW converter, Aperture. Chapter 7 presents the key features of four more popular converters: Phase One's Capture One, Bibble Labs' Bibble, Canon Digital Photo Professional, and Nikon Capture. Chapter 8 covers Adobe's new integrated digital photography application, Lightroom.

Chapter 9 extends the basic workflow to the corrections and refinements most commonly implemented in Photoshop.

The remaining chapters focus on more specialized topics: streamlining the workflow with batch processing in Chapter 10, the promise of Adobe's new digital negative (DNG) format in chapter 11, the various uses of metadata in Chapter 12, creating a custom camera profile and calibrating your coverter in Chapter 13, and converting RGB images to black-and-white in Chapter 14.

Because these topics involve some fairly specialized vocabulary, we've also included a glossary as Appendix A; and we've compiled sources of information, products, and other resources in Appendix B.

PLATFORMS: WINDOWS OR MAC OS?

Most of the software used in this book is available in both Windows and Macintosh versions. (A few tools we use are available only for Windows. For most of these, you can locate an equivalent tool for the Mac platform.) Uwe and Bettina Steinmueller work on Windows machines most of the time. Fortunately,

Photoshop cs is pretty much the same for Windows and Mac os (apart from some different keystrokes). Thus, all the Photoshop content is valid on both platforms. Author Jürgen Gulbins uses a Macintosh as his primary platform. So, both systems are used in this book without any serious incompatibilities or problems. As for the computer configuration, dealt with in a later section, the requirements are very much the same for a Windows pc or a Macintosh.

KEYBOARD SHORTCUTS

Microsoft Windows and Mac os x use some different keyboard shortcuts. In most cases, substitute the Windows [Ctrl] key with the Mac [⌘] key (labeled and also known as the *command key*) and the Windows [Alt] key with the Mac [⌥] key (called the *option key*). When you read a key sequence like [Ctrl]/[⌘]-S it means you have to press [Ctrl] and S together in Windows and [⌘] together with S with Mac os.

COMPUTER CONFIGURATION

Image processing often places significant demands on your computer hardware. Here are some guidelines for what you'll need (valid for both Macs and pcs):

Memory: 1GB of memory is a good start, and more is better. At a bare minimum, you need 0.5GB.

Monitor: Don't settle for a low-quality monitor. 1280 × 1024 is an acceptable resolution. Again, more is better (we use 1600 × 1200). To take advantage of this high resolution, you also need a sufficiently large screen; we suggest at least 19".

Connections: Having both usb 2.0 and Firewire ports is a plus.

Processor: A fast cpu buys you speed and saves you time. We recommend a 1 ghz Pentium or a 450 mhz G3 Macintosh as a reasonable minimum. A faster cpu will give you more immediate response and make your work more pleasant. Having dual processors is a plus, as both can be utilized by Photoshop.

Disk space:
- 1 × 80gb or more for your operating system
- 1 × 80gb or more for working files
- 2 × 120gb or more for archiving (external usb 2.0 or Firewire drives are fine)

Card Readers: External Compact Flash (cf) card reader with usb 2.0 or Firewire connection (usb 1.0 is considerably slower)

Other Hardware:
- dvd reader/writer (external Firewire is fine)
- Device for monitor profiling (see Chapter 2, Section 2.3)

In all cases, more is better. The result is faster operation, a more comfortable workflow, and a more pleasant working environment. When doing color work, the importance of a good large monitor should not be underestimated. Although it was true a few years ago that crt monitors were universally better than lcds—especially for color accuracy—this is no longer the case. There are many very good lcd monitors on the market. However, you have to spend up to 3 times the amount of money to get an lcd with the same size and quality of a crt. For color work, laptop screens are usually not as effective as stand-alone monitors. In most cases, their contrast is lower and in almost all cases their color quality is lower.

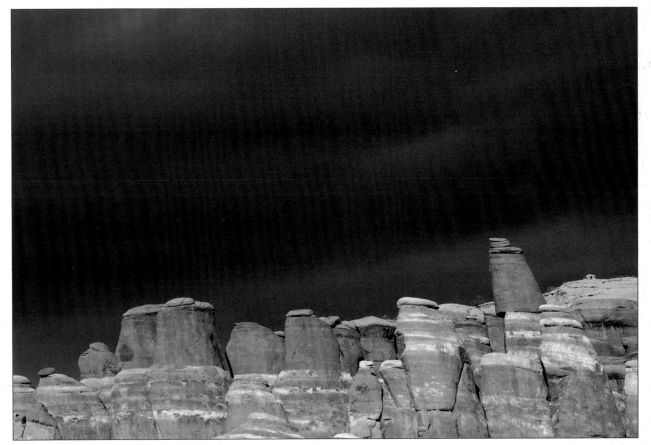

CAMERA: CANON 10D

Our goal in this book is to demonstrate a reliable workflow that will help you achieve optimal image quality from your digital camera using the RAW file format. After capturing RAW images, you can use your computer (rather than your camera) to convert them to JPEG or TIFF.

To help you better understand what you'll be doing when you work with the RAW converter software covered in later chapters, this chapter will explore how the camera creates a JPEG file. In the process, we'll cover some of the limitations of in-camera file conversion, and we'll outline a basic strategy for beginning your workflow with the best possible source image.

1.1: How the Camera Creates JPEGS

JPEG (Joint Photographic Experts Group) is the image format most commonly used by today's digital cameras. It provides reasonably good image quality, but as you'll see, it has some limitations. The obvious one is that its compression format, although excellent, is lossy; some information is always thrown away when an image is compressed. (There are lossless JPEG formats, but they are rarely used in cameras.) And, even when the JPEG compression is low, the image still degrades slightly.

A more significant problem is that before a camera converts an image to JPEG format, the image must undergo extensive processing within the camera. This processing includes color and exposure correction, noise reduction, and sharpening. Because these adjustments are made in the camera, your ability to make further post-processing corrections is limited.

The upshot is that JPEG compression works best for images that don't need further substantial post-processing, or when such post-processing is prohibited. However, if you demand high quality from your work, you will find that it is the rare image that does not need some post-processing. 🌸

NOTE:
Many photographers try to get the best possible quality from their cameras by saving their images as TIFF or as a vendor-specific RAW file format (if available). As you will see, RAW file formats allow the greatest post-processing flexibility.

HOW IN-CAMERA CONVERSION WORKS

All new digital cameras capture color photos, right? Well, not exactly. While you ultimately get color prints from a digital camera, most modern digital cameras use sensors that record only grayscale (brightness or luminance) values. (The Foveon x3 sensor, digital scanning backs, and multishot digital backs are exceptions.)

For example, say you want to photograph a box of Crayola crayons (Figure 1-1).

A grayscale sensor would see the picture as shown in Figure 1-2; that is, it would see only shades of gray.

But how do you use a grayscale sensor to capture color photos? Engineers at Kodak came

FIGURE 1-1: Full color sample target

FIGURE 1-2: Grayscale picture seen by the sensor

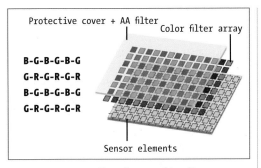

Protective cover + AA filter
Color filter array

B-G-B-G-B-G
G-R-G-R-G-R
B-G-B-G-B-G
G-R-G-R-G-R

Sensor elements

FIGURE 1-3: Bayer Pattern achieved by a
matrix of color filters

FIGURE 1-4: Color mosaic seen through the color filter

up with the Color Filter Array configuration illustrated in Figure 1-3. This configuration is called the Bayer Pattern after the scientist who invented it back in the 1980s. (Other pattern variations are used, but this is the basic technology used in most CCD and CMOS sensors.)

The yellow squares in the grid shown in Figure 1-3 are the photoreceptors that make up the sensor; each receptor represents one pixel in the final image. Each receptor sees only the part of the light that passes through the colored filter just above the sensor element (either red, green, or blue).

Notice that 50 percent of the filter elements (and thus the receptor elements) are green and only 25 percent each are red and blue. This pattern works because the human eye can differentiate many more shades of green than it can red or blue ones (which should be no surprise when you consider the number of shades of green in nature). Green also covers the widest part of the visible light spectrum.

Each receptor in the sensor captures the brightness value of the light passing through its color filter (Figure 1-4).

Each pixel, in turn, contains the information for one color (like a tile in a mosaic). However, we want our photo to have full color information (the R, G, and B channels) for every pixel. How does that magic happen? Here's where a software trick comes into play: a process called demosaicing or color interpolation adds the missing RGB information by estimating information from neighboring pixels.

Demosaicing and Color Interpolation

Demosaicing, then, is the method of turning the RAW data into a full color image. A good demosaicing algorithm is quite complicated, and there are many proprietary solutions on the market.

The challenge is to resolve detail while at the same time maintaining correct color. For example, think of capturing an image of a small, black-and-white checker pattern that is small enough to just overlay the sensor cells, as in Figure 1-5.

White light consists of red, green, and blue, and the white squares in our example pattern correspond exactly to the red- and blue-filtered photoreceptors in the sensor array. The black squares, which have no color information,

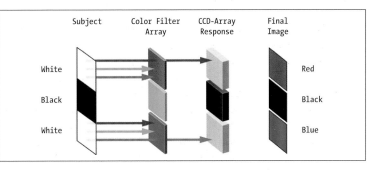

FIGURE 1-5: CCD/color-mosaic sensor with color interpolation errors

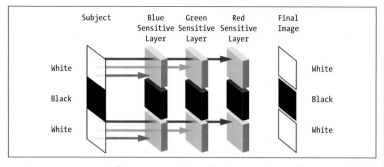

FIGURE 1-6: Foveon sensor with no color interpretation problems

correspond to green-filtered photoreceptors. So for the white squares that align with red photoreceptors, only red light passes through the filter to be recorded as a pixel; the same is true for the blue photoreceptors.

Color interpolation cannot correct these pixels because their neighboring green-filtered photoreceptors do not add any new information, so the interpolation algorithm would not know whether what appears to be a red pixel really is some kind of "red" (if the white hits a red filter) or "blue" (if the white hits the blue filter).

Contrast this with the Foveon sensor technology illustrated in Figure 1-6. Instead of the Bayer Pattern where individual photoreceptors are filtered to record a single color each, the Foveon technology uses layers of receptors, so that all three color channels are captured at the

same photosite. This allows the Foveon sensor to capture white and black correctly without the need for interpolation.

The resolution captured by the Bayer sensors would decrease if the subject consisted only of red and blue shades, because the pixels for the green channel could not add any information. In the case of monochromatic red or blue colors (those with very narrow wavelengths), the green sites get absolutely no information. But such colors are rare in real life and, in reality, even when the sensor samples very bright and saturated red colors, information is recorded in both the green and (to a much lesser extent) blue channels.

The problem in our example above is that in order to correctly estimate the color, we need a certain amount of spatial information. If only a single photosite samples the red information, there will be no way to reconstruct the correct color for that particular photosite.

Figure 1-7 illustrates a test we did in a studio to demonstrate the loss of resolution with a Bayer sensor when capturing monochrome colors. Notice how blurry the text in the Canon image is compared to that of the Sigma image. [⚡]

Some of the challenges that face interpolation algorithms include image artifacts, like moirés and color aliasing (shown as unrelated green, red, and blue pixels or resulting in discoloration). Most cameras fight the aliasing problem by putting an antialiasing (AA) filter in front of the sensor (which actually blurs the image and distributes color information to the neighboring photosites). Of course, blurring and high-quality photography don't usually go together, and finding the right balance between blurring and aliasing is a true challenge for camera design engineers. (In our experience, the Canon 1Ds does this job well.)

After antialiasing, an image needs to have stronger sharpening applied in order to re-create much of the original sharpness. (To some extent, AA-filtering degrades the effective resolution of a sensor; therefore, some strong sharpening is typically needed later, during the RAW workflow.)

The mission of creating a high-quality image from the data recorded by a sensor is a complicated one, but it works surprisingly well. Every technology has to struggle with its inherent

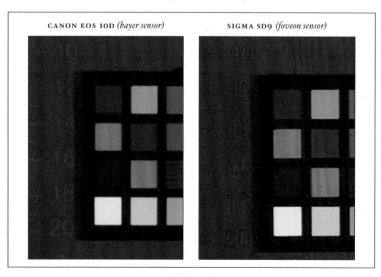

CANON EOS 1OD *(bayer sensor)* **SIGMA SD9** *(foveon sensor)*

FIGURE 1.7: Fooling a Bayer sensor

limitations and digital photography can beat film today in many ways because film has its own limitations. [❀]

THE LIMITATIONS OF IN-CAMERA PROCESSING

For any given digital camera, the RAW data is all the data for grayscale brightness values captured on a chip. To produce a final image, this RAW data needs to be processed (including demosaicing) by a RAW converter. In order to produce JPEG images, the camera must have a full RAW converter embedded within its firmware.

As you've already seen, one effect of in-camera conversion to JPEG is artifacts caused by lossy compression, but camera-produced JPEGs have other limitations as well:

- Although most sensors capture 10- to 14-bit color (grayscale) information, only 8 bits are used in the final file. (JPEG can't encode more than 8 bits per color channel.)
- The in-camera RAW converter can use only the camera's own, limited computing resources. Good RAW conversion can be very complex and computer intensive. It is much more efficient to have the host computer convert the image than it is to use the onboard ASIC chip commonly used today. Additionally, the in-camera chip can't be upgraded, so as software technology evolves, the difference in efficiency will only increase.
- White balance (WB), color processing, tonal corrections, and in-camera sharpening are all applied to the photo within the camera. This fact limits your post-processing capabilities because a previously corrected image must be corrected again, and the more a photo is processed (especially 8-bit), the more it can degrade.

RAW FILE FORMATS

The advantage to working with RAW file formats directly is that they essentially store only RAW data (although they also contain an EXIF section, which holds additional metadata that describes properties such as camera type, lens used, shutter speed, f-stop, and more). Fortunately, you can perform all the processing that would be done in the camera to convert a file to JPEG or TIFF (including white balancing, color processing, tonal/exposure correction, sharpening, and noise processing) on a more powerful computing platform. This offers several advantages:

- No JPEG compression. You can work directly with the RAW data.
- You can take full advantage of the 12-bit color information (10 to 14 bit). This becomes particularly significant if you need to make major corrections to the white balance, exposure, or color. When processing an image, you lose bits of image data because of data clipping (which accumulates over multiple steps). The more bits you begin with, the more data you'll have in your final corrected image.
- You can use very sophisticated RAW file converters such as Adobe Camera Raw, Pixmantec's RawShooter Essential, Apple's Aperture or Phase One's Capture One DSLR. Chapters 4 through 7 provide hands-on guidance for using these tools.
- You can do color correction (white balance).

Working with JPEGs created in-camera is like working with images produced by a Polaroid camera (where you simply shoot and receive your processed image immediately). Working with RAW files is more like working with a traditional film negative that can be developed and enhanced in the darkroom. RAW converters mimic the film development process, and because you can always return to your original RAW file and process it again, you aren't limited by the technology built into today's cameras or even today's software. Over time, improved RAW file converters will produce even better results from the same data.

All in all, shooting in RAW gives you much greater control while processing your images.

The TIFF Option

What about setting your camera to save images as TIFF files? Saving as TIFF files solves only the lossy compression issue because the images are still converted to 8-bit inside the camera. Too, most TIFF files are larger than RAW files (RAW files hold

NOTE:
Keep in mind that lost detail cannot be recaptured regardless of the fancy sharpening methods used. Sharpening does, however, do quite a good job, and digital cameras work fairly well.

only one 12-bit grayscale value per pixel), and they don't offer the flexibility and control benefits that RAW does. An 8-bit in-camera processed TIFF file is only slightly better than a high-quality/high-resolution JPEG.

1.2: The Digital Negative/Slide

The files created on your computer when shooting RAW are often called digital negatives. You should keep these RAW (or original JPEG or TIFF) files even after converting them because they hold all the information captured when you took your original shot. You might want to revisit them when:

- You've improved your own digital workflow (which is very likely over time).
- Better RAW converter software becomes available. We have seen many improvements over the last four years and expect more to come.
- You lose your derived files.

A RAW file is like a latent image, and RAW converter software can bring detail out of over-exposed or underexposed shots. The one big difference between film and digital photography is that you can perform multiple kinds of development on your digital images over time, and you can return to them over and over again.

1.3: Some Strategic Reasoning

Just as many paths lead to Rome, there are many ways to shape your digital workflow. The most appropriate way for you will depend on the kind of photographs you shoot, how you intend to use or reproduce your images, your equipment, and your personal preferences. To set up a workflow that suits your work best, you may need to try different variations before you finally settle on one (which you may still adjust for special cases).

Several of the steps we follow when processing an image (including white balancing, sharp-ening, enhancing contrast, noise reduction, and enhancing saturation) can be performed at any one of three different stages:

- Inside the camera (some of the operations mentioned above, even if you shoot RAW files)
- Inside your RAW converter
- When using Photoshop or a Photoshop plug-in

Performing an operation at an early stage doesn't necessarily mean that you cannot perform it again at a later one. For example, there will be times when it will make sense to perform some sharpening globally with the RAW converter and then add more sharpening when you tweak the image with Photoshop, which allows you to sharpen either the whole image or certain edges or areas.

You may even want to perform some final sharpening when you are preparing a dedicated form of output. (For example, an image printed using an inkjet printer or offset printing will require more sharpening than one that is to be presented on-screen or printed with a lightjet printer on photographic paper by a photo service.) In-camera RAW converters and software RAW converters allow only global changes to the whole image, while Photoshop allows you to make selective corrections using selections, masks, layers, and filters.

The general rule is that corrections done in the camera or (with more control) in the RAW converter, will do less to degrade the quality of your images than corrections made in Photoshop. This is especially true when correcting exposure, which should be done within the camera; it is much better to correct exposure values with the RAW converter than to do so within Photoshop.

WHITE BALANCE

When you shoot RAW files, make sure to set the proper white balance in the camera, because this value will be used as the default starting point for your white balance inside the RAW converter. However, this is only a starting point and may be changed without losing color quality. White balancing is one of the most important tasks in a

RAW converter and should usually be done there (as you'll see demonstrated in the chapters on individual RAW converters). [⚡]

SHARPENING, SATURATION, CONTRAST ENHANCEMENTS

Apart from the exposure and white balance settings, you should deactivate all other settings (such as sharpening, saturation, and contrast enhancements in the camera) or set them to the lowest possible value when you shoot RAW files. This is even more important if you shoot JPEG or TIFF. The only exception would be if you shoot JPEG or TIFF and don't want to do any post-processing in Photoshop.

UP-SAMPLING OR DOWN-SAMPLING

When scaling, we recommend using the camera's highest resolution and then performing up-sampling or down-sampling either in the RAW converter or in Photoshop. Photoshop and Capture One both support reasonably good up-sampling, but they offer only certain fixed sizes. To prepare an image for large-scale printing, you may find it helpful to do a rough up-sample in your RAW converter and a final sizing in Photoshop.

CROPPING

Adobe Camera Raw 3 (or newer), Nikon Capture, and Capture One all offer cropping. Cropping results in smaller image files and, as a result, faster processing.

1.4: Choosing a RAW Converter

Several RAW converters are available, and more are being released. Almost all DSLRS come with a native RAW converter, which might be a Photoshop plug-in, a stand-alone RAW converter, or both. For example, Canon cameras that offer the RAW format ship with both the Canon EOS Viewer Utility (EVU) and Canon Digital Photo Professional (DPP). If you use Photoshop CS1 (alias Photoshop 8) or CS2 (alias Photoshop 9), or even Photoshop Elements 3 or higher, your software includes a good RAW converter (for Adobe Camera Raw, see Chapter 4). If you use a picture database or a good picture file browser (also referred to as a Digital Asset Management Systems or DAMS), it probably will have a RAW converter of its own. Stand-alone RAW converters include RawShooter by Pixmantec (covered in Chapter 5), Capture One by Phase One, Nikon's Capture, and Bibble (all covered in Chapter 7)—just to name a few.

The RAW converters that are part of a DAMS system (such as ThumbsPlus, iView Media Pro, and Extensis Portfolio) are primarily intended to produce a reasonable preview. Although they can be used to convert a RAW file to TIFF or JPEG, conversion is not their primary focus. Therefore, you should seriously consider converting your RAW file with one of the "real" RAW converters.

The range of formats and cameras supported by the various RAW converters differs. Nikon's tools, for example, support only Nikon cameras, and Canon's tools support only Canon's cameras. Adobe Camera Raw, Capture One, RawShooter, and Bibble support a wide range of formats, but check to be sure that they support your camera. Too, some converters are faster than others, and some offer better workflow integration. For this reason alone, you should read the descriptions of all the RAW converters covered in Chapters 3 through 7, download their trial versions from the Internet, test them, and settle on the one that best fits your needs and budget. You may also find it useful to use more than one converter, depending on the type of work and the images you have to process.

[⚡]

NOTE:
With cameras that support black-and-white shooting, you may consider using a black-and-white setting if you are sure that you don't want color. However, shooting color offers more control and more options. You can always convert color to black-and-white inside the RAW converter or in Photoshop (see Chapter 14).

CAMERA: CANON 1D MK. II

Most of us usually shoot in color, and it's essential that the color we see on the monitor closely matches the color seen by the camera when a photo is taken. When white balancing, adjusting color saturation, and making similar color corrections, it is crucial to make sure that the monitor accurately represents the color values in an image. If we print our image (after finishing all our optimizations and enhancements), we want the colors in our print to be as close as possible to those we saw on the monitor.

Color management is one of the most demanding subjects in digital photography, and it is the subject of entire books. This chapter presents a quick introduction to color management, focusing on those aspects important to a RAW conversion workflow. You'll learn about color models and spaces, the role of ICC profiles, and how to calibrate your monitor using the popular GretagMacbeth Eye-One Display package, which includes both a sensor device and software.

Color management is about accurately mapping colors from the input source to the tools used for processing and output. In order to work efficiently with color, you must understand the basics of color and color management.

2.1: Color Models and Color Spaces

A **color model** uses numerical values to define how colors in an image are described. Photoshop supports several different color models, but the models most commonly used by photographers are

- RGB
- LAB
- CMYK
- Grayscale

THE RGB COLOR MODEL

RGB is the color model most commonly used in digital photography, and we use it almost exclusively in the RAW conversion workflow. In this

FIGURE 2-1: The RGB color model

model, all colors are created by combining three primary colors: red, green, and blue (Figure 2-1). RGB is an **additive color model**, meaning that the sum of all three basic colors at full strength (100 percent) will add up to pure white. [⚡]

An RGB value of 0, 0, 0 defines black, and an RGB value of 255, 255, 255 is bright white. (Of course, both extremes should occur rarely in any photo.) As you'll learn later in this chapter, pure RGB values do *not* define colors in an unambiguous way without an additional reference to the device or color space these values are used for.

Color Depth

When discussing RGB color, you'll see references to **color depth**. Color depth refers to the number of bits used to represent a single channel (such as red) in an image. You can use either 8 bits (1 byte) or 16 bits (2 bytes) to specify this value. Photoshop CS2 supports HDR mode (high dynamic range) where 32 bits are used per channel, but most functions do not yet support that mode.

Depending on whether you choose to use 8 or 16 bits (a choice you'll usually make in the RAW conversion software, as you'll see in Chapter 3), your image is said to be in either 8-bit or 16-bit mode. Using 8-bit, the value of a single channel may range from 0 to 255; combining the three primary colors of RGB gives us 256^3 (16,777,216) possible shades of a primary

NOTE:
To learn more, see one of several good books on color management, such as Color Confidence *by Tim Grey (Sybex, 2004) or* Real World Color Management *by Bruce Fraser (Peachpit Press, 2004).*

NOTE:
Additive color models describe light projected from a source, such as a monitor. With a printed image, by contrast, you're looking at reflected light. A subtractive color model is needed to describe how the inks absorb some colors and reflect others, as discussed later in "The CMYK Color Model."

color. Using 16-bit, the range would run from 0 to 65,536 (actually only 15 bits are used, so the range becomes 0 to 32,768).

For most issues in color management, it doesn't matter which mode you use. Using 16-bit doubles the space needed to store the values, but it gives you more headroom for differentiating color values and allows more precise calculations with fewer rounding errors.

When producing final output (e.g., when printing), you will be required to reduce your image to 8-bit mode, since almost no real device can actually produce more than 256 different shades of a color. Our eyes can only distinguish about 120 to 200 color shades, depending on illumination. During the color optimization phase, however, where a large amount of color shifting and transformation and lots of color value calculations are done, 16-bit is the better mode.

THE LAB COLOR MODEL

The **CIE-LAB color model** (often spelled Lab, LAB, or L*a*b*) separates colors (chroma, A+B) from the detail and brightness (luminance, L) in images. As in RGB, LAB uses three basic components to build (or describe) a color—*L* (for Luminance), ranging from Black (0 = no light) to white (100%), and two color axes (*A* and *B*). As shown in Figure 2-2, the A-axis represents a Green to Red spectrum and the B-axis represents Blue to Yellow.

LAB is designed to be an absolute color space which is completely device-independent; whereas RGB or CMYK are inherently device-dependent. LAB color is rarely used directly in digital imaging.

Although LAB is modeled according to the human perception of color, working directly with the LAB model is not very intuitive for most users. However, color management systems use LAB as an intermediate color space when converting colors between different color spaces.

THE CMYK COLOR MODEL

The CMYK color model uses four primary colors to define a color: cyan (C), magenta (M), yellow (Y),

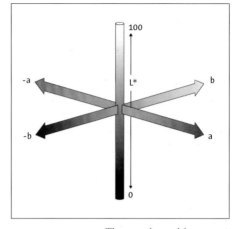

FIGURE 2-2: The LAB color model

NOTE:
Although we recommend using 16-bit mode whenever feasible, most explanations in this book follow the common convention of using 8-bit (0–255) values for simplicity.

and black (K). CMYK was designed for printing, where incoming light is reflected by the print.

CMYK is a **subtractive color model**, as each of these colors absorbs (subtracts) a certain spectrum of light. As you see in Figure 2-3, mixing cyan and magenta gives you blue, and when you add magenta to yellow you get red. In theory, combining the colors C, M, and Y should produce black, but because of certain impurities in ink, it produces a dark, muddy brown instead. To solve this problem, the model adds a fourth color, black, which is called the **key color** (K).

Although CMYK is an important color model for the printing press, it is not used much in digital photography. While inkjet printers

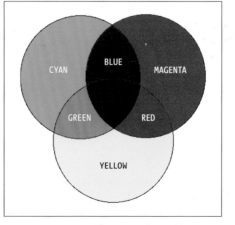

FIGURE 2-3: The CMYK color model

are technically CMYK printers (in fact, most are actually CcMmYK, as they add light Cyan and Magenta inks), they provide an RGB interface to the user, and the conversion from RGB to CMYK is done by the printer driver in an almost transparent way.

We rarely use the CMYK color model in our workflow. Even if you intend to prepare your images for prepress work, which ultimately requires CMYK, you should stick with RGB mode images whenever possible and convert to CMYK as the very last step (you may need to apply some additional sharpening and slightly increase the saturation for the final touchup).

Working on photos in CMYK mode does have its disadvantages:

- CMYK image files are larger than RGB files (because they store four color values per pixel instead of three).
- Some photo filters won't work in CMYK mode.
- The CMYK color space usually has fewer colors than most RGB color spaces. Therefore, when you convert from RGB to CMYK, you will probably lose some colors, and there is no way to retrieve them if you ever want to use your image for anything that requires RGB colors, such as lightjet printing (used by photo services to output your RGB image on photographic paper) or a monitor-based presentation.

GRAYSCALE MODE

Photoshop also works with images in either pure Black-and-White (B&W, or bitmap) or Grayscale mode. In grayscale, however, the color of a pixel is described by only a single (gray) value. Consequently, even when you intend to produce a grayscale (black and white) photo, we recommend using RGB mode, to preserve color information.

In Photoshop's Bitmap mode, a picture has only two possible color values: black or white, with no gray. Bitmap mode is rarely used for photographs, and most imaging techniques and filters do not support Bitmap mode.

NOTE:
For more information, read about the European Color Initiative (ECI) at www.eci.org.

NOTE:
Photoshop offers additional color models, but photographers rarely use them. Bitmap is used for pure black or white (bitonal) images. Index mode is used primarily for web graphics (where the need to reduce file size in the interest of download time can make the limit of 256 different color values an acceptable trade-off). Duotone is used for black-and-white images and allows the addition of a second color to give a print more depth.

COLOR SPACES

A **color space** is the total range of colors (or color values) that either a real device (such as a monitor or printer) or a virtual device (such as a **theoretical average monitor**, represented by the SRGB color space) can record or reproduce. This range is also known as the **gamut** of the device.

Every real device has a unique color space, and even identical devices of the same make and model can have slightly differing color spaces (e.g., because of differences in age, production tolerances, and so on). These differences are multiplied by the various choices you make in hardware or software, such as different monitor resolution, different printer inks and papers, and even by changing the brightness setting on a monitor.

To improve your ability to work with colors, the International Color Consortium (ICC) and some other companies (Adobe, Kodak, Apple, Microsoft, and so on) have defined **virtual color spaces** that represent the gamut of a virtual device rather than a real device. As you explore and learn more about color management, you'll see the advantages of using virtual, standardized color spaces.

2.2: Color Management and Color Profiles

We've said that the goal of color management is to ensure that the photo you see on your monitor looks as much as possible like the print you'll get from your inkjet printer or a photo service's lightjet printer. Color management helps to reproduce colors as truthfully as possible across a broad range of different devices, even though truly identical reproduction is often impossible because of the different ways different devices produce color. Still, you should at least be able to predict as closely as possibly the color you'll get when printing based on the color you see on your monitor.

THE IMPORTANCE OF COLOR MANAGEMENT

If you were to post a photo on the Web without utilizing color management and you asked different people to discuss the photo's color quality, the responses would vary widely because the colors would appear differently on each monitor. The viewers would see different versions of the same photo; in fact, some monitors might not even be able to render some of the picture's RGB values. [☉]

The goal of color management is to significantly reduce the problem of unpredictable color output.

THE CHALLENGE

The challenge here is to have a monitor accurately display how a certain photo will print on a color printer. The latest inkjet printers can produce amazing results, but without proper color management, color printing remains trial and error. You can end up changing the printer's color settings for every print, with results that usually aren't satisfactory.

THE SOLUTION

The solution to the color problem is to accurately determine the color characteristics of a device and to take those characteristics into account when reading colors from an input device or sending color to an output device. Additionally, we tag color images to define how to interpret their color values.

ICC *Profiles*

This solution has been implemented throughout the digital imaging industries in the form of standardized device descriptions called **ICC profiles** (the format of which is defined by the International Color Consortium).

The ICC color profile describes a device's color characteristics, including the range or gamut of colors the device can record or reproduce. For an input device, it also notes the values recorded for a perceived color; for an output device, it specifies the values you must send to the device to produce a certain color.

Almost all color management systems today use ICC profiles. With the help of such a profile, the color values required to produce a specific color on device A (e.g., a monitor) can be translated to values that will reproduce the same color on device B (e.g., a printer) as close as technically possible.

ICC profiles are supplied by the device manufacturer (usually called **generic profiles**), or you can produce your own using special profiling hardware and software. A profile produced for your specific device is called a **custom profile**. [▪★]

Besides camera, monitor, and printer profiles, there are also ICC profiles (known as *tags*) for images; these tags define how the color values of the image are to be interpreted.

Let's return for a moment to the problem of the image sent across the Web that (without color management) would display different colors on different monitors. With the help of the input profile, a color management system or an application using color management may correctly interpret the RGB values of the (input) image and, with the aid of an ICC profile for each viewer's monitor, may transfer them to color values that produce (nearly) the same color on each of those output devices. We'll see how this is done in the next section.

WHAT IS A COLOR MANAGEMENT SYSTEM?

A color management system (CMS) is a set of program modules that handle color translation. These modules are often part of the operating system but may be provided by applications, such as Photoshop. When an application displays or prints a color image, it calls up these functions and hands over the image values and ICC profile information to the CMS modules, telling them what function should be performed. The central part of the CMS is its color management module (CMM) or color management engine. The CMM performs the calculations needed to translate (transform) a color from color space A to color space B. Here's how it works:

1. The color management module translates the device-dependent color values of the image to the device-independent LAB color

────[☉]────

NOTE:
To verify that your color-managed software (such as Photoshop) is mapping your image's colors to a printer's color space as accurately as possible, you should "proof" that mapping. Photoshop can simulate on your monitor the colors and the impression that an image will have when printed on a specific printer or other output device; a technique called soft proofing. *(Because most people use their monitor as their soft-proofing device, the first step toward complete color management is to profile your monitor.) If you proof by actually printing with the same inks and the same paper you'll use for your final output, you're* hard proofing.

────[▪★]────

NOTE:
A raw RGB value does not define color in an absolute way; the color produced depends to a great extent on the output device used or on the device that recorded that value. An RGB value in the context of a specific color space (defined by an ICC profile), however, defines an absolute color.

space, using the description of the source ICC profile. This intermediate space is called the **transfer color space** or **profile connection space** (PCS).

2. These LAB values are translated to color values that will produce a color on the output device that is as close to the original color impression as possible. If the output device cannot produce the very same color, the CMM will try to find a close match, based on the **translation intent** (described under "Color Space Mapping" later in this chapter).

The ICC profiles used in this scheme are actually simple translation tables. They support translation from device-dependent color values to the device-independent color values (and vice versa). Figure 2-4 illustrates the roles of the different ICC profiles.

Photoshop and other applications that support color management embed ICC profile data within the image file, and files with this embedded information are called **tagged files** (or *tagged images*). When you copy or transfer the tagged image, the profile information is copied or transferred too. Unfortunately, not all image file formats can include ICC profiles. TIFFS and JPEGS can include ICC profiles, but GIFs and PNGs cannot. (GIF has an unacceptable color depth anyway.)

COLOR WORKING SPACES

Although profiling makes it possible to map from any device-dependent color space to another, it would be cumbersome to work with a large number of such spaces. This is why virtual, standardized color spaces were defined, which describe the gamut of an abstract (virtual) device rather than a specific real device.

There are several different such spaces for each of the color models (RGB, LAB, CMYK), with gamuts ranging from narrow to broad. For example, for the RGB color model, there are (from narrow to wide) sRGB, Apple RGB, Adobe RGB (1998), ECI-RGB, and Pro Photo RGB (along with several others).

We define several working spaces for a color model because these spaces differ mainly in the color range (the gamut) they cover. In some work-

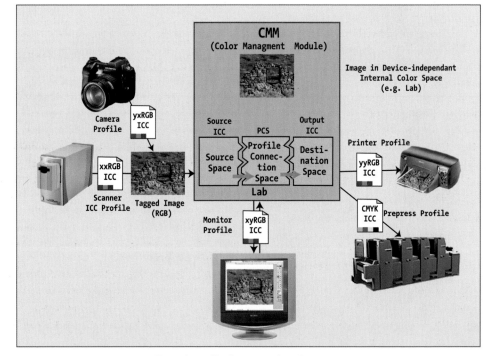

FIGURE 2-4: How color profiles function with a color management system

flows, it is advantageous to use a narrow color space, while in others, a wide space is better. [⚡]

Because digital cameras allow a wide gamut, you should use a work space with a wide gamut if you intend to produce output for several different output methods (such as an inkjet printer, lightjet printer, monitor, and so on). If you convert your image to a working space with a narrow gamut, you may lose some colors that could be reproduced by some of your output devices.

However, if you use a working space with a very wide gamut, the bit depth available for representing color values may not be sufficient to differentiate the many different colors your gamut allows (with 8-bit, only 256 discrete values are available per channel). As a result, many of the values that are theoretically available may be lost, because your image may never have colors that extend to the outer edge of the theoretical gamut of the space. This loss of effective bit depth may worsen if you have to do a lot of correcting, rounding, and transformations.

In order to preserve all the color data in your image, we recommend using 16-bit mode when you intend to use a color space with a wide gamut.

IMPORTANT COLOR SPACES

These are some of the most important color spaces for photographers:

sRGB: This color space was designed to be used with monitors, and it is a good one to use for photos to be presented on the Web. It defines the relatively narrow gamut that can be displayed by the average monitor, which is a relatively small color space. Although many DSLRs allow you to produce images using sRGB, it is a much narrower color space than the cameras can see and record.

Adobe RGB (1998): This color space is very popular among Photoshop users. It has a larger gamut than sRGB and covers most printable colors. We use this color space for digital photos.

Pro Photo RGB: This color space was defined and is supported by Kodak. It provides a very large gamut and should only be used when working

with a color depth of 16-bit. This is the only working space mentioned here that can hold all the colors that a good DSLR can deliver.

Apple RGB: This color space was defined by Apple Computer and is commonly used with Macintosh systems. Its gamut is wider than that of sRGB but smaller than that of Adobe RGB. We do not recommend this for photos.

ECI-RGB: This color space was defined by ECI (the European Color Initiative), a group of companies organized to set color production standards in Europe. The ECI-RGB color space was designed to include all the colors that printers can reproduce. Its gamut is somewhat wider than that of Adobe RGB and includes some greens that can be reproduced by many printers (inkjet and offset, as well as gravure) but which are not part of either sRGB or Adobe RGB (1998). ECI-RGB is the standard RGB color space within the European prepress industry and serves as the European alternative to Adobe RGB for prepress work. [⏻]

VISUALIZATION OF COLOR SPACES

Color spaces are three-dimensional, and are based on the LAB color model, meaning that each color space has a lightness axis and two color axes..

The profile shown in Figure 2-5 is that of sRGB, using the ColorSync utility of Mac OS X. The gray outer space shows the gamut of Adobe RGB (1998) and allows us to compare these two color spaces. As you can see, Adobe RGB is a superset of sRGB.

The industry sometimes uses 2D graphs to display color spaces. For example, the color space plot shown in Figure 2-6 was generated with the GretagMacbeth Profile Maker Pro 4.1 Profile Editor.

As you can see in Figure 2-6, the color space for Pro Photo RGB is extremely wide, while that of Adobe RGB (1998) is much smaller, and sRGB is very narrow.

A comparative display like Profile Maker Pro's Gamut view is especially useful because so many variables go into defining a profile. A printer profile, for example, is actually a profile

[⚡]

NOTE:

In the RAW conversion process for a digital photo, we usually replace the camera's device-specific working space (including its ICC profile) with a standardized color space and continue to work on the image using this working space.

[⏻]

NOTE:

If you have the profile of a particular color space installed, Adobe Photoshop will support that color space. The standard Photoshop installation will install all of the color spaces mentioned above—apart from ECI-RGB (which you will have to download from the ECI internet site (www.eci.org).

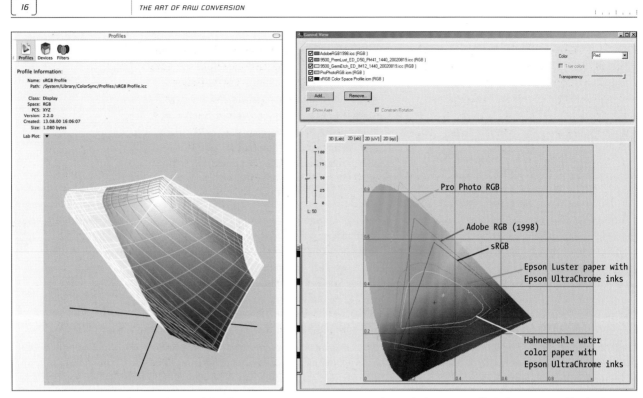

FIGURE 2-5: 3D diagram of sRGB (color) and Adobe RGB (1998) (gray shape)

FIGURE 2-6: Gamut display (using Profile Maker Pro 4.1 Profile Editor)

for a particular combination of printer, inks, and paper.

For example, we often use Hahnemühle German Etching watercolor paper for printing with our inkjet printers. The gamut that can be reproduced using this paper with Epson's UltraChrome inks exceeds sRGB but fits into Adobe RGB. On the other hand, the color space of the Epson Luster paper has a much wider range than that of the Hahnemühle water color paper (no surprise here) and exceeds both sRGB and Adobe RGB (in some blues and greens).

If you have ICC profiles that describe different printing sets (combinations of printer plus ink plus paper), a display like Figure 2-6 will allow you to compare the gamut and, as a result, the color richness you'll be able to achieve with different papers.

COLOR SPACE MAPPING AND INTENTS

An image needs to be converted from one color space to another whenever it is input or output. Even simply displaying an image on a monitor requires converting it from its source color space (either the camera's device color space or the working color space you've chosen) to the monitor's device color space.

In most cases, because the gamut of the source and the destination will differ, some color mapping is required. This transformation is performed by the color management module (also called the color management engine), which must determine what to do with the colors in the source space that are not available in the destination space.

Because there are several ways to handle this task, ICC has defined four different ways of mapping, called **intents**:

*Perceptual (*also called *Photographic):* If the gamut of the source space is wider than that of the destination space, the entire range of colors is scaled (compressed) to fit within the destination space. If the gamut of the source space is smaller than that of the destination space (that is, all colors in the source space are present in the destination space), a one-to-one mapping takes place and all colors keep their original appearance.

When mapping from a wider to a smaller space, the Perceptual intent usually shifts colors to be a bit less saturated and somewhat lighter, while preserving the overall impression of the image. That is, colors maintain their relative color distance from each other. Perceptual mapping is one of the two intents we use when converting photographs (the other is *relative colorimetric*).

Relative colorimetric: When you map from a wider to a smaller color space, and a color in the source space does not exist in the destination space, the Relative Colorimetric intent maps that color to the closest color in the destination space, which usually lies at the border of the space.

With this mapping, two colors that are different in the source space but which are absent from the destination space, may be mapped to the same color in that space. (This may result in some color clipping or banding.) The white point of the source space is mapped to the white point of the destination (if they differ), and all colors are adapted relative to the destination white point.

The Relative Colorimetric intent is useful for photographs and should be used when the source and the destination spaces have a similar gamut with lots of overlap. It's also the best choice if most of the colors in your image (which may not use the full gamut of the source space) have an identical color in the destination space because in such case most colors will remain unmodified when the image is converted. When an image is displayed in Standard mode, this intent is used implicitly to translate colors in your image to colors on your monitor.

Absolute colorimetric: As in the Relative Colorimetric intent, when using this intent, colors that are present in both color spaces are mapped 1:1, and colors that are **out of the gamut** are mapped to the border of the destination space. With absolute colorimetric, however, there is no mapping for the white point.

This mapping is particularly useful if you want to use your output device (say your monitor) to simulate the behavior of another device (such as a particular printing set). In fact, you should use this intent *only* for soft proofing; that is, when using your monitor to display what your image will look like when printed on an inkjet or with offset printing (the monitor simulates the white of the paper).

Saturation: This intent tries to maintain the visual difference between two colors but not their color impression. It is used where color intensity is more important than accuracy because it tries to map an out-of-gamut color to a color within the destination space that has the same saturation, even if the color has to be shifted significantly. Saturation is used in printing when converting images like logos and colored diagrams to a smaller colorspace. It is of absolutely no use for photographs.

CREATING DEVICE PROFILES

You've now seen the importance of using accurate device profiles. Because most of our digital work is done using a monitor, creating an accurate monitor profile is our most important task when setting up a color-managed workflow. In the next section, we'll show you how to profile your monitor using hardware calibration as we outline the process of creating a device profile.

There are normally two steps when profiling a device:

1. **Calibration.** When calibrating a device, the goal is to define a *standardized state* for that device, and to set its controls so that the ouput of the device is as close to that defined state as possible. For example, when calibrating a monitor, you manually set its controls to achieve a certain *luminance* (brightness) that has proven to be good for color work. You also set a *white point* that

conforms to an industry standard, such as D50 or D65 (color temperatures of 5000 or 6500 Kelvin, respectively). The *white point* of your monitor is a mix of R, G, and B that will represent white.

2. **Characterization.** When characterizing a device, a *target* (a pattern of color patches with known color values) is recorded by the input device or sent to an output device. By comparing the color values recorded by the device (such as a scanner) to the target's known color values, the profiling program can calculate the device's color profile using what is essentially a translation table of device-dependent color values to device-independent color values, or vice versa. For example, if the profile is for an input device, the profiling program will translate device-dependent colors seen by the device into the device-independent profile connection space (PCS), which is a CIE-LAB space. For a profile of an output device, on the other hand, the table translates from the PCS to the device-dependent color values of the output device.

When performing both steps, you should use a hardware device to measure color. For example, when calibrating monitors, you would use either a colorimeter or a spectrophotometer.

Camera Profiles

There are two types of camera profiles: *generic*, which are standard profiles created for a specific camera, and *custom*, which are created for specific cameras. All of the RAW converters we discuss in the following chapters include quite good generic camera profiles; some (such as RawShooter and Capture One) also support custom profiles. [✿]

It can be very tricky to create your own camera profiles because the targets must be shot under highly controlled light conditions. Additionally, individual cameras of the same model can vary significantly (certain cameras vary more than others within type and brand). For more details on camera profiling, see Chapter 13.

Printer Profiles

There is no single profile for a printer; a printer profile is always specific to a combination of a printer, the specific paper and ink set used with it, and a specific driver and its settings (such as the same DPI). To make life even more interesting, profiles for different types of printing paper also vary significantly. [⚡]

To profile a printer, you print a target using the exact printer settings, ink, and paper for which the profile is intended. Once the print has dried (which can take anywhere from 1 to 24 hours), you measure the print's color values using either a spectrophotometer or a profiled scanner (the latter is less accurate). By comparing the known values of the color patches of the target to those of the measured patches of the print, the profiling software produces the printer profile.

Fortunately, you don't need to invest in a costly spectrophotometer and profiling software to create a profile; you can use one of several profiling services to do this job for you. When using one of these services, you download their target image, print it, and mail it back to them for profiling; they then e-mail you the profile. (Search for "printer profiling service" online to find them.)

═══

2.3: Profiling Your Monitor

═══

As previously stated, an accurate monitor profile is the basis for any serious color-managed workflow. When calibrating your monitor, you can "eyeball it" using tools included with Photoshop, or use specialized hardware for more accurate calibration.

When profiling your monitor, turn it on and leave it on for at least 30 minutes before beginning any calibration. To perform the calibration, follow the instructions provided by your choice of tool, whether calibrating by eye or using the hardware-based tools discussed below.

[✿]

NOTE:
Because the focus of this book is on processing RAW files, this chapter provides a very brief overview of profiling and a little more detail on profiling a monitor.

[⚡]

NOTE:
While some newer inkjet printers may vary little between individual printers of the same make and model, you should still generate profiles for each printer and its specific settings.

CALIBRATION BY EYE

Photoshop for Windows includes a utility called *Adobe Gamma* that lets you calibrate your monitor, and the Mac OS X version has a similar utility called *ColorSync Calibrator*. Both utilities use your eyes as their measuring instrument for monitor calibration. The tools are easy-to-use wizards, and the Web offers plenty of guidance for using them. You might consider using one of these utilities until you've invested in a hardware solution. ⟨⟩

HARDWARE-BASED CALIBRATION

Although calibrating your monitor by eye is better than not calibrating at all, if precision is important to you, you should use a hardware-based color measuring device (a color spectrophotometer or colorimeter) to achieve much more precise results. While the software and hardware for monitor profiling used to be quite expensive, there are several complete kits available for anywhere from USD $100 to $300. Your choices include:

- GretagMacbeth's *Eye One Display 2* (www.gretagmacbeth.com), which is discussed in the next section
- ColorVision Spyder and Spyder Pro products (from ColorVision, www.colorvision.com)
- MonacoOPTIX from Monaco Systems (www.xritephoto.com)

We use and recommend GretagMacbeth Eye-One Display 2.

The entire calibration and profiling process will take you about 10 minutes. Once you have achieved a good calibration, the next one will be much faster.

RECOMMENDED CALIBRATION SETTINGS

You have several options to choose from when calibrating and profiling a monitor. Whichever calibration method or tool you choose, you'll need to set three basic values: the white point, the gamma, and the luminance. We recommend using the following values even if you do prepress work (where a white point of 5,000 K is the standard), and even if you work on a Mac where a gamma of 1.8 is tradition: [✸]

White point	6500 K (D65)
Gamma	2.2
Luminance	100–150 cd/m²

CALIBRATING AND PROFILING WITH EYE-ONE DISPLAY 2

The Eye-One Display package from Gretag-Macbeth includes the Eye-One Match software for calibrating and profiling monitors as well as a sensor (colorimeter). The Eye-One Display package supports both Windows and Mac OS, and allows the calibration of CRTs, LCDs, and laptop displays.

Once you've installed the software, follow these steps to calibrate your monitor:

1. Launch Eye-One Match (EOM), and select the monitor from the list of devices you can profile (Figure 2-7). We recommend using Advanced instead of Easy mode.

2. ▶ Select the type of monitor you wish to calibrate (whether LCD, CRT, or Laptop), and then press to continue.

3. Follow the onscreen instructions to calibrate the sensor. (Help will provide you with additional information.)

4. ▶ Once the sensor is calibrated, select your target calibration settings for the monitor. We recommend the values shown in Figure 2-8.
 The arrow will take you to the next step.

5. Attach the sensor to your monitor (as shown in Figure 2-9) using either the suction cup (if you are calibrating a CRT) or by attaching the lead weights to your sensor cable and letting them dangle down the back side of the monitor. When calibrating an LCD you may have to tilt the monitor backward a bit for the sensor to lie flat on the screen.

6. Begin the calibration phase using your monitor's controls if available. (Skip this

⟨⟩
NOTE:
Room lighting, the color of your walls and desktop, and even your clothing can influence precise calibration.

[✸]
NOTE:
Gamma is defined by digital-imaging expert Charles Poynton as "a numerical parameter that describes the nonlinearity of intensity reproduction." This means that the brightness of a monitor does not increase directly with the intensity of the signal. Fortunately, you don't need to understand the technical details to work with gamma in monitor calibration. Essentially, the number you enter in setting "Gamma" is actually a Gamma correction value, designed to offset the nonlinearity. See www.poynton.com/notes/color/GammaFQA.html for more information.

FIGURE 2-7: Select the monitor to profile on the Startup screen of Eye-One Match.

White point:	Medium White (6500)
Gamma:	2.2 – Recommended
Luminance:	140 – LCD recommenda...

FIGURE 2-8: Recommended settings for
monitor calibration

step if you are calibrating a laptop or LCD without controls and continue with step 8.) Set the contrast control to maximum, and then slowly reduce it until the black bar is centered within the green (see Figure 2-10). Eye-One Match will guide you through this calibration.

7. ▶ Press **Start** to have EOM begin measuring the contrast values, and adjust your contrast control until the black marker is inside the green area. Press **Stop** and then to begin calibrating the RGB controls. This step will set the control dials so that the monitor's white point is set close

to the intended color temperature (6500 or 5000 Kelvin). You can do this either by adjusting an OSD (Online Screen Display) setting on the monitor or by setting the monitor's R-, G-, and B-controls, if it has any. All three colored bars should be in the green area for optimal calibration, as shown on the right in Figure 2-11. (The Eye-One Match screen will give you useful feedback.)

Next, set the luminance using your monitor's brightness controls, as shown in Figure 2-12.

8. This completes the calibration phase. Eye-One Match should now begin the actual characterization by displaying several color patches and measuring their values (this step should take about five minutes). You shouldn't need to do anything while this process runs.

9. Once the characterization is finished, Eye-One Match should display the values used

FIGURE 2-9: Eye-One display colorimeter

FIGURE 2-10: Use your monitor dial to bring the
contrast marker near the zero value.

FIGURE 2-11: If your monitor has RGB controls, try to use
them to set your target white point.

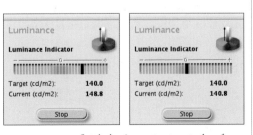

FIGURE 2-12: Set the luminance to a target value of
120 to 150 cd/m² using your monitor's brightness control.

as well as a diagram of the resulting color space (see Figure 2-13).

EOM will also prompt you for a profile name. Choose a descriptive name that reflects the tool that you used, the make of the monitor, and the values that were used. For example, if you are using EOM to calibrate an NEC 2180 monitor with standard values, you might use EOM-NEC2180-D65-G2.2.

Eye-One Match will save the ICC profile to the appropriate folder (depending on your

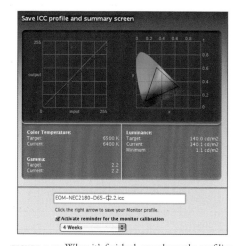

FIGURE 2-13: When it's finished, EOM shows the profiling values and the monitor color space. You should enter a descriptive profile name here.

operating system) and immediately make it the active, default monitor profile. If you are running Windows and have Adobe Gamma installed, you should move Adobe Gamma out of your Start folder to prevent it from interfering with the correct loading of the new monitor profile when Windows starts up. (See the Adobe Knowledgebase page on Adobe Gamma for more information.)

Once you have completed these profiling steps, do not change any monitor settings without recalibrating. Also, you should plan to recalibrate your monitor about once a month.

2.4: Photoshop Color and Monitor Profile Settings

Before you begin to work seriously with Photoshop in a color-management workflow, you should configure it with your personal color management preferences to ensure that it will use your preferred work spaces and default actions. All Adobe Creative Suite 1 (CS1) applications offer a similar way to adjust color settings. With CS2, you can conveniently set the centralized color settings in Bridge and these settings will be the default for all other CS2 applications.

Because Photoshop arguably offers the most advanced color management support of any application, its color settings show many different options and parameters. We'll focus on the settings relevant to a RAW conversion workflow.

To begin setting your color management preferences, select **Edit > Color Settings** to open the color setting dialog shown in Figure 2-14. This figure shows how we set the color settings in Photoshop; the most important settings are discussed below.

WORKING SPACES

Here you define your default working spaces for the various color modes (RGB, CMYK, Grayscale, and Spot Color). The RGB working space is the most important one for photographers. We use either Adobe RGB (1998) or Pro Photo RGB.

The CMYK working space is important only when you convert your RGB images to CMYK, and the profile selected here is used as the destination color space. In the United States, U.S. Web-Coated (SWAP) v2 is the best choice if your print shop does not provide you with different directions.

Dot Gain 20 is usually appropriate (and the Photoshop default value) when you work with

FIGURE 2-14: Photoshop's color settings

grayscale images. If your print shop gives you different values here or for spot color, you should use them.

COLOR MANAGEMENT POLICIES

Color Management Policies allow you to define the default action that Photoshop takes when you open an image or paste pixels into your opened image, and when no profile is embedded or the image's color space differs from your current working space. You can set this for RGB, CMYK, and grayscale images.

In most cases, Preserve Embedded Profiles is the best choice though Convert to Working is a reasonable alternative. It rarely makes sense to use Off in a color-managed workflow. The check boxes allow you to define Photoshop's default actions when a mismatch is found. If no box is checked, Photoshop will execute the action selected for the particular color mode. When a box is checked, Photoshop will prompt you for the action it should take.

Conversion Options

Use the Engine drop-down menu to select the color engine (color management module) you want to use. We prefer Adobe (ACE) because it is probably better than ICM (Microsoft Windows) or ColorSync (Mac OS), and it will be the same on Macintosh and Windows.

- For Intent, choose Relative Colorimetric or Perceptual for photos (see "Color Space Mapping").
- Always turn on (check) the Use Black Point Compensation option. This option helps when you are converting images from one profile to another by adapting the black point of the image to that of the destination space, thereby ensuring that the full tonal range of your destination (such as your printer) is used.
- The Use Dither (8-bit/channel images) setting is effective only when you are converting 8-bit images from one color space to another. If the source color is not present in the destination space, Photoshop will try to simulate the source color using dithering. While this may improve the color accuracy, it will introduce some random noise into your image, due to dithering. Experiment on your own to find the setting you like.

Advanced Controls

Leave these settings at their defaults, as shown in Figure 2.14. ✿

Because Photoshop is not particularly intuitive when it comes to finding the monitor profile in use, we use the operating system tools to find the currently active monitor profile.

FIGURE 2-15: Recommended working spaces for prepress work in Europe

- To do so under Windows, right-click on your desktop and select **Properties**. Then select the **Settings** tab, click **Advanced**, and select the **Color Management** tab. You should see all available monitor profiles, with the current one marked by a gray background.
- Under Mac OS X, use the **System Preferences** > **Display**. (The **Color** tab will show the currently active monitor profile with a gray background.)

NOTE:
If you live in Europe, your CMYK Setting should be either Euroscale Coated or ISO Coated. If you are mainly preparing your images for prepress, use ECI-RGB as your default RGB color space. In which case, your settings might look like Figure 2-15.

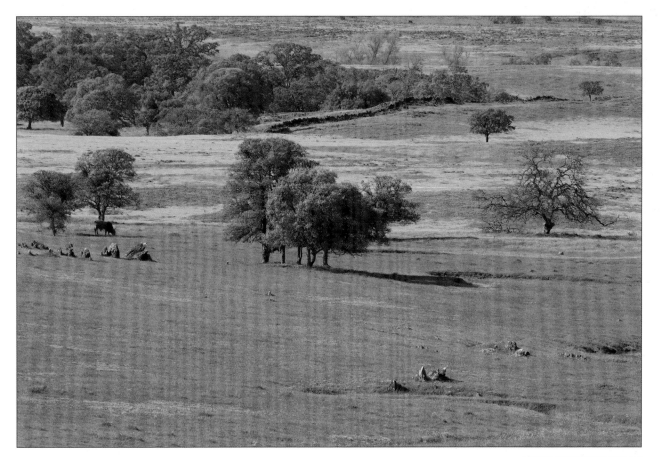

CAMERA: CANON 350D (REBEL XT)

In Chapters 1 and 2, we looked at the advantages of working with RAW files over letting the camera save your images as JPEGS. We also looked at the basic elements of color management and monitor calibration. In this chapter, we'll outline the basic tasks involved in a digital RAW negative workflow. The RAW converters you'll work with in the following chapters will perform most of the tasks outlined here.

Specifically, we'll discuss:

- Setting up the camera and shooting for RAW file photographs
- Transferring images to the computer
- Setting up digital workflow tools
- Browsing and evaluating RAW images
- Making essential image corrections including white balance (WB), improving tonality, and getting better colors
- Advanced image corrections
- Advanced workflow helpers

3.1: Setting Up the Camera and Shooting RAW

The old saying "garbage in, garbage out" applies to RAW conversion just as it does to other computer processing functions. The better your image is to start with, the better the final result will be. This section discusses the steps you'll take in the field before and during shooting, including:

- Setting the camera to RAW mode
- Working with the LCD histogram to get the best exposure
- Getting the best white balance
- Setting the proper ISO for the shot

SET YOUR CAMERA TO RAW MODE

Your camera manual should describe how to set the camera to RAW mode. Although some cameras allow you to capture both RAW and JPEG simultaneously, we don't usually recommend this option because doing so uses more memory

space on the card. However, there may be times when you don't have the time to optimize an image, but you need to have the image immediately available as a JPEG and also want to be able to use the RAW file later.

EXPOSURE, EXPOSURE, EXPOSURE

Correct exposure is the key to taking quality images. This is as true with digital photography as it was with film. In some ways, overexposure becomes more problematic in digital photography because as the sensors tend to clip data beyond a certain threshold. So the first rule of good photography is never overexpose your photos. If the highlights are lost, you may not be able to recover them—although there are some techniques to estimate lost highlights. RAW file processing may allow you to get good results from a not-so-perfect exposure, but the ability to correct mistakes should not be taken as an excuse for sloppy exposures. Taking good exposures may sound easy, but it is not.

You should avoid the following mistakes:

- Blown-out highlights
- Overexposed or underexposed images
- Noise (artifacts) and dark shadows

The good news is that digital cameras have a tool that allows you to evaluate exposure instantly after you've taken a photo: the histogram.

Optimize Exposure Using Your Camera's Histogram

In the field, the main difference between using a film and a digital camera is that the LCD on the back of the digital camera allows you to evaluate an image right after you shoot it. You may think that viewing your pictures on that tiny LCD is one of the major benefits of going digital. Yes, if you try hard enough, you can check the sharpness by zooming in on the image. However, the main advantage of the LCD is its histogram display, which makes it possible to check the exposure of a picture right after you take it. After evaluating the histogram, you can make

any necessary adjustments and then reshoot the subject immediately, if necessary.

A histogram is a graph that displays the grayscale brightness (**luminance**) values recorded in an image. In an 8-bit file, the brightness values range from 0 (black) to 255 (white), which correspond to the 256 different numeric values that 8 bits can represent. This is the camera's **dynamic range**, and it is shown on the horizontal axis. The vertical axis shows how much of the image is at a given brightness level.

Figures 3-1 through 3-4 show four examples (created in Photoshop) of how histograms display different characteristics of a photograph and how to read that display.

In Figure 3-1, the highlights (the right side of the histogram) have been lost. This shot would be a candidate for deletion in all but a few rare cases. (You might be able to "burn" the photo in Photoshop, but that would be faking details in the highlights that are not actually there.)

Figure 3-2 shows only a small spike in the highlights. Whether this spike is a problem will very much depend on the photo and its subject. If the spike represents a real pure white or an unimportant specular highlight, then this photo may be okay. If not, you are in trouble. If your camera can indicate overexposed areas (usually with a blinking light), you should check the camera's LCD preview with the overexposure indicator enabled before you reshoot.

In Figure 3-3, the highlights are okay. A bit of the dynamic range in the highlight area is lost, but Photoshop can correct for that.

Figure 3-4 shows another candidate for deletion. Here the data in the shadows is lost, and the image probably can't be fixed in Photoshop. Digital cameras show much more noise in the shadows than in the midtones and highlights, so if this image is corrected, extended noise will show up even in the midrange.

Expose to the Right

The ideal histogram should not indicate any overexposure or missing highlights; nor should it indicate underexposure because you could lose shadow details, and, more importantly, end up with more noise.

The histogram of the perfect digital exposure peaks as far to the right as possible without being overexposed. The overall shape of the histogram does not matter at all, as it merely reflects the tonal distribution of the scene you have photographed. (Of course, the reality is not that simple.)

In the next section, you will see why it is safer to slightly underexpose your images than to risk highlight clipping. This is especially true

NOTE:
You should try to get histograms similar to the one shown in Figure 3-3. In principle, it is best to get the spike as close as possible to the right without actually touching it.

FIGURE 3-1: This histogram indicates strong overexposure.

FIGURE 3-2: This histogram indicates potential overexposure.

FIGURE 3-3: This histogram indicates good exposure.

FIGURE 3-4: This histogram indicates strong underexposure.

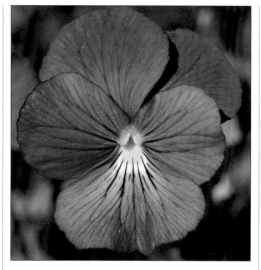

FIGURE 3-5: Image with clipping in the blue channel

FIGURE 3-6: Camera Raw 2.0 histogram for figure 3-5

because some LCD histograms are hard to read outdoors in bright daylight.

Color Channel Clipping

Recall that histograms in most cameras are displayed as grayscale levels. However, in color images, the information is recorded in all three RGB channels. Most cameras average the three channels into a **luminance histogram**, where green is valued higher than red or blue. Some clipping can occur in just one or two of the three RGB channels and not show up in the luminance histogram. Figure 3-5 shows an example from the Canon 10D that demonstrates a problem that can occur with saturated colors. Blue, orange, and yellow flowers are good candidates for such a demonstration, and it is safer not to use the full exposure headroom to the right.

Figure 3-6 shows the histogram for this image as it appears in Camera Raw 2.2. You can clearly see the challenge this photographic subject poses in the blue channel.

The overexposure in the blue channel was not shown by the camera histogram because that tool averages all three channels. In this difficult situation, it would have been very helpful if you also had histograms for the three color channels.

Thankfully, some high-end DSLR cameras, including the Fuji s2, Canon 1D/1Ds Mark II, and the Nikon D2x, now come equipped with color histograms. Figure 3-7 shows an example from the Canon 1D/1Ds Mark II.

Before and After Histograms

Most cameras allow you to examine the histogram as part of the instant preview of a shot you've just captured. Figure 3-8 shows an example from the Nikon D70.

FIGURE 3-7: The Canon 1D/1Ds Mark II's color histogram

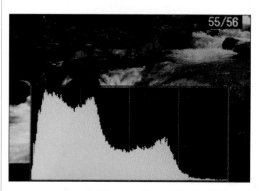

FIGURE 3-8: Histogram from a Nikon D70

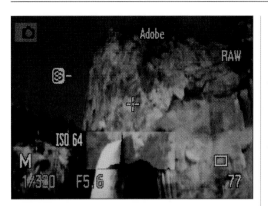

FIGURE 3-9: Viewing the "live" histogram in the Konica Minolta DiMAGE A2

Of course, the "after" histogram only helps if you can repeat the shot, which is often the case in nature photography (except when photographing birds or other wildlife). Check your histogram constantly until you get the exposure right. Once you have, you'll only need to check the histogram occasionally, unless the light changes.

The ideal would be to display a live histogram and use it instead of the camera meter, and in some digital cameras, this dream is coming true. The new 8MP, Sony F828, Leica Digilux 2, and Olympus 8080 all sport live histograms. Figure 3-9 shows an example from the Konica Minolta DiMAGE A2.

Unfortunately, this feature may not be widely available in digital SLRs for some time because the viewing mirror hides the sensor in digital SLRs, making it technically challenging to implement live histograms in them. But one thing is for sure: refined versions of live histograms are the way to go.

Do You Really Need the Histogram?

What you actually need from the histogram is the information about underexposure or overexposure. If you can get this information by other means, then the histogram may become obsolete. But, for now, the histogram is your ticket to better exposures.

CORRECT WHITE BALANCE (WB) FOR OPTIMAL COLOR QUALITY

The key to producing correct color is to get the white balance correct. With digital photography, getting the correct white balance depends on the light source(s) illuminating the photographed scene. This is a simpler situation than with film, where the choice of film type and the filters used to compensate for different lighting conditions (indoor, sun, cloudy, shade, flash, and so on) influence the white balance.

As you learned in Chapter 1, when you let the camera convert to JPEG, the camera sets the white balance for you, and you're stuck with the result. However, if you use only RAW file formats, WB can be corrected later. Of course, for fine art photography, true color isn't what really matters; most photographers are more interested in producing "subjectively correct" (that is, pleasing) white balance.

Digital SLRs allow you to measure the right WB (custom WB) when you photograph. This might be the optimal way to do things, but it is not always easy to do in the field, particularly when you're shooting nature scenes. Therefore, your best bet is to set the WB to "auto" for all cameras and adjust it later in the RAW converter. [⚡]

Correcting WB (and color in general) can be very tricky because both are highly subjective and require a lot of experience. Also, judging colors is very much a function of mood. Sometimes you'll see colors as colder (bluer) than they really are, in which case you may want more warmth (more yellow).

When you experiment with these properties, you can spend a lot of time optimizing your images. If occasionally you feel lost, don't worry. You are not alone! With practice, you will improve.

Understanding Objective and Subjective White Balance

There is a significant difference between "pleasing" and "correct" color. Relatively few photographic disciplines are concerned with producing the correct color. Accurate color might be necessary when you're photographing

[⚡]

NOTE:
One good strategy is to photograph a gray card (or even better, a Macbeth ColorChecker) in the same light as the shots you're going to take next. You can use this shot as a reference point when you later do WB correction on your computer.

fabrics or, perhaps, taking catalog shots but, for other kinds of shots, you should usually aim for pleasing colors.

Heated discussions can occur over what constitutes good skin tone, as cultural differences come into play. The best advice is to begin with a white balance you prefer, optimize the contrast, and change colors selectively only if there are major issues. You may want to correct the skin tone in some shots, while in others you may want to adjust the shade of a boring blue sky.

ADJUST YOUR CAMERA'S SENSITIVITY

Today's digital cameras allow you to change the ISO (speed) value on the fly by simply dialing in a new value. Compared to film, where a given roll has a fixed ISO, this is a huge plus for digital cameras, as you can change ISO picture-by-picture.

A low ISO normally results in less noise (better image quality) and a high ISO means more noise (lower image quality). Noise can show up in many different ways. If a camera shows noise-like grains of "salt and pepper," the ISO is clearly set too high—just as graininess usually means you've chosen a film with too high an ISO rating. [✿]

If you need to use a higher ISO, you can try to improve grainy photos by using top-class noise removal tools (see Chapter 9).

NOTE:
Use a low ISO whenever possible, and use a tripod.

3.2: From Camera to Computer

The next broad phase of the workflow is to get the images from the camera into your computer. Before you physically transfer your images, make sure that you have adequate storage for all those big files, and that you have an organizational scheme that is logical and consistent so that you can find your images later.

MANAGE YOUR IMAGE STORAGE

When you're back from the field with memory cards and/or digital wallets filled, you need to transfer your images to your computer. This requires a lot of disk space, and converting images to 16-bit TIFFs places even more demands on disk space. As professional photographers, we currently have about 1000 GB of storage in our network (to accommodate organization and duplicates). A reasonable starting point is 80 GB of storage at a minimum; you can add external Firewire drives as backup (perhaps start with 160 GB).

TRANSFERRING THE FILES TO YOUR COMPUTER

Most cameras today come with either a USB or Firewire interface. Although these ports are used primarily for connecting card readers, many photographers also use them to transfer files directly to a computer. We choose not use this feature, as it offers little help if you have multiple memory cards and/or digital wallets, and we don't think that cameras make the most robust CF card readers.

Instead, we use a USB 2.0 card reader that we have installed on our main computer (available for both PCs and Macs), and we copy our images from a day's shoot into a new directory in our Inbox folder. Figure 3-10 shows an example of our typical folder structure; the next section explains our organization and naming scheme.

FIGURE 3-10: Inbox folders

ORGANIZING AND NAMING THE FILES

As in any system of folders and files, the ultimate goal is to give every file a unique name that includes relevant information about it. As professional photographers, we often use several different cameras on a shoot, which may be different types of cameras or even two cameras of the same type. The information about the camera we used may be relevant to the processing we'll

do later in the workflow, so our naming system should reflect it.

Here's a summary of the folder hierarchy shown in Figure 3-10 and a description of the information that it contains:

- all_2005 is the top-level folder. All RAW files shot in 2005 go here, regardless of the cameras used to take the images.
- all_dvd_2005_001 is the first DVD set for 2005. All of the files stored in this folder will be backed up to DVD #1 for 2005. When this folder's content exceeds about 4 GB (the capacity of a single DVD), we'll create a new folder. If we were backing up to CD, we would start a new folder every 600 MB.
- 20050913_300d_LosGatos is the lowest folder level, containing files from a single photo session. We can parse the fields of this name as follows:

 20050913 is the date in *yyyymmdd* format; we use this format to more easily sort the images.

 300d is the type of camera used (in this case, a Canon EOS 300D).

 LosGatos is the subject. This shoot was done in Los Gatos, CA. This may be followed by _01 or _0x if more than one card was used that day.

All of the images within a folder are given a name of the form 300d_nnnn_mmm, where:

- 300d describes the camera type.
- *nnnn* is an extra numeric sequence we added to supplement the camera's own autogenerated sequence, which will restart when it passes 9999. When that happens, we'll increment the *nnnn* portion of the name from 9901 to 9902, so that all of the filenames remain unique. Adding a second number sequence can also keep filenames unique even if we use two 300d cameras on the same day.
- *mmmm* is the four-digit image number generated by the camera. You may need to supplement this number sequence, as described above, if you expect to shoot more than 10,000 shots with the same camera or use more than one camera of the same model.

If we later work on a file in Photoshop, the result will be saved as a master TIFF file. The original 300d_nnnn_mmm portion of the filename will be kept, and we can append more descriptive text. For example:

Original: 300d_0001_1256

Derived: 300d_0001_1256_Los_Gatos_Bear_Cafe

By following this system, we keep every file linked by its original filename to the RAW file in the archives.

RENAMING TOOLS

The file naming system we've just described may sound like a lot of manual work, but tools are available to automate the renaming process. For example, we sometimes use Rname-It, the free Windows utility shown in Figure 3-11. (You can find a download link at www.outbackphoto .com.) Rname-It allows us to prefix file names with the camera type and an extra sequence number as described above. For Mac OS X, a free utility called Renamer4Mac is available from www.Macsoftpedia.com.

The Photoshop CS File Browser and Capture One also allow renaming your files,

FIGURE 3-11: Rname-It: the freeware Windows renaming tool

and the program Downloader Pro handles both downloading and renaming. (Downloader Pro is available for Windows only; information about it is also available at our website.)

<div align="center">SECURING YOUR VALUABLE PHOTOS:
BACKUP, BACKUP, BACKUP</div>

Once you've transferred your images to your computer, you may be tempted to delete them from the card right away. Don't do before you back up your files to CD/DVD or to a different hard disk. Once you have, it is safe to erase the images from your memory card or reformat the storage medium.

Follow these guidelines when you make backup CDs or DVDs:

- Use two different CD/DVD brands if you make two copies. If a CD from one manufacturer fails, there is a chance that additional copies of CDs produced by that manufacturer may be faulty, as well.
- Store each copy in a different location.
- Once you have stored your files on a disk drive, you can confidently enter the digital darkroom and begin to work on your images. [⚡]

NOTE:
Occasionally, a microdrive or compact flash card will become corrupt. If that happens, don't panic! The program PhotoRescue (Windows and Mac; also available from our website) can recover erased or deleted files from flash cards and similar media.

3.3: Setting Up Your Digital Darkroom

When you install a new RAW converter (and sometimes if you change its options), you'll need to configure your digital darkroom, making the following choices:

- **The location of the cache folder.** Most modern RAW converters use a cache to store previews so that they don't need to re-create them repeatedly while you're working on a set of images.
- **The work space you will use.** Mainly ProPhoto RGB for 16-bit only, Adobe RGB, or SRGB.
- **The output file format.** Select either 8-bit or 16-bit TIFFs or 8-bit JPEGs. (We do not recommend JPEG.)

- **The application (if any) to launch after converting an image**.

Some RAW converters also allow you to select the per-image-settings storage area.

3.4: Browse and Evaluate Your RAW Files

Every photographer needs to inspect both new and older images. As you upload your work to a computer, make a point to analyze new images as quickly as possible, deciding which to retain and which to delete, so you can begin working on the "keepers."

Older file browsers typically provide a "gallery" of thumbnail previews, though this view is usually not good enough to determine whether a photograph meets the essential criteria. Instead of using it, you should open the files in your RAW converter and use that program as a kind of "digital light table" to scrutinize them carefully. The critical questions to ask when inspecting your RAW files are:

- Is the composition satisfactory?
- Is it sharp enough? Sharpness is, of course, crucial.
- Is the exposure OK? For this, you need to see a histogram.
- Are the colors correct, or at least pleasing? This step usually requires a white balance correction.
- Is the orientation (portrait or landscape) correct? At this stage you're not concerned about minor tilt, just basic rotation in 90-degree increments.

Based on those criteria, you can flag files to keep or reject and/or set priorities for further processing.

The Deletion Workflow

Deleting sounds simple, right? In fact, it is one of the most dangerous operations you can perform. When you realize you've deleted a valuable image, you know you have a problem. On the other hand, if you keep all your questionable

images, you'll need lots of disk space, and you'll have to page through all those bad images again and again.

An effective delete workflow is a three-step process:

1. Mark the images for deletion.

2. Revisit the marked images to confirm.

3. Finally, delete the images.

All of the major RAW converters featured in this book, especially Adobe Camera Raw 3.0, Pixmantec's RawShooter, and PhaseOne's Camera One, are very capable browsers and inspectors. The RawShooter solution is simple, yet elegant, and ACR 3.0 and Capture One can provide helpful solutions, as well. A couple of their valuable features include:

- **Ad hoc corrections.** The settings stick with the image. This implies that in previewing an image you can correct white balance and exposure on the fly. These settings remain when you revisit the RAW files later. (All the RAW converters covered in this book have this feature.)
- **Ad hoc slideshow.** The slideshow is available in Bridge and RawShooter.

3.5: Essential Image Corrections

Once you have downloaded, organized, and evaluated your photos, you can begin the work of image correction. You can make those corrections in the RAW converter of your choice as you'll see in the next three chapters, which offer detailed hands-on instruction in image-correction techniques for Adobe Camera Raw (Chapter 4), Pixmantec's RawShooter (Chapter 5), Apple's Aperture (Chapter 6), and other programs (Chapter 7). But first, here's a quick look at those tasks and how the different programs handle them.

WHITE BALANCE (WB)

As most photographers know from their film experience, white balancing means adjusting the colors in a photograph to correct for the "color cast" created by the light in which it was taken. When you adjust WB with film, you simply select a grade of film that is white balanced for the light you'll shoot in and/or use WB correction filters. When using a digital camera, you can choose white balance presets for different kinds of light (daylight, shade, tungsten, and so on) that are roughly equivalent to different films. But with RAW conversion software, you have much more control, which is why we recommend using the camera's automatic white balance as a starting point if you're going to do RAW processing.

The particular options you'll use will vary between programs, but good white balance support is crucial for any useful RAW converter; and white balancing is not a trivial task for the software. Figures 3-12, 3-13, and 3-14 show the white balance controls in Adobe Camera Raw, Capture One, and RawShooter respectively.

As you can see, all of these tools use at least two sliders, one for color temperature and another for tint. ❀

FIGURE 3-12: Setting white balance in Adobe Camera Raw

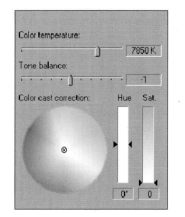

FIGURE 3-13: Setting white balance in Capture One

NOTE:
Some RAW converters do have a single color temperature slider (measured in Kelvin), but they oversimplify color cast. In many lighting conditions, especially outdoors, color cast cannot be corrected with a single slider.

FIGURE 3-14: The white balance Colder/Warmer controls in RawShooter

Although we usually speak of colors as "warm" or "cool" to describe their emotional effect, color temperature in photography refers to the temperature to which a theoretical "black body" would have to be heated to emit light of a given color, as measured in Kelvin. This can be confusing because the colors we normally think of as emotionally "warm," like red and orange, actually have a lower temperature than those we think of as "cool," like blue and white. That is, it takes a higher temperature to produce white light than red.

When discussed in the context of white balancing, color temperature refers to the color of the light source for which you are adjusting. For example, if you adjust for a red cast (a low physical color temperature but an emotionally warm color), you are skewing the colors toward blue (a high physical color temperature but an emotionally cool color); so in effect, choosing a lower color temperature does produce a "cooler" image.

Example: Using a RAW Converter's White Balance Controls

Figure 3-15 shows an image open in Camera Raw, ready for white balance correction.

The White Balance setting in this example is currently As Shot, which means that the color temperature and other values are as measured by the camera. The image might have been captured with any of the following camera settings:

- **Auto:** The camera attempted to make a good guess. As noted, this is a good starting point for RAW conversion.

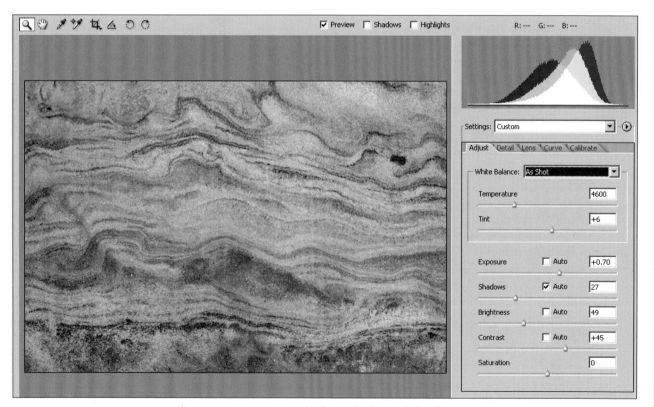

FIGURE 3-15: An image with its white balance "as shot," ready for adjustment

- **Camera presets** (like daylight, flash, tungsten, and so on): Use these options only if you know the light source for sure.
- **Custom white balance:** The white balance is measured in the camera. This is useful with mixed light or if the light stays constant for a period of time (for example, in the case of sports photography).

Now let's see how small changes in color temperature can affect color balance. In Figure 3-16, we've lowered the color temperature setting from 4600 K to 4400 K. The image looks slightly "cooler" because we assumed that it was shot at a lower color temperature, and the software has adjusted for that.

In Figure 3-17, we set the color temperature higher (that is, we've assumed it was shot at a higher color temperature), and Camera Raw has given us a warmer-looking picture.

TONALITY

Creating good tonality is a key factor in getting a correct image. Consider a black-and-white photo and you realize that tonality is the only thing you care about: You focus on the smoothness of tonal transitions, the contrast, the highlights and shadows, and the white point and black point.

It is more difficult to judge optimal tonality with color images, yet the same criteria hold. Image tonality is influenced by exposure, contrast, and brightness. Figures 3-18 and 3-19 show the tonality controls in Capture One and Camera Raw, respectively.

It is essential that you compensate for exposure properly. Your tools should include a histogram or equivalent with underexposure and overexposure indicators. (Beware of overall overexposure, as well as in a single RGB channel.) While underexposed shots can often be corrected to one or two stops without losing too much quality, it is very difficult if not

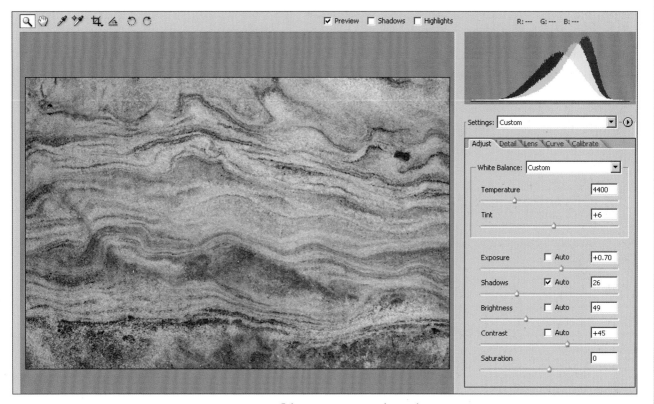

FIGURE 3-16: Color temperature set to a lower value

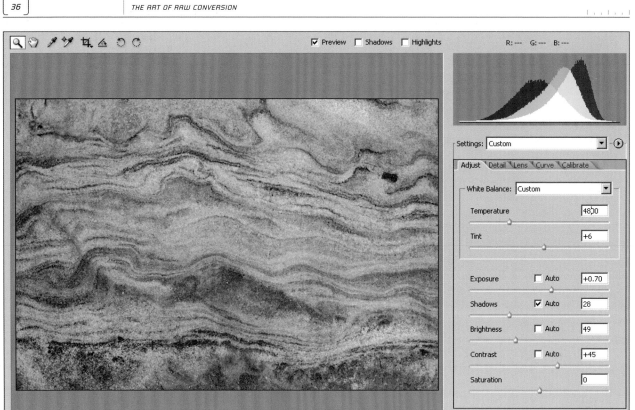

FIGURE 3-17: Color temperature set to a higher value

impossible to correct overexposure. Once values have been clipped in the highlights (which may also occur in any single RGB channel), it is rarely possible to make a correction. You should be sure to control exposure to avoid overexposure at all times.

FIGURE 3-18: Tonality correction in Capture One

FIGURE 3-19: Tonality controls in Adobe Camera Raw

Santa Cruz Public Libraries

Aptos Library
Thank you for using SelfCheck.
This is a summary of items scanned at:
APT Kiosk 02

Borrowed Items 10/30/2015 12:45
XXXXXXXXX2001

m Title	Due Date
ıe Bob Dylan albums : a itical study	11/20/2015
ıadows in the night	11/20/2015
ɔund midnight original otion picture soundtrack.	11/20/2015
arah Vaughan [the Roulette ears. Volumes one/two].	11/20/2015
rst issue the Dinah ashington story : the iginal recordings	11/20/2015
ıe live adventures of Mike oomfield and Al Kooper	11/20/2015
et the good times roll the ıthology 1938-1953	11/20/2015
reative digital photography	11/20/2015
ıe art of raw conversion : w to produce art-quality otos with Adobe ıotoshop CS2 and leading w converters	11/20/2015

ıank you for visiting the library today. :-)

ɔrary Web Site at:
http://www.santacruzpl.org

ɔrary Catalog at:
http://catalog.santacruzpl.org

ɔcations, Hours, and Phone #s at:
http://www.santacruzpl.org/branches

Adaptive Tonality Controls

When brightening shadows, controls that apply a curve or levels across the whole image are not quite optimal. You need tools that work adaptively, and that will correct contrast locally in proportion to the area in which the pixels reside. For example, Photoshop has its Shadow/Highlight function, and RawShooter offers the Fill Light control shown in Figure 3-20.

FIGURE 3-20: RawShooter's adaptive Fill Light and other tonality controls

Example 1: A Photo with Too Little Overall Contrast

Figure 3-21 shows a photo shot at very low contrast.

This image may actually be an accurate representation of the original scene as photographed, and its colors may be correct, but sometimes a truthful image looks a little flat, or even dull. All this image needs is a bit more contrast to bring it to life.

The histogram shows what this image is lacking:

- There are almost no dark or black tones.
- There are no real bright tones.

In Figure 3-22, we've applied Camera Raw's Curve tool with a setting of Medium Contrast.

FIGURE 3-21: Rock colors photographed at low light

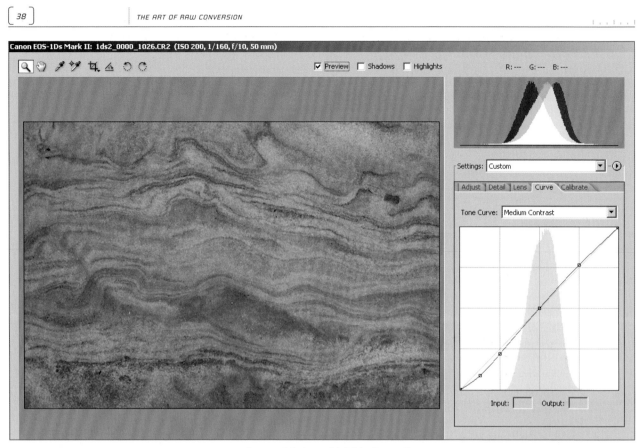

FIGURE 3-22: Improved shadows with Adobe Camera Raw curves

Although the curve control improves the shadows somewhat, the image is still unacceptable. In Figure 3-23 we use the Adjust tab, and set the Exposure, Shadows, Contrast, and Brightness all to Auto.

Using Adobe Camera Raw's Auto settings lets the image pop, but possibly too much so. We can use these settings as a starting point and tweak further to get the final image you see in Figure 3-24. [⚡]

From this example, you can see that a low-contrast image can be a suitable starting point, because RAW converters allow you to improve the overall contrast.

Example 2: A Photo with a Wide Contrast Range

Images that cover a wide contrast range, like the one shown in Figure 3-25, are much more difficult to correct. In this image, the Levels and Curves tools show their limitations.

Normally, images like these are candidates for a Shadows/Highlight tool treatment in Photoshop CS. The RawShooter converter, however, permits adaptive correction as a part of tonality control at this early stage of RAW conversion, as shown in Figure 3-26.

A bit of manual fine-tuning with the Tonality sliders brings out the best results, as shown in Figure 3-27.

We are certain that more RAW converters will provide adaptive tonality control in the future.

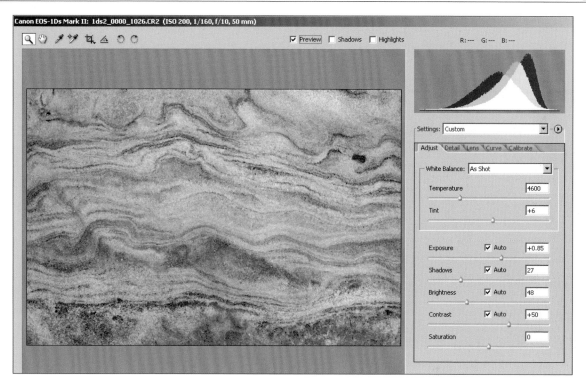

FIGURE 3-23: Using the Camera Raw Auto settings gives us a little too much pop

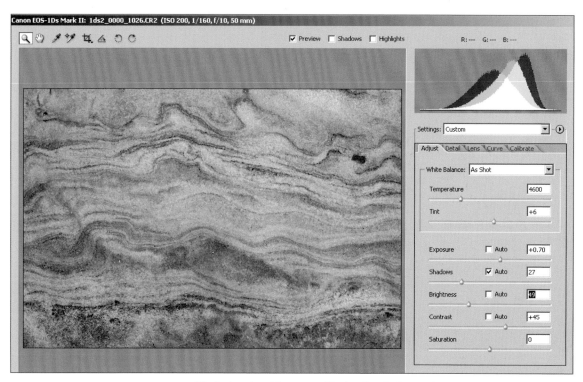

FIGURE 3-24: The final version with some tweaking based on the Auto setting

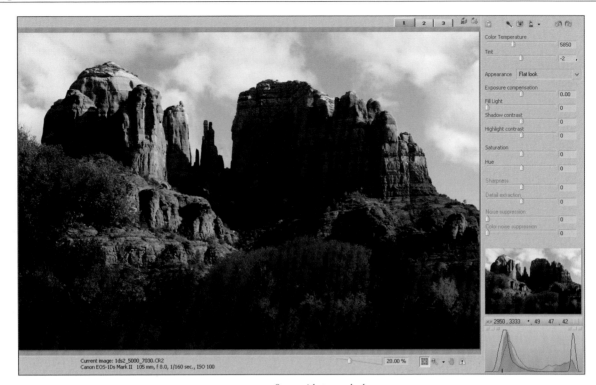

FIGURE 3-25: Scene with strong shadows

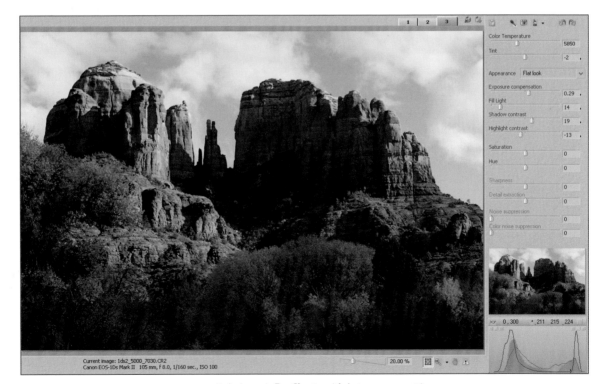

FIGURE 3-26: An image in RawShooter with Auto exposure settings

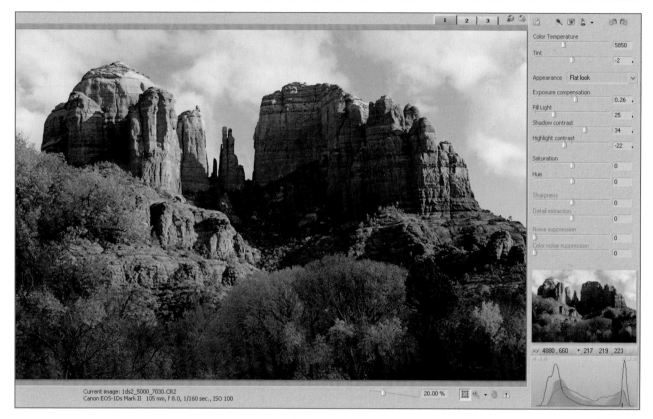

FIGURE 3-27: The result after careful fine-tuning

FURTHER COLOR CORRECTION

The first major step toward color correction is to get the white balance right, at which point (once you have corrected tonality with a focus on contrast), your image should be almost where you want it. But the colors in RAW converters are also influenced by these factors:

- The converter's profile for the camera
- Saturation settings
- Color controls in the RAW converter

All of the RAW converters we discuss include reasonably good camera profiles, but third-party profiles may improve the results for your camera. [❀]

3.6: Extra Workflow Support

In addition to tools for making specific image corrections, good RAW converters also offer tools for streamlining and simplifying your workflow. These tools can include:

- Applying settings from one file to other files
- Background processing
- Batch conversion
- Sampling RGB values
- Saving and restoring settings
- Supporting scroll wheels
- Taking snapshots of different conversion settings
- Undoing and redoing operations
- Using camera default settings
- Using keyboard shortcuts

NOTE:
As a final thought on color, note the distinction between correct and pleasing colors. Only in limited areas of photography do you want true and correct colors; most photographers aim for pleasing or even expressive colors. Skin tone is a particularly problematic and pleasing colors are highly subjective.

We'll discuss these features in Chapters 4 through 7, as we show you how to work with the various RAW converters.

═══

3.7: Advanced Image Corrections: Beyond the RAW Converter

═══

When you look carefully, you can find an amazing number of defects in an image. While, as we've seen, some RAW converters can help to solve many problems, you may ultimately choose Photoshop to fix the defects that remain after the conversion. Chapter 7 will show you how to use Photoshop to deal with workflow problems like the following:

- Correcting perspective
- Correcting tilt
- Cropping
- Eliminating noise (luminance and color noise)
- Removing chromatic aberrations (CA)
- Removing dust
- Sharpening
- Upsampling
- Vignetting

═══

3.8: RAW Converters and "Good" Colors?

═══

We hear a lot of discussion today with respect to RAW converters producing good color quality. Unfortunately, the problem is not as trivial as one might imagine.

Let's go back a few years and look at film. If we were to photograph the same scene with the same light using four different films (say Fuji Velvia, Fuji Provia, Kodak Kodachrome, and Kodak Ektachrome), we would get very different colors, not to mention different skin tones. Each film was developed to please as many photographers as possible.

Now, assume that engineers were able to produce a truthful film (these films do exist). The result would be complaints from photographers about boring colors or a lack of saturation.

In the days of film, photographers would buy the film that produced the colors they preferred; they would even use different film for different types of scenes. With relatively few films to choose from, photographers used filters and lights to create the effects they wanted. Your digital camera is a kind of camera and film combined (at least when photographing in JPEG).

Some people think we are fortunate to have RAW to bring us closer to true colors. RAW gives us a kind of a latent color slide. In fact, the camera doesn't capture true RGB colors; the colors are interpreted by the RAW converter, and all RAW converters perform this task slightly differently. To produce reasonable colors (however we define them), the RAW converter needs to profile the cameras and transform the colors into something that photographers like. And, because all RAW converters have a different way of doing so, each has a different bias as to what those colors actually look like.

In actuality, most photographers don't really want true colors (Kodak and Fuji would not sell any film if that were true); instead, they want colors that they like. To make matters worse, we need to consider the following issues when settling on colors (this list certainly is not complete):

- Brightness
- Contrast
- Light
- Mixed light sources
- Saturation
- Viewing light (of the original scene and photograph)
- White balance settings

No profile can be judged without reflecting all these factors, especially white balance, contrast, saturation, and brightness.

We want things to be simple, but color is not as simple as it may seem. Film shielded us from this problem because the only way we

could influence colors was to use a different film and filters. Now we have control, and we must resolve these issue ourselves. (Fortunately, RAW converters allow us to do so after shooting.)

But why not just trust our eyes? Well, for one thing, we see colors differently, and many of us are, at least to some extent, color blind. Our eyes and brain fool us quite a bit because they white-balance a scene automatically (*auto-white-balance*, if you will).

Consider this very extreme situation: In a canyon, we don't really see blue light because our eyes white-balance (see Figure 3-28). But when we look at a photograph taken from within that canyon, the white border is the reference, and the blue shows up. In this case, we are pleased about the bluish tone, but in other cases, we may not like what we see in the photograph. (Remember that we often have mixed light from the sun and sky.)

As a result, the generic profiling in today's RAW converters will never please all users. What are we to do? There are a number of other answers.

- Experiment with alternative RAW converters (try before you buy). RAW converter 1 may work best for some photos and RAW converter 2 may be the better choice for others.
- Tune the colors in Photoshop.
- Try the powerful selective color corrections in RAW converters like Capture One.
- Create your own profiles for certain lighting situations. (This is, unfortunately, not a trivial thing to do.)
- Buy alternative profiles.

Skin tones are especially tricky:

- They are highly subjective.
- They depend on personal experience.
- They depend on cultural elements.

The best solution when pursuing good color is to find ways to improve RAW converter profiling, which will allow you to find a good starting point for your photos. [⚡]

FIGURE 3-28: A photo taken in the Upper Antelope Canyon. Your eyes don't see the blue because they auto-white-balance.

There are two schools of thought among photographers today:

- Some believe measuring brings them closer to the truth. The problem may be that shooting real-world colors is not the same as photographing test charts.
- Others are happy with a highly subjective color balance (we are part of this camp).

For these reasons, we never do color tests with any RAW converter, but we have achieved pleasing results with most of them.

Whatever you do, be sure to try out new software and buy it only if you like it. And consider using more than one RAW converter because there is probably no single one that is best for all images.

---[⚡]---

NOTE:
Profiling experts come up with very different profiles for the same camera and RAW converters. (See the profiles or calibrations offered for some of the RAW converters.) Often, they even offer different profiles for different levels of saturation. When creating our own profiles, we have found one of the main challenges to be lighting the target evenly without any reflections. We have been able to improve some colors to our taste, while others have suffered in different lighting situations.

ADOBE CAMERA RAW

CAMERA: CANON 1DS MK. II

Adobe Camera Raw (ACR) is Adobe's RAW converter. Originally introduced as an optional plug-in to Adobe Photoshop 7, it has been supplied free of charge since Photoshop CS1 (also called Photoshop 8). There was a substantial jump in functionality from ACR 1 to ACR 2, and it is now in its third generation (ACR 3) and is probably the most widely used third-party RAW converter. It is supplied free with every version of Photoshop CS1/CS2.

Figure 4-1 shows the Adobe Camera Raw interface. New with ACR 3 are automatic corrections and improved batch processing as well as cropping and straightening tools.

Camera Raw 2.x and 3.x can open RAW files created by nearly all of today's digital cameras, though when a new camera is introduced to the market, you may need to wait for the next update of ACR to get support for its proprietary RAW format. (Adobe has been known to ship early beta versions to satisfy its customers; so if you need one, it doesn't hurt to ask.)

As you might expect, everything in Adobe Camera Raw (ACR) is fully color managed. Monitor profiles are the same as those used by Photoshop, and for all supported cameras, Camera Raw uses built-in generic camera-specific profiles.

We'll use Adobe's file browser, Bridge, together with ACR. As you'll see, the two programs are closely integrated. Then, at the end of the chapter, we'll show you how to use RAW files embedded in the Smart Objects tool in Photoshop.

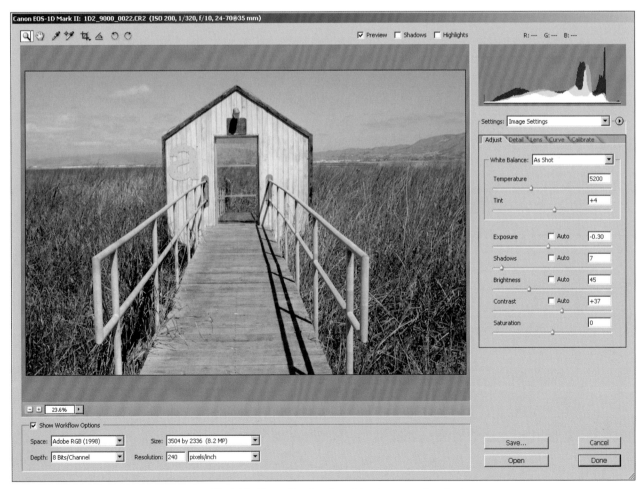

FIGURE 4-1: The Adobe Camera Raw interface with an image open for adjustment

4.1: A Real-Life ACR Workflow

You do not need to understand all of ACR's features in order to use it. We'll describe how we use ACR in our own workflow before we discuss its numerous features. Our walkthrough uses images taken from a real-life photo session in Monterey, California (using the Canon 1DS Mk. II camera). By demonstrating how to approach working with ACR on this particular set of images, we will also demonstrate a general technique. Our workflow has the following stages:

1. Transfer the images to the computer.

2. Browse the images to select the ones to work on.

3. Correct the white balance. At this stage, we usually apply the White Balance settings from one "master" image to all the images shot in the same light.

4. Fine-tune the tonality.

5. Rank the images for further processing in Photoshop.

6. Mark any unwanted images for deletion.

7. End the Camera Raw session, usually by saving and converting the files or by opening them in Photoshop.

STEP 1: TRANSFER THE IMAGES TO YOUR COMPUTER

Our workflow begins with the transfer of files from the camera to the computer. As you may recall, Chapter 3 described our organization and naming system, implemented using Downloader Pro. Here is an example of how our filenaming pattern works, using the file 1ds2_5001_0039.CR2 as an example.

- 1ds2 is our specific code for this camera type.
- 5001 is a code we use to identify multiple cameras of the same type or for images that overrun the 9999 number limitation. We also use 5001 to indicate a loaner camera.
- 0039 is the number the camera automatically generates for the shot (this particular camera was new when this series of photos was taken).

STEP 2: BROWSE THE IMAGES USING ADOBE BRIDGE[ACR3] AND CAMERA RAW

We use Adobe Bridge (the file browser you'll learn more about in the next section) to open a batch of images for processing n in ACR. We use Bridge in its Filmstrip mode, with a layout like the one shown in Figure 4-2.

While we could open each picture individually, doing so would be inefficient. Instead, we press Ctrl/⌥-A to select all the images in the folder, and then press Ctrl/⌥-R to open ACR in Filmstrip mode (Figure 4-3).

ACR's Filmstrip mode offers an important workflow improvement over older versions of Camera Raw. In Filmstrip mode, all of the RAW files from our photo session are now directly accessible, and we can switch from one file to the next almost instantly.

STEP 3: MAKE INITIAL CORRECTIONS TO WHITE BALANCE

Once we've selected the images to work on, we correct the white balance. We'll demonstrate this step in two different ways:

- Using the one-click White Balance eyedropper tool as a starting point for tweaking
- Using one of ACR's presets as a starting point.

Example 1: Starting with the Eyedropper Tool

When you examine the crab photo in Figure 4-4, you can see that the white balance is off—it's too blue. In fact, the white balance is off in all of the images in the group in the same way. (We expected this to happen because the photo was taken in the shade, and few cameras with automatic white balance will correct this properly.) Figure 4-5 shows the As Shot WB settings displayed in ACR.

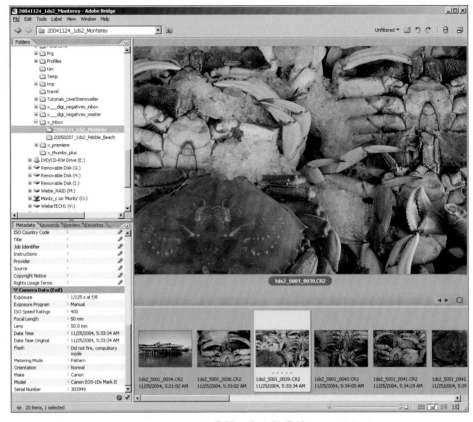

FIGURE 4-2: Folder selected in Bridge

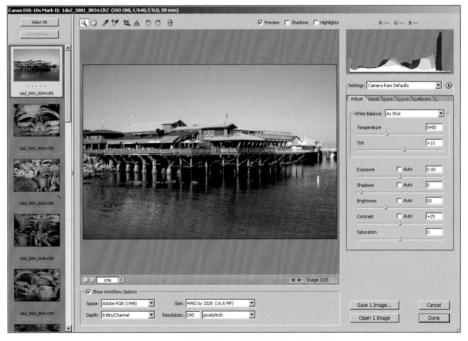

FIGURE 4-3: Adobe Camera Raw in Filmstrip mode

FIGURE 4-4: The camera's automatic white balance made this image,
taken in the shade, too blue.

FIGURE 4-5: The As Shot White Balance settings
for the crab photo

Whenever possible, and when we know that white balance may be an issue, we photograph a gray card or mini-ColorChecker to use as a color reference for the white balance. (You'll learn more about this technique when we return to the White Balance tools later in the chapter.) While we don't have such a standard reference point here, that doesn't pose a serious problem because white balance for these kinds of photos is highly subjective.

Figure 4-6 shows how we chose a point within the ice as the basis for the WB tool's correction. Figure 4-7 shows the resulting settings in the Adjust tab.

The result looks significantly better, but it's a bit too yellow for our taste. To reduce the yellow in the image, we enter a color temperature of about 5800 K. Again, white balancing is highly subjective, so you'll need to rely on your own style and taste.

FIGURE 4-6: White balance after correction (note the Eyedropper cursor)

FIGURE 4-7: The settings resulting from
one-click white balance

Example 2: Starting with a Preset

Figure 4-8 shows another shot taken from the same series of images, and Figure 4-9 shows its White Balance settings as reported in ACR. This image is also on the cool side.

Again, we did not include a ColorChecker with this shot, which is why there is no defined gray as a reference point in the image. This time, we begin correcting by choosing a WB preset of Daylight. Figure 4-10 shows the result

as previewed, and Figure 4-11 shows the White Balance settings as reported in ACR.

Again, this result was a little bit too warm for our tastes. Ultimately, we chose a color temperature of 5000 K, about halfway between the As Shot and the Daylight settings.

Applying Settings to Other Images

Because the rest of the crab photos were shot in identical light, we'd like to apply the same white balance settings to them, too. The Synchronize tool makes this easy to do. You'll learn more about this feature later in this chapter, but here's a quick preview of how we use it.

Because the current image is the one whose settings we want to apply, we keep it selected and add the other images to the selection. As shown in Figure 4-12, ACR marks the first image with a blue border to indicate that it's the master.

Next we click Synchronize, to display the window shown in Figure 4-13. Here we choose White Balance as the only setting to synchronize. Once we've done that, all the crab photos will have the same white balance, and their other original image settings will be left untouched.

FIGURE 4-8: The white balance in this image is too cool.

FIGURE 4-10: The cart photo with the white balance preset Daylight applied

FIGURE 4-9: The As Shot White Balance settings for the cart photo

FIGURE 4-11: The settings resulting from the Daylight preset

1ds2_5001_0039.CR2

1ds2_5001_0040.CR2

1ds2_5001_0041.CR2

FIGURE 4-12: The blue border marks the master image for synchronizing settings.

Synchronize

Synchronize: White Balance

OK
Cancel

☑ White Balance
☐ Exposure
☐ Shadows
☐ Brightness
☐ Contrast
☐ Saturation

☐ Sharpness
☐ Luminance Smoothing
☐ Color Noise Reduction

☐ Chromatic Aberration
☐ Vignetting

☐ Tone Curve

☐ Calibration

☐ Crop

FIGURE 4-13: Using the Synchronize window to synchronize only the White Balance setting

STEP 4: FINE-TUNING THE TONALITY

The next image correction we usually make in the RAW conversion software is to fine-tune the tonality. Again, we'll demonstrate this with two examples. The first example uses a feature added to ACR in version 3.0.

Example 1: Using Auto Adjustments[ACR3]

Although we normally avoid tools called *auto*-anything, we select Camera Raw's Auto adjustments (not yet available in ACR 2.*x*) to provide a solid headstart for our first tonality fix. You can easily toggle Auto adjustments on and off using Ctrl/⌥-U. Auto adjustments are signaled by the check marks in Exposure, Shadows, Brightness, and Contrast. Figure 4-14 shows the photo and its settings with the Auto adjustments toggled on.

With this image, the Auto adjustments bring us pretty close to what we want. We just need to fine-tune the **Exposure**, **Shadows**, **Brightness**, and **Contrast** manually (Figure 4-15). The goal is to retain shadow details while keeping the image slightly on the soft side to allow for further fine-tuning in Photoshop.

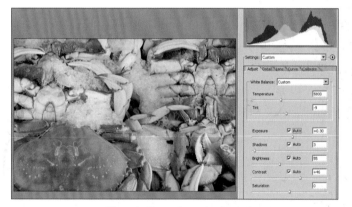

FIGURE 4-14: The crab photo with tonality Auto adjustments on

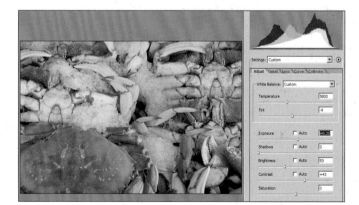

FIGURE 4-15: The crab photo with its tonality fine-tuned

Example 2: Using Curves[ACR3]

The Curves tool offers another way to adjust tonality in ACR. We usually leave it at a moderate setting, such as Medium Contrast.

The image shown in Figure 4-16 requires further minor tweaks. We need to avoid small aggressive highlights and open up the shadows.

To do make these corrections, we'll make very slight changes to the Exposure and Shadows parameters and we'll set the Tone Curve to Linear. Figure 4-17 shows the tweaked image, and Figure 4-18 shows its Curve window.

STEP 5: RANK THE IMAGES[ACR3]

Now that the basic image corrections have been made, we can decide what further work we'll do in Photoshop. At this stage, we use the new ACR 3 Ranking tool, which allows us to assign a rating of 0 to 5 stars to any image, as shown in Figure 4-19.

When we work on the files later, Bridge will allow us to display only the higher-ranked images, so we can concentrate on the "keeper" photographs. It's also possible to flag images with different colors.

In ACR 2.x and Photoshop CS1, we can flag files by selecting them in the file browser and clicking the Flag icon; a simpler option than the Ranking tool. The browser will display only the flagged images (or only unflagged images, if we choose).

STEP 6: MARK BAD PICTURES FOR DELETION

It's always disappointing to look at poor photographs; and even the best photographers often have quite a few. (This is especially true when shooting sports or wildlife, often at high rates of frames per second.) So we mark the obvious

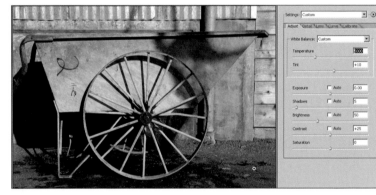

FIGURE 4-16: The default tonality settings for this image give us aggressive highlights and deep shadows.

FIGURE 4-18: A linear curve

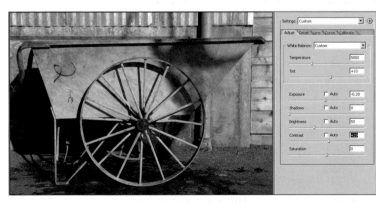

FIGURE 4-17: The cart image with tweaked tonality settings

FIGURE 4-19: You can rank images in ACR 3.

FIGURE 4-20: An image marked for deletion

1ds2_5001_0034.CR2	16,206 KB	CR2 File	11/25/2004 5:21 AM
1ds2_5001_0038.CR2	15,792 KB	CR2 File	11/25/2004 5:33 AM
1ds2_5001_0038.xmp	4 KB	XMP File	3/11/2005 3:53 PM
1ds2_5001_0039.CR2	16,548 KB	CR2 File	11/25/2004 5:33 AM
1ds2_5001_0039.xmp	4 KB	XMP File	3/11/2005 3:53 PM
1ds2_5001_0040.CR2	14,773 KB	CR2 File	11/25/2004 5:34 AM
1ds2_5001_0040.xmp	4 KB	XMP File	3/11/2005 3:53 PM
1ds2_5001_0041.CR2	15,477 KB	CR2 File	11/25/2004 5:34 AM
1ds2_5001_0041.xmp	4 KB	XMP File	3/11/2005 3:53 PM

FIGURE 4-21: XMP files store ACR settings.

bad images for deletion with an X, as shown in Figure 4-20.

STEP 7: FINISHING THE RAW CONVERTER SESSION

Once we've made all our corrections and selected the files we intend to work on further, we have four options for ending the session:

- **Save**: This new ACR 3 option saves the images with your changes and converts them to the file format you select.
- **Done**: Also new in ACR 3, this option saves all your revised image settings and closes Camera Raw without converting or opening images.
- **Open**: The same as **Done,** except that this option opens all the selected files in Photoshop.
- **Cancel**: Abandons all your changes and closes Camera Raw.

If you terminate your session with **Open** or **Done,** ACR stores (saves) all settings. We store settings in local XMP files (for files that have nondefault settings). When we do, our folder also displays small XMP files stored with the RAW images, as shown in Figure 4-21.

4.2: Browsing and Evaluating RAW Images with Bridge

While Photoshop 7 and CS1 had a file browser as an integrated module, with CS2 the file browser was separated into a stand-alone application called Bridge. Bridge is now the universal file browser for all the Adobe applications in Creative Suite 2. Bridge provides previews of all kinds of Adobe data files. Although Bridge offers several enhancements over the Photoshop CS1 file browser, you may still use the PS CS1 file browser instead of Bridge for many things.

Bridge is highly customizable, and, in our estimation, the most flexible and powerful file browser of all file browsers discussed in this book. If you do desktop publishing, its full strength will become obvious as you take advantage of its close integration with all the Adobe applications, such as Photoshop, Camera Raw, InDesign, Illustrator, Acrobat, GoLive, and Version Cue. In this book, however, we'll focus on the functions that are relevant to Camera Raw, Photoshop, and our workflow.

ACR plays a special role in the context of Bridge: it can be hosted by either Bridge or by Photoshop (Figure 4-22).

Bridge uses Adobe Camera Raw to create thumbnails and high quality preview images (1024 pixels wide) for all supported RAW file formats. There are basically two ways to work with RAW files in Bridge:

- Single files can be opened into ARC hosted by Bridge or Photoshop. Ctrl/⌥+O opens ACR in Photoshop and Ctrl/⌥+R in Bridge. Except for

FIGURE 4-22: Bridge file browser using Camera Raw

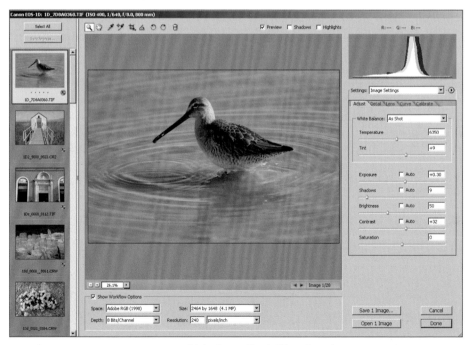

FIGURE 4-23: Adobe Camera Raw in Filmstrip mode

minor speed differences, the tool you use to open ACR is unimportant.

- You can select a set of RAW files in Bridge and press Ctrl/⌥+R to open them all in ACR's Filmstrip mode, as shown earlier in Figure 4-23. Once you open ACR in Filmstrip mode, previews are created on the fly. For this task, ACR uses a cache that is stored in a database or in XMP sidecar files. You can select the size and location of this cache in ACR's Preferences window (Figure 4-24). (Choose a size that will hold previews of all the files in the largest folder you intend to process; a single preview file needs about 4.5 to 6.5MB of disk space.)

⚠ Occasionally, ACR may need to make minor adjustments to the histogram and preview as it creates a full-size image. When that happens, it will briefly display this warning icon.

Filmstrip mode allows you to navigate through the image set, make changes, and rate or mark images for deletion. Changes are temporary until you confirm them by clicking **Done**. [⚡] (In fact, deleted images are put into the system's

FIGURE 4-24: The Cache settings

Recycle Bin, where you can retrieve them if the bin hasn't been emptied.)

4.3: The Adobe Camera Raw 3.*x* User Interface

The Adobe Camera Raw user interface (shown in Figure 4-25) is clean and easy to use. Like most applications, it can be sized up to full screen though, depending on your computer's power, running in Full Screen mode might slow down some operations that run in real time when displayed in a smaller window. We use a window

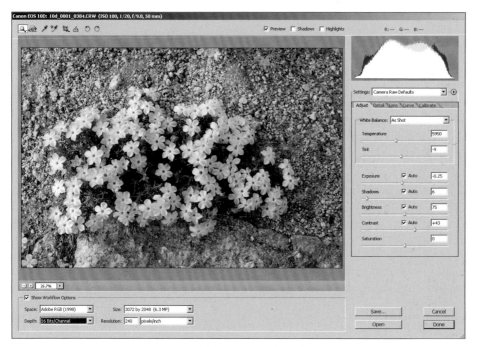

FIGURE 4-25: Adobe Camera Raw's user interface

—{⚡}—

NOTE:
If you work on a set of images and then press **Cancel**, *all changes you made to the images in that set will be undone.*

size that is quite large, and Camera Raw still performs in virtually real time, and the preview image is large enough to judge color and other details. If you need to view finer details, you can zoom the preview to 100 percent pixels and beyond.

THE HISTOGRAM

Chapter 3 discussed the role of histograms in evaluating exposure and white balance. Figure 4-26 shows an RGB histogram that also includes histograms of the three individual color channels (R, G, and B). The white areas are those where all three primary colors are present. Cyan shows areas with both green and blue pixels, yellow combines red and green channels, and magenta combines red and blue pixel values. (It would be nice if you could disable the display of the combined channels, but that is not currently possible.)

FIGURE 4-26: Use the histogram as an aid when making slider changes.

THE TOOLBAR

The tools in the window's upper-left corner should be familiar to most people who use Photoshop and other graphics software. They are discussed from left to right below.

The Zoom/Hand Tool

ACR supports all the usual zooming and image moving controls that you are accustomed to in Photoshop. Normally, we begin by setting the preview to Fit In View, because we do most

of our detailed inspections later in Photoshop itself. (Of course, that's just our personal work-flow preference.)

The Eyedropper

 You saw a preview of the eyedropper in the earlier workflow example, where we used it for one-click white-balance correction. (We'll explain this technique in more detail later in the chapter.) The eyedropper can also be used to take RGB readouts, which are displayed on the right side below the preview window.

The Color Sampler[ACR3]

ACR 3 allows you to place as many as nine color samplers in an image. As shown in Figure 4-27, a sampler displays the RGB values at the selected point. Color sampling can be extremely useful when you want to monitor specific areas in an image to see how they change as you change image parameters.

FIGURE 4-27: The Color Sampler

The Crop Tool[ACR3]

 You can crop and rotate images in ACR with the Crop tool.

The Straighten Tool[ACR3]

Even the best photographers sometimes create a tilted image. The Straighten tool offers an easy way to correct for tilt. As shown in Figure 4-28, you apply the Straighten cursor (a dashed line) to

a line in the image that's close to horizontal or vertical; ACR then corrects the tilt automatically.

FIGURE 4-28: Applying the Straighten tool

The Rotators[ACR3]

ACR 3 offers two controls that let you rotate an image either clockwise or counterclockwise.

WORKFLOW OPTIONS

The workflow options displayed at the bottom of the main ACR window (shown in Figure 4-29) let you select the ICC working space, the bit depth and pixel size of the converted images, and the resolution. (You probably won't change most of these options often once you have been using Camera Raw regularly.)

FIGURE 4-29: ACR workflow options

ICC Working Space

ACR offers four different ICC working spaces (as explained in Chapter 2). We use either Adobe RGB (1998) or ProPhoto RGB (which should only be used for 16-bit files). There is currently no way to add additional working spaces (such as ECI-RGB).

Bit Depth

You can produce either 8-bit or 16-bit TIFF files from RAW files when converting. (JPEG allows only for 8-bit files.) We use ACR in 16-bit mode most of the time.

Output Size

ACR allows you to upsize or downsize an image for most RAW file formats. Of course, changing the size of an image requires adding or deleting pixels, and the software needs to decide what colors the new or remaining pixels should be. The algorithm that ACR uses for upsampling or downsampling is much improved over the standard Photoshop bicubic interpolation.

In the Size dropdown list (shown below), a minus sign (–) indicates downsampling from the native camera format and a plus sign (+) indicates upsampling.

If you intend to print your image in a large format but its native resolution is not high enough, we recommend upsizing the image in ACR first and, if required, upsizing it a second time in Photoshop.

Resolution

This option defines the resolution, in pixels per inch (ppi) or other standard measures, that is used to tag the opened file. We work with either 240 or 300 ppi, both of which are common standards.

THE IMAGE CORRECTION CONTROLS

In its Extended mode, ACR 3 offers five tabs with image-correction controls as shown in Figure 4-30. They are Adjust, Detail, Lens, Curve (new in ACR 3), and Calibrate. For most work, you will only need to bother with Adjust, Detail, and Curve.

FIGURE 4-30: ACR's main correction tools (tabs) when Extended mode is active

The Adjust Tab

We used the Adjust tab (Figure 4-31) in the workflow examples. It contains the essential controls we use for any RAW conversion, which are white balance correction (WB) and exposure (EV),

FIGURE 4-31: Camera Raw's Adjust tab

White Balance (WB)

The two sliders **Temperature** and **Tint** control white balance in ACR. This is how Thomas Knoll, the original creator of Photoshop and also of Camera Raw, explains their function:

> To get a color to appear white, you need to get three parameters correct. This is a basic feature of human vision, stemming from the three types of color sensors in the eye. There are several common ways of factoring these three parameters. Probably the most familiar is red-green-blue values, where white is when they are all equal to some maximum value. Another common factoring is luminance-temperature-tint, which is what the Camera Raw plug-in is using.
>
> Luminance is basically how bright the light is. This is what photographers fiddle with all the time by adjusting shutter speed and f-stop. The Camera Raw plug-in allows you to fine-tune this using the "Exposure" slider. The remaining two parameters describe the "color" of the light.
>
> If you take a black object and start heating it up, first it starts to glow red, then orange, then yellow, then white, and then to a blue-white.

> The exact color of this light is dependent only on the temperature of the object and is called "black body radiation." It is usually measured in degrees Kelvin. Unfortunately, humans usually describe lower Kelvin numbers as being "warmer," and higher numbers as being "colder," which is opposite what science would suggest.
>
> But real-world light is rarely pure black body radiation. Tungsten light comes very close to being a pure black body, but other light sources usually have a color that is offset from the black body curve. On one side of the black body curve, the light is greener; on the other side, the light is more magenta. Fluorescent lights are often very green. The standardized average daylight values (D55, D65, and D75) are all slightly greener than black body. Flashes are sometimes more magenta than black body.
>
> The Camera Raw plug-in has two sliders to adjust for the color of the light. The first is Temperature, which is a closest point on the black body curve to the light's actual color. The second is Tint, which is the offset distance perpendicular to the black body curve. Positive values mean the light is greener than black body; negative means the light is more magenta than black body. [❀]

As you saw in the workflow example, Camera Raw also allows one-click WB correction. Click with the eyedropper on a neutral gray or white area (making sure not to click on overexposed white), and ACR will set the correct temperature and tint values for the whole image based on that point. The most accurate way to make WB correction is to photograph a gray card or ColorChecker under the same light as other images during a photo session, correct from the gray card image, and then apply the resulting WB settings to all photos with the same lighting conditions.

NOTE:

Having used nearly every available RAW converter, we conclude that using only a single color temperature slider does not cut it. We consider the WB control in Camera Raw one of the best we have seen.

Camera Raw also offers the standard WB presets shown in Figure 4-32, which can be used as good starting points for manual WB correction (when you don't find a neutral/gray object in the image).

As we've said before, white balance is inherently a matter of subjective preference, and frequently the "correct" WB requires further adjustment.

FIGURE 4-33: The Threshold view shows clipped highlights.

(Figure 4-32 is the White Balance dropdown on the left)

FIGURE 4-32: ACR offers several predefined White Balance settings.

Exposure, Shadows, Brightness, and Contrast

The **Exposure** slider allows you to control the proper settings for tonality (something that also be accomplished with use the Curves tool). The Exposure slider allows you to control the brightest point in your image. The brightest point in your image should contain the value you choose, and should not be a white without any detail unless you have some specular highlights.

ACR has a very powerful and unique feature for examining possibly blown-out highlights. To try it, hold down the [Alt] key as you drag the Exposure slider, to display a Threshold view (Figure 4-33). The Threshold view works like Photoshop Levels.

If you check the Shadows and Highlights boxes at the top of the ACR 3 window, as indicated here:

ACR[ACR3] indicates the blown-out image area with color (red for highlights and blue for shadows, by default).

The Shadows slider allows you to control the darkest point in your image, which should have a value you choose. The darkest area in an image does not need to hold any detail and it will be mapped to the deepest black your printer can produce. As with the Exposure slider, you can hold down the [Alt] key to see a Threshold view (Figure 4-34) with the Shadows slider. [⚡].

—[⚡]—

NOTE:
With both the Exposure and Shadows sliders, the preview and histogram are both updated in real time.

FIGURE 4-34: The Threshold view shows clipped shadows.

Once you have set the Exposure and Shadows, you can tune Brightness and Contrast. ⟨☉⟩ We recommend using all four sliders to produce either the final tonality or one that is left slightly soft for further processing in Photoshop. Again, the goal is to have:

- No blown highlights
- No blocked-up shadows
- No harsh contrast

Saturation

Saturation is the last slider on the Adjust tab. This control works quite nicely, but we prefer to fine-tune color saturation in Photoshop, and we usually do so only for selected regions or selected colors.

The Detail Tab

The Detail tab, shown in Figure 4-35, includes controls that handle sharpness and noise.

FIGURE 4-35: Camera Raw's Detail tab

Sharpness

The Sharpness slider controls the degree of sharpening you apply to the image, expressed as a percentage; 0 performs no sharpening and 100 performs the maximum. You can achieve good sharpening results with the Sharpness tool, but you may choose not to sharpen in Camera Raw.

There are three ways to correct sharpness in a RAW conversion workflow:

- Do all the sharpening in ACR. This is the recommended approach if you're doing batch conversion.

- Sharpen by approximately 10 percent in ACR, and do your final sharpening later in Photoshop.
- Do all of your sharpening in Photoshop.

We currently use the third method. We have very good sharpening tools that we can use in Photoshop (including CS **Smart Sharpen** and our own EasyS Sharpening Toolkit), so we set sharpening to zero and perform sharpening as the final step.

Figure 4-36 shows a 4064 × 2704-pixel image from a Canon 1DS. When sized to fit the printed page, the image looks reasonably sharp.

FIGURE 4-36: 1DS image (4064 × 2704 pixels)

But when we examine a detail at 100-percent pixel size, we see that the image actually looks blurry when it isn't sharpened (see Figure 4-37 on the left). The figure on the right in Figure 4-37 is considerably better because we added 50-percent sharpening to the image in Camera Raw.

Even if you plan to do your sharpening later in Photoshop in order to use its more sophisticated techniques, you may still want to preview the result as you work in Camera Raw because doing so will make it easier to evaluate the image. To preview your result, go to Camera Raw Preferences and set the Apply Sharpening To option to Preview Images Only, as shown in Figure 4-38.

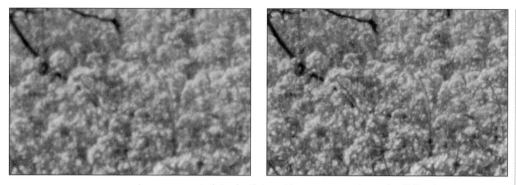

FIGURE 4-37: A 100-percent pixel size detail view with 0-percent ACR sharpening *(left)* and 50-percent ACR sharpening *(right)*

FIGURE 4-38: Choosing the Preview Images Only sharpening option in Camera Raw Preferences

Luminance Smoothing and Color Noise Reduction

The Detail tab provides two sliders that control image noise removal:

- Luminance Smoothing (which reduces detail noise)
- Color Noise Reduction (good values seem to be 20 to 30)

These smoothness controls can be used to remove some noise, especially for images shot at higher ISO. When you use these controls, ACR will try to maintain sharpness on all the edges but, as with any noise filter, the images tend to degrade a bit. (We try to shoot with the ISO as low as possible on all our cameras to minimize the need for later noise removal.)

The general workflow strategy choices are similar to those for sharpening:

- When working with images with really high ISO, do all of your noise removal in ACR.

- Smooth by approximately 10 percent in ACR, and then continue your work in Photoshop, using the **Reduce Noise** filter, the plug-in Noise Ninja, or other equally good tools.
- Leave all noise removal to Photoshop (using the tools noted above).

As with the Sharpness slider, we tend to use the third method when we remove noise.

The Lens Tab

The Lens tab, shown in Figure 4-39, offers two unique tools for correcting effects that can be

FIGURE 4-39: The Lens tab in Camera Raw. The Midpoint slider for Vignetting is grayed out until an Amount is set.

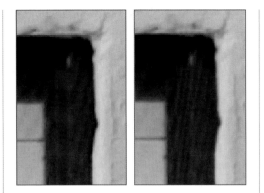

FIGURE 4-40: An example of chromatic aberration *(left)* and the result as fixed by Camera Raw *(right)*

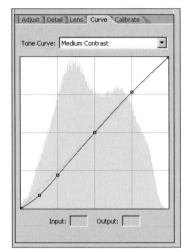

FIGURE 4-41: The Curve tab in Camera Raw

FIGURE 4-42: The Curve presets

introduced by some lenses including Chromatic Aberration removal and Vignetting compensation.

Both lower quality lenses and even some better lenses (when used with full-frame sensors) show chromatic aberration (CA), mainly in the corners. Figure 4-40 (left) shows the effect of CA and Figure 4-40 (right) the result of correcting it in Camera Raw.

CA typically shows up on high-contrast edges with one side green and the other purple. ACR's chromatic aberration tool, introduced with ACR 2, is first class, and will help to remove or at least minimize CA. And it's easy to control, too, because it works in real time. In contrast, the CA filter in Panorama Tools (a free Photoshop plug-in for image stitching) is pretty slow, and requires you to manually find the right values. It's worth upgrading to CS if you are still using Photoshop 7 and see a lot of CA in your images.

We haven't had to use ACR's Vignetting filter yet. However, if your lens shows strong vignetting, you should perform this correction in Camera Raw. Because vignetting can occur a little bit off the lens center, you can use the **Midpoint** slider to position the center of the vignetting for correction.

The Curves Tab[ACR3]

The Curves tab is shown in Figure 4-41. In theory, you could control an image's entire tonality using this curves control; however, correcting with curves is not terribly intuitive. We use it only for final fine-tuning.

The Tone Curve dropdown list (Figure 4-42) includes some presets that improve contrast. [❀] (They are mostly weak S-curves.)

The Calibrate Tab

Some users may love the Calibrate tool (shown in Figure 4-43), and others may hate it.

As you'll see in Chapter 7, some RAW converters (including Capture One DSLR) control colors for different cameras by using standard ICC camera profiles and allow users to replace those profiles with their own. That's a powerful solution if you can get "good" (subjective) profiles. But creating your own profiles is not easy and, in our opinion, is better left to experts. (You will find third-party profiles for tools, like Capture One DSLR, on the market.)

ACR, on the other hand, uses hard-coded Matrix profiles for all cameras, and the **Calibrate** sliders allow you to tweak its profiles. This is a powerful tool, but you must know what you are doing when you use it. We usually use the default settings (all = 0), but we're sure that

NOTE:
Officially, Camera Raw provides no support for creating your own permanent presets. Fortunately, the developers allowed a workaround. You can save a group of ACR settings to a file (see "Saving and Reusing Settings" later in this chapter). If you select only Tone Curve when you save them, the settings will be saved in a different folder and will show up as Curve presets.

FIGURE 4-43: The Calibrate tab in Camera Raw

FIGURE 4-44: The Camera Raw 3.0 final processing options

FIGURE 4-45: The Save Options dialog box

FIGURE 4-46: The background processing Status message

some photographers will come up with useful settings for different cameras. (See Chapter 13 for more details on camera profiling.)

4.4: Final Processing

Our earlier workflow example gave a quick preview of the options for finishing a Camera Raw session. Here are the details.

Before ACR 3.0, your only final options were **Open** and **Cancel**. That is, you could either apply your changes and open the file in PhotoShop, or abandon your changes. Neither of these options allows you to apply changes to multiple images simultaneously.

ACR 3 adds two additional buttons: **Save** and **Done** (Figure 4-44). It is important to understand these options and their implications.

SAVE

This option might be better called "Convert," as it converts an image and returns you to ACR. When you click it, you'll see the **Save Options** dialog box (Figure 4-45).

In this dialog box, you specify the following:

- The destination folder for the converted image. We always use a unique folder named x_acr_temp for ACR output files.
- File naming options. In our workflow, the file naming pattern was created when we downloaded the files (see Chapter 3), so we can leave this as the default (the existing document name with the standard extension for the output file type).
- The output file type (DNG, TIFF, PSD, or JPEG).

Once you click **Save**, you will return to ACR's main dialog and conversion will proceed in the background. (You can also Save by pressing Alt-Ctrl-S (Mac: ⌥-⌘-S.) While that's happening, you'll see the status message shown in Figure 4-46.

Camera Raw Save Status

Remaining images to process: 5

Original File:	Saved File:	Status:
1D2_9000_0022.CR2	1D2_9000_0022.tif	Processing
1Ds_0000_0112.TIF	1Ds_0000_0112.tif	Waiting
10d_0000__0061.CRW	10d_0000__0061.tif	Waiting
10d_0001_0384.CRW	10d_0001_0384.tif	Waiting
10d_0001_0385.CRW	10d_0001_0385_2.tif	Waiting

FIGURE 4-47: The background Save Status dialog box

If you have several images in the queue and need to stop processing, simply click on the message and you should see the dialog shown in Figure 4-47. Click the **Stop** button to terminate all unfinished processing.

OPEN

The Open option converts all of your selected files, opens them in Photoshop, and closes ACR and saves all of your settings. Even the settings for images that aren't currently opened will be saved (and the files will be opened in Photoshop CS2), so be careful not to open too many files at once.

DONE

Done saves all your changed image settings and closes the ACR dialog. No images are opened or converted.

CANCEL

The Cancel option closes the ACR dialog without saving any changes. No files will be opened or deleted, and no image processing will be performed. If you choose Cancel while working on a set of images, all of your changes (including your deletions) to all images in that set will be lost.

SAVING AND REUSING SETTINGS

We often want to use the same settings for an entire set of photos. You saw earlier how the Synchronize tool can be used when you're working in Filmstrip mode. You can also click the right arrow next to the Settings list in the main Camera Raw window to display the Save

Settings and Save Settings Subset options shown in Figure 4-48.

Choose the Save Settings option to save all of the settings you've just indicated in an image, or choose Save Settings Subset to save only specific settings (for example, to create a Curve preset as suggested earlier). Be sure to use descriptive names for your saved settings, so you'll know their function when you need to use them later. Once they're saved into the Presets/Camera Raw folder, these settings will also appear in the Settings dropdown list, as shown in Figure 4-49.

The Settings options are:

Image Settings: Apply the last saved setting to this image.

Camera Raw Defaults: Apply the default settings for the camera.

Previous Conversion: Apply the settings from the last Camera Raw conversion for a picture from the same camera type.

Custom: This is displayed when you've changed any values in your current conversion.

Other entries: These are the settings you've saved.

FIGURE 4-48: Use this menu to save or load settings.

FIGURE 4-49: The Settings dropdown list

Saved Settings and the Photoshop History Log

When you look at a converted image in Photoshop, you may wonder which settings you used for the RAW conversion. If you use Camera Raw for the conversion, you can find out if you enable Photoshop's History Log. With the log enabled ACR records all settings used in the created file's meta information. You can view that information in Photoshop with Photoshop's **File Information** function (**File** > **File Info** or via ⇧+Alt+Ctrl+I) (see Figure 4-50).

BATCH CONVERSION

There are actually three ways to batch process with Adobe Camera Raw. (Chapter 10 discusses batch processing in more detail.):

- Provide your RAW files with the appropriate settings. Select all the images you want to convert using either the Photoshop file browser (in Photoshop CS or earlier) or Bridge, then ⇧+double-click on the last selected file to bypass the Camera Raw dialog box and convert the selected images. (You will need to turn off the Bridge preference "Double-Click Edits Camera Raw Settings In Bridge" in order to do this.)
- Create a Photoshop action, as described in Chapter 10. The action should open a file, do a RAW conversion in ACR using the assigned settings for each individual file, open the converted image in Photoshop, perform some Photoshop steps, and save the image in a predefined format. Next, use Photoshop's function **File** > **Automate** > **Batch** to apply the action to all files in a folder (and, optionally, all subfolders).
- Use a script to do the job. A script can perform operations that Photoshop actions cannot. [⚡] (For example, you can use a script branch and apply different processing steps based on some predefined condition.) A script can use several applications, such as Bridge (to select), ACR (to select dedicated settings), and Photoshop. Adobe supports scripts either in Visual Basic (with Windows), AppleScript (with Mac OS), or JavaScript (which runs on both platforms).

FIGURE 4-50: Viewing recorded Camera Raw settings in Photoshop

ADVANCED IMAGE CORRECTIONS

Once you've finished correcting the white balance, exposure, and other primary functions, you will still need to make other advanced image corrections. Here is a summary of how we deal with them in Adobe Camera Raw:

Noise (luminance and color noise): We rarely use Luminance noise removal in ACR because it degrades the details too much. We often leave the color noise slider at a low level (10 to 15). (Be aware, however, that even color noise removal can result in colors bleeding into other areas.)

Sharpening: For optimal sharpening, we use other tools in Photoshop (Smart Sharpen or EasyS Sharpening Toolkit).

Removal of chromatic aberrations (CA): This is a powerful option in ACR. (You can also use the Lens Correction tool in Photoshop CS2.) If you still use Photoshop CS1, we recommend that you remove CA here.

Vignetting: As mentioned previously, we have had very few vignetting issues (vignetting mainly occurs with extremely wide angle lenses).

Cropping[ACR3]: Although the cropping support in ACR is very useful, we often leave the final crop to Photoshop.

Correcting tilt[ACR3]: The Straighten tool is very helpful in correcting tilt in images. If your image is only slightly off, we recommend doing any straightening here, especially if you convert to 8-bit output.

—[⚡]—

NOTE:
Scripting is very powerful, but it requires some study before you can become proficient. We recommend JavaScript, mainly for its platform-independence. A few JavaScripts ship with Bridge; studying them can provide a painless way to begin scripting.

Perspective corrections: ACR does not have a dedicated tool for perspective correction, so we use Photoshop CS2's Lens Correction tool.

Dust removal: Dust removal is best performed with the Photoshop Healing Brush.

Upsampling: If you know your image needs to be upsampled, ACR provides good options. We usually perform any upsizing later with Photoshop CS tools (see our upsizing articles at http://www.outbackphoto.com/workflow/wf_60/essay.html)

4.5: RAW Files Embedded in Photoshop Smart Objects

One of Photoshop CS2's powerful new features is the **Smart Objects tool**. A smart object is a type of layer, embedded in a Photoshop document, which can contain various kinds of image data, including RAW files. Many of the uses of smart objects are of more interest to web designers than photographers. (For a complete description of smart objects, read *Photoshop CS2: Up to Speed* by Ben Willmore [Peachpit Press, 2005]).

CREATING A SMART OBJECT LAYER THAT CONTAINS A RAW FILE

Embedding a RAW file into a Smart Object layer gives you more flexibility than simply using a converted RAW file as a normal background image. The process is not complicated, but it's not particularly obvious, either. The method we describe was introduced to us by Ben Willmore.

1. First, in Photoshop **General Preferences**, make sure that the **Resize Image During Paste/Place** property is unchecked, as in Figure 4-51.

FIGURE 4-51: Clear the Resize Image During Paste/Place check box in Photoshop's General Preferences.

2. Create a new 16-bit RGB document in Photoshop of about 300 × 300 pixels, as shown in Figure 4-52.

FIGURE 4-52: Create a new 16-bit document in Photoshop.

3. Select a RAW file in Bridge, and place it into the new document by using the **Place > Photoshop** command in Bridge, as shown in Figure 4-53.

FIGURE 4-53: Use Bridge to place the file in Photoshop.

Canon EOS Digital Rebel XT: 350d_0000_1563.CR2 (ISO 100, 1/400, f/10, 70-200@84 mm)

☑ Preview ☐ Shadows ☐ Highlights R: --- G: --- B: ---

Settings: Camera Raw Defaults

Adjust | Detail | Lens | Curve | Calibrate

White Balance: As Shot
Temperature 5650
Tint +14

Exposure ☐ Auto 0.00
Shadows ☐ Auto 5
Brightness ☐ Auto 50
Contrast ☐ Auto +25
Saturation 0

19.5%

☑ Show Workflow Options
Space: Adobe RGB (1998) Size: 3456 by 2304 (8.0 MP)
Depth: 16 Bits/Channel Resolution: 240 pixels/inch

Save... Cancel
Open Done

FIGURE 4-54: The Camera Raw dialog box

4. This opens the Camera Raw dialog in Photoshop, as shown in Figure 4-54.

5. Make any adjustments to your RAW settings, and confirm the changes with **Open**. In Photoshop CS2, your screen should look like Figure 4-55.

6. At this point, the image is not yet really placed. To continue, confirm the placement with the **Return** key. Your screen should look like Figure 4-56.

7. Because the RAW image is larger than the newly created document, you can see only part of it. Fortunately, Photoshop's **File > Reveal All** command (Figure 4-57) allows you to display it full size.

FIGURE 4-55: The image opened in Photoshop

FIGURE 4-56: The image after confirming placement

FIGURE 4-57: Select the Reveal All command to see the whole RAW image.

8. At this point, you see the full-sized converted RAW image as it would normally look as a background image. A closer inspection reveals that you have created a Smart Object layer containing the original RAW file. The first indication of this is the different image title bar (Figure 4-58).

The filename is still Untitled-1, whereas a RAW file opened normally would show the RAW filename.

The RAW filename shows up as a layer name indicating that we have a layer and not simply a background image.

The Layers palette (Figure 4-59) shows more. In this example, the symbol flags a smart object.

FIGURE 4-59: The Smart Objects layer in the Layers palette

WHY USE RAW FILES AS SMART OBJECTS?

Now that you have your RAW file as a Smart Object layer, you may wonder if it was worth the hassle. What's the big deal about using a converted RAW file as a normal background image? When working with converted RAW files, you have the following limitations:

* If you want to change any parameters for the RAW conversion, you have to begin all over again.
* You must also locate the matching RAW file first.

FIGURE 4-58: The Page Title bar

The RAW file in the Smart Object layer makes it much simpler. Double-click on the image icon and Camera Raw 3.*x* will open up again, and you can fine-tune your RAW conversions settings. There is no need to search for your RAW file, because it is contained in the Smart Object layer. Finally, all the information you need for your work on a certain RAW file is part of the image.

EXPORTING RAW FILES FROM A SMART OBJECT

Because the Smart Object layer contains the full, original RAW file, you can even go back to the original file. To do so, elect the Smart Object layer that contains your RAW file and use **Layer > SmartObjects > Export Contents**, as shown in Figure 4-60.

Smart Objects allow for the seamless integration of RAW files with finely tuned images from Photoshop.

FIGURE 4-60: Export contents

PIXMANTEC RAWSHOOTER (RS)

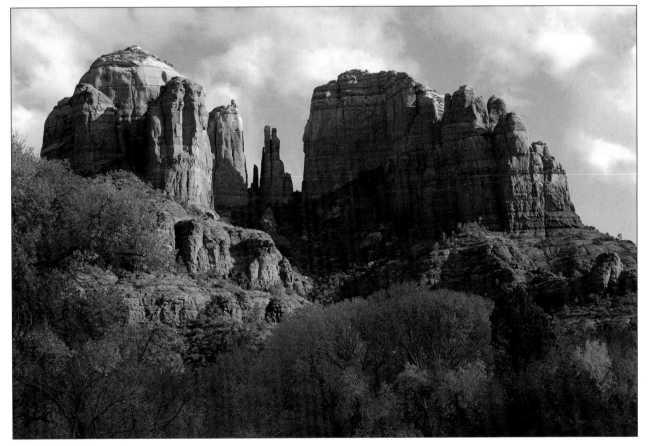

CAMERA: CANON 1DS MK. II

NOTE:

As with all of the software covered in this book, this chapter is not intended to replace the manual. Further details and principles are covered in our e-book Digital Photography Workflow Handbook, *which is available from our website (www. outbackphoto.com).*

Pixmantec RawShooter (RS) is a new RAW converter that was created by the same software designer who created Capture One, a program that has proven to be very influential in the evolution of RAW converter software. (You'll learn more about Capture One in Chapter 7.) RawShooter was designed to be very simple and quick to use, while producing excellent RAW conversion results at the same time. It's also free! (The current version of RawShooter Essentials can be downloaded from the www.pixmantec.com website.)

As of mid-2005, RawShooter is a Windows-only application; there is no Mac version. Hopefully, Mac users will see a version of this technology in the future. ❦

5.1: A Quick RawShooter Real-life Workflow

You don't need to know about all of RawShooter's features to use it effectively. As we did with Adobe Camera Raw, we'll begin this chapter by demonstrating how we use RS in our own workflow. Then, in later sections, we'll describe its many features in detail. Again, we'll work with images from a real-life photo session in Monterey, California (using the Canon 1Ds Mk. II camera) and explain how we approach working with RawShooter on this set of images.

STEP 1: TRANSFER THE IMAGES TO THE COMPUTER

The workflow begins with the transfer of files from the camera to the computer. Chapter 3 described our organization and naming system, implemented using Downloader Pro.

STEP 2: BROWSE THE RAW FILES USING THE RS RAW FILE BROWSER

RawShooter has a RAW-only file browser, so the other types of files aren't distracting. This browser acts as a digital light box. We use the layout shown in Figure 5-1, with a filmstrip at the bottom. When we create or switch to a new folder, RS creates preview files for all of the images in that folder. We wait for all the previews to be created because our work goes significantly faster once previews are available.

STEP 3: BROWSE THROUGH THE IMAGES

Filmstrip mode allows us to inspect all shots as quickly as we like.

STEP 4: MAKE THE INITIAL WHITE BALANCE CORRECTIONS

Once we've selected the images to work on, the first correction we make is to the white balance (WB). As we did with Adobe Camera Raw, we'll demonstrate this in two different ways: first using the White Balance eyedropper tool as a starting point for tweaking and then using the Color Temperature slider control.

Example 1: Using the Eyedropper Tool

The white balance in the crab photo shown in Figure 5-2 is incorrect. This was expected because the photo was shot in the shade. Few cameras have white balance processing that will correct for this situation. Figure 5-3 shows the "As Shot" WB settings that RawShooter displays for the image.

As we mentioned in Chapter 4, when in doubt it's best to photograph a mini ColorChecker or gray card within a scene and use that as a reference for correcting other shots of the same scene made in the same light. In this case, however, we didn't do that, so we will have to use other means to correct the WB. Because white balance for these kinds of photos is highly subjective, the lack of a defined reference point doesn't cause any serious problems.

For this correction, we're using the White Balance eyedropper tool, and we've chosen a point within the ice as the most neutral gray to sample. This produces the correction shown in Figure 5-4; you can see the resulting settings in Figure 5-5.

The adjustments have improved the white balance. After we work on tonality in the next section, the image may still need to be tweaked.

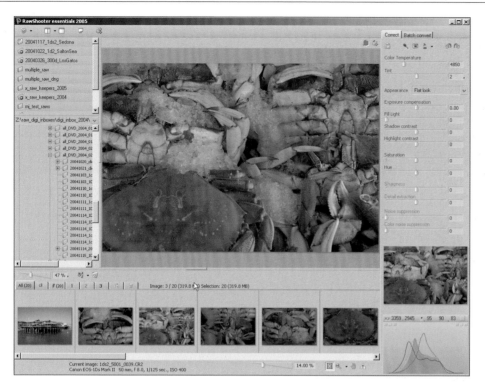

FIGURE 5-1: Folder selected in RawShooter

FIGURE 5-2: The white balance in this shot
needs to be corrected.

FIGURE 5-4: White balance after correction
(note the eye dropper cursor)

FIGURE 5-3: The "As Shot" white balance settings for
the crab photo as displayed in RawShooter

FIGURE 5-5: The white balance settings after
clicking with the eye dropper

FIGURE 5-6: Cool white balance

FIGURE 5-7: "As Shot" white balance settings for
the cart image

FIGURE 5-8: White balance at color temperature 6000 K

FIGURE 5-9: White balance set to 6000 K

Example 2: Using the Sliders

Figure 5-6 shows the cart photo. Note that the white balance is on the cool side. Figure 5-7 shows the "As Shot" settings that RawShooter reads for the photo.

Once again, we have no ColorChecker to use as a reference. However, this time we have no real defined gray for the eyedropper to sample. So instead, we'll change the color temperature by adjusting the Color Temperature slider. Figure 5-8 shows the corrected image, and Figure 5-9 shows the settings we used.

The result is slightly too warm for our taste. (As always, that's a highly subjective judgment.) Finally, we settled on a WB temperature of 5800 K. Again, after we work on the tonality, we might need to revisit the WB settings.

STEP 5: APPLY WB SETTINGS FROM ONE IMAGE TO OTHERS

Because the other crab photos were shot in identical light, we'd like to apply the same white balance settings to them. RawShooter's Copy Settings tool makes it easy to do that. First, we keep the current image selected (it becomes the master picture) and add the other crab photos to the selection (Figure 5-10).

 Then we click the **Copy Settings** button to display the window shown in Figure 5-11. Although other correction settings can be copied, we're only interested in white balance.

Now, all of the crab photos have the same corrected WB settings, leaving their other original image settings untouched.

FIGURE 5-10: Select master and target images

STEP 6: FINE-TUNE THE TONALITY

The next image correction we usually make in the RAW conversion software is to fine-tune the tonality. Again, we'll demonstrate this with two examples.

Example 1

Normally, we ignore tools called **auto**-anything. But for tonality correction, the RS Auto Exposure tools (Alt+E) often give us a head start. They change the settings for Exposure, Fill Light, Shadow Contrast, and Highlight Contrast. Figure 5-12 shows the crab image after being corrected with Auto Exposure, and Figure 5-13 shows the resulting settings.

This adjustment brought a lot more life to the photo. However, it could still be tweaked to make it a bit brighter. We control overall brightness using the Exposure slider and brightness in the shadows using **Fill Light**. (Note that there is no equivalent for this control in other RAW converters.)

FIGURE 5-11: Copy only the white balance settings.

Figure 5-14 shows the fine-tuned image, and Figure 5-15 shows the settings we applied.

Making a few slider changes can make a huge difference. When we compare the final result to the original image, those differences can be quite impressive.

FIGURE 5-12: The crab image corrected using Auto Exposure

FIGURE 5-14: The crab image after more tonality tuning

FIGURE 5-13: The settings applied by Auto Exposure

FIGURE 5-15: The fine-tuned tonality settings

Example 2

When we finished making the initial white balance corrections to the cart image, we noted that it also needed exposure correction. Clicking +E to apply the Auto Exposure settings listed in Figure 5-15 produces the results shown in Figure 5-16.

We still need to make some minor tweaks:

- Brighten the image overall.
- Open the shadow up (more Fill Light).
- Keep some aggressive highlights in check.

Figure 5-17 shows the image after we make these final adjustments, and Figure 5-18 shows the corresponding settings.

Achieving a usable result takes less than 30 seconds.

STEP 7: RANK AND PRIORITIZE THE KEEPERS

Now that we've tweaked our images, we want to prioritize them for possible further work. RS allows us to flag images and rank them from 1 to 3. After we move the cursor over an image to display its toolbar (see Figure 5-19), we can click one of the buttons to assign its priority.

After we do that, we can click on the tab above the filmstrip marked with "1" to display only the first-ranked pictures (see Figure 5-20).

Converting Images in the Background

At any time, we can convert selected single images or sets of images in the background by clicking the Process button or by pressing the Insert key.

STEP 8: MARK BAD PICTURES FOR DELETION

Even the best photographers take a few bad shots. We can mark those poor images for deletion by using the filmstrip thumbnail's Delete button, as shown in Figure 5-21.

When an image is marked for deletion, RawShooter does not actually remove it immediately. Rather, it moves the image from the All Images tab to the Wastebasket tab. When we view

FIGURE 5-15: The settings produced by using Auto Exposure

FIGURE 5-16: The cart image with Auto Exposure applied

FIGURE 5-17: The cart image after tweaking Exposure, Fill Light, Shadow contrast and Highlight contrast

FIGURE 5-18: The final tonality settings used to create figure 5-17

FIGURE 5-19: Prioritized images

images on the Wastebasket tab, we can undelete them by clicking the Delete button on the thumbnail view again. To permanently delete the images, we next click the button. The warning dialog shown in Figure 5-22 displays. If we confirm it, our images will be removed completely and will no longer be in the Windows wastebasket.

STEP 9: ALL CHANGES ARE PERMANENT

When we close the RS application, all of our changes are permanent.

Settings (.rws) Files

RS saves all of its changes in **settings** files. As shown in Figure 5-23, RS creates a corresponding .rws file for every image that is converted, and it stores the settings. These .rws files are stored in the .RWSettings subfolder, which is created within the image folder.

5.2: Getting Started (Setting Up RawShooter)

Now that we've demonstrated how we use RawShooter in our workflow, let's see how you can use it in yours. Once you've installed and

FIGURE 5-20: RS shows only the images that are assigned priority 1.

FIGURE 5-22: A warning is issued before the images are permanently deleted.

FIGURE 5-21: Mark image for deletion

FIGURE 5-23: Setting files used by RS

registered RawShooter, it's just about ready to go. Only a few options need to be configured; we suggest the following:

1. Select the **Batch Convert** tab (Figure 5-24). Here are the settings you need to be concerned about:

 Camera Profile: We used the default internal profile. You can also use custom camera profiles. However, we think the internal profiles are quite good. To learn more about creating a custom profile, see Chapter 13.

 RGB ***Working Space:*** We use either 16-bit Adobe RGB (as shown) or ProPhoto RGB.

 Sharpening: This is the first RAW converter we've used where it makes sense to leave its automatic sharpening set to On. Minor sharpening can be added later with EasyS in Photoshop.

 Automatically Open With: You can also open converted files directly into Photoshop. We don't do this most of the time because we have a different browser (Bridge) displaying the folder with converted files.

2. You should also configure a default naming scheme and storage location for the converted files that RawShooter will output. Under **Batch Convert**, click the

FIGURE 5-24: The Batch Convert tab

Naming and Output Locations button to open the **Naming and Location** window, as shown in Figure 5-25.

Notice the special folder (D:_tmp_workfiles\ x_raw_shooter) we created for all of the files converted by RSE.

FIGURE 5-25: Set up the naming and location for converted RAW files.

5.3: Inspecting and Browsing Your Files with RawShooter

Besides the convenience of filtering out other file types, RawShooter's RAW file browser supports various features. First, you can choose any of five different screen layouts and switch between them "on the fly," using either the toolbar or shortcut keys (Figure 5-26). We use the Thumbnails Below option, which places a filmstrip of thumbnails below the full-size current image. This creates a display like the one in Figure 5-27.

SELECTING A FOLDER AND CREATING PREVIEWS

Figure 5-28 shows the folder browser and favorites list.

At any time, you can add a folder to the list of favorites, either by right-clicking to display the folder's context menu or by dragging and dropping. Designating favorites is crucial for getting to your current or recent projects quickly.

FIGURE 5-26: Layout options for the RAW file browser

FIGURE 5-28: Folder navigation in RS

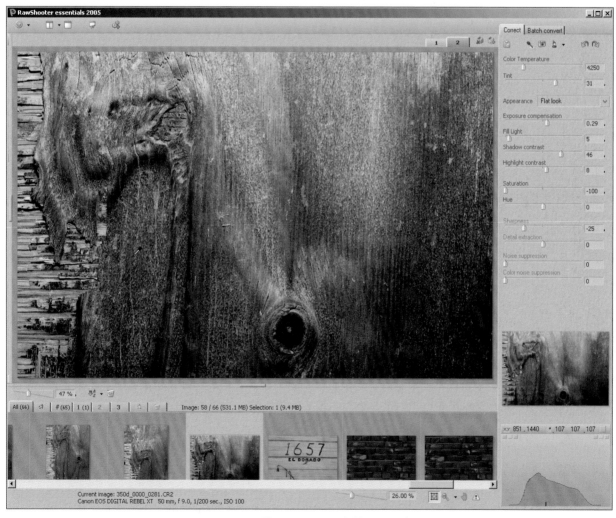

FIGURE 5-27: Viewing option 5 with Filmstrip mode

Once you have selected a folder, RS will start to create previews and thumbnails. RS is very fast, but for a folder with many large files, creating these previews will take some time. While this is happening, RawShooter displays two indicators to show that building is in progress. The progress wheels (Figure 5-29) appear in the lower left, and the message in Figure 5-30 appears in the title bar.

FIGURE 5-29: The progress wheels display when a single image is perfected.

FIGURE 5-30: The top border shows how many previews still need to be created.

WORKING IN FILMSTRIP MODE

Once the previews have been created, the workflow is quite fast. The filmstrip area allows you to organize your images into different priorities (Figure 5-31).

From left to right, the eight tabs on top let you display:

- All images in the folder
- All flagged images in the folder
- All images that have no priority assigned and that are not marked for deletion
- Images of priority 1, 2, or 3
- Recently processed images
- Images marked for deletion

The Filmstrip toolbar has three controls. The first two affect the filmstrip display:

- The size of the thumbnails

- The sorting order (by name or date)

The rightmost icon deletes the images that you've marked for deletion. For any single image, you can perform the following operations on the thumbnails:

- Flag the image.
- Set its priority to 1, 2, or 3.
- Mark it for deletion.
- Rotate it by 90 degrees, left or right.

Once you have selected a single image to work on, press `Tab` to display it in Full Image view (Figure 5-32); press `Tab` again to toggle back to Filmstrip mode.

FIGURE 5-31: The Filmstrip display

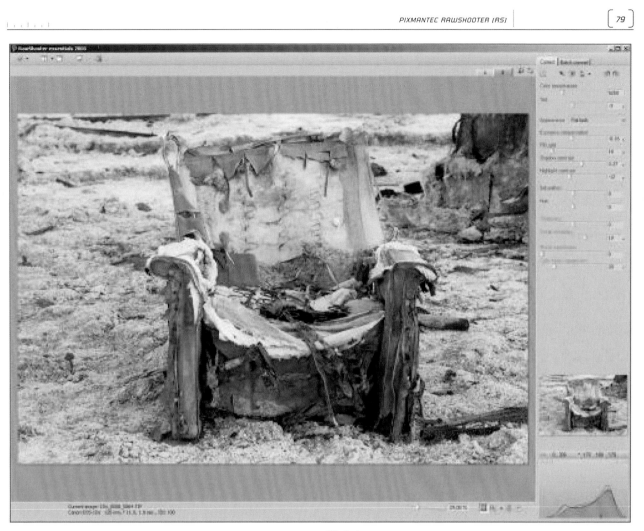

FIGURE 5-32: Work view

PREVIEW SIZE

RawShooter provides full-sized previews for all cameras. If you're familiar with Capture One, you'll find that working with 100 percent views or larger is much more convenient in RS (particularly with the slideshow feature, which is discussed below). In the Work view, you can

scale images up to 800 percent; the 100 to 400 percent increments are predefined settings.

For convenience, RS lets you toggle between the Fit view and the last selected zoom level by using ⇧+Tab.

If you're working at a higher zoom level, the navigator pane in the lower right helps you stay oriented by highlighting the zoomed-in portion within the whole image. (See Figure 5-33.)

THE MAIN VIEW TOOLBAR

Figure 5-34 shows the view controls on the main toolbar.

From left to right, the controls are

- Zoom level
- Fit to screen
- Zoom presets

FIGURE 5-33: The RawShooter Navigator pane

FIGURE 5-34: View controls in RawShooter

files for deletion folder-by-folder. Once you have marked all of the files that you want to delete from a specific folder, you can revisit those files in the Marked for Deletion tab, perhaps displaying them in a slideshow for quick review, as discussed later in the chapter. To undelete a file, just uncheck the deletion mark on the thumbnail pane. When you are sure you want to delete the files you've marked, click the Wastebasket icon to remove the images completely. (They will not show up in your system wastebasket.)

- The Hand tool (Using the spacebar is better in this instance.) The Hand tool allows you to move the enlarged image in all directions.
- Show under/overexposure warning colors (This feature can also be activated on-demand by using the Ctrl key.)

SLIDESHOWS

You can launch a slideshow by pressing Alt+E or by clicking on the Slideshow icon at the top left. Slideshows serve three purposes:

- To simply display your pictures
- To set priorities
- To tag files for deletion

Figure 5-35 shows a slideshow in progress. Figure 5-36 shows the slideshow controls.

The slideshow may be the best way to initially preview your images.

You should wait until previews for all of the images in a folder have been created before you generate the slideshow, because this process can be very slow if you try to do both simultaneously.

You can control the duration of each slide and the transition, if any, between slides. Figure 5-37 shows the options.

THE DELETION WORKFLOW

Deleting files is an important process, and deleting them correctly so that you don't lose the files you want to keep is critical. RawShooter gives you plenty of safeguards. In RS you mark

SOME USEFUL KEYBOARD SHORTCUTS

Like other tools, RS provides a number of keyboard shortcuts to speed up the work process. Using the following shortcuts can help you work more efficiently:

Tab	Toggles the browser between Image view and Filmstrip view
Ctrl	Shows overexposure indicator colors
Ctrl+Tab	Toggles between the Zoom and Fit Size views
Alt+E	Enables autoexposure

5.4: Image Corrections

All of RawShooter's correction tools are on the Correct tab, as shown in Figure 5-38.

Like other parts of the RawShooter interface, this tab has its own toolbar.

From left to right, the tools do the following:

- Apply settings to other selected images.
- Activate the WB Gray Balance tool. (We use ↑+Click to launch this tool.)
- Reset white balance to "As Shot" In Camera.

FIGURE 5-37: The timings and transitions available for slideshows

FIGURE 5-35: Slideshow

(4 / 78) 1Ds_0000_5849.TIF : 200 mm, f 11.0, 3.2 sec., ISO 100

FIGURE 5-36: Slideshow controls

FIGURE 5-38: The RS Image Correction tab

FIGURE 5-39: With RS, you can use Auto White Balance as a good starting point.

- Apply Auto WB or autoexposure. (Figure 5-39 shows the drop-down list.) As you saw in the workflow examples, both of these controls frequently provide a workable starting point for correction.
- Return to the initial settings.
- Forward to the last active settings.

The last two options are essentially undo/redo features, and in that context we should mention a very powerful RS tool: the snapshot. Snapshots are multiple versions of different corrections applied to the same image. You can create a new snapshot by pressing [Ctrl]+B or by clicking the **Add Snapshot** button. Create as many

snapshots as you want. All of the snapshot settings will be stored for later use. You can select different snapshots of an image with the numbered tabs (Figure 5-40).

Essential image corrections can be grouped into the following categories:

- White balance (WB)
- Exposure and tonality
- Color tuning
- Sharpness and detail
- Noise handling

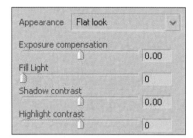

FIGURE 5-42: The adaptive exposure and tonality controls in RawShooter

SETTING WHITE BALANCE (WB)

White balance works the same way it does in most RAW converters. You can either use the eyedropper tool to sample a light neutral gray object as the reference point for correction (do not use overexposed white areas), or you can use the Color Temperature and Tint sliders. By default, the Color Temperature slider is simply a range between Colder and Warmer, as shown on the top in Figure 5-41. In RawShooter's Preferences window, you can change this to use absolute color temperature, as shown on the bottom. We like the default colder/warmer method because we believe that white balance adjustment is, in most cases, a highly subjective decision.

We find that white balance is often satisfactory "as shot." However, we do like to photograph a gray card or ColorChecker and use the Gray Balancing eyedropper. [⚡]

FIGURE 5-40: Use the numbered tabs to switch between different snapshots of an image.

FIGURE 5-41: The color temperature controls can use either a Colder/Warmer range *(top)* or absolute temperatures *(bottom)*.

EXPOSURE AND TONALITY

In addition to white balance tools, which are necessary for obtaining good color, exposure and tonality controls are essential for giving your images a pleasing photographic look. RS has unique controls (Figure 5-42), and we had to learn how to use them. Most RAW converters

support controls that are, in principle, a variant of levels and curves. RawShooter works differently. It actually operates adaptively. Pixels are evaluated in their scene context, much the way the Photoshop Shadow/Highlight tool works. To get the best results for an image, you must find the optimum settings for all four sliders.

- Exposure Compensation
- Fill Light
- Shadow Contrast
- Highlight Contrast

As you're using all four sliders, be sure to avoid extremes. Make your corrections visually, checking the histograms as you adjust the sliders. (Figure 5-43 shows the three types of histograms; clicking on top of the histogram toggles the display between all three types.)

From left to right, the first two histograms display three channels that include luminosity and brightness (the gray or white area). The third histogram shows only luminosity. We like to use the first histogram.

Three indicators for highlights and shadows appear at the top of each histogram. They signal whether a certain channel is being clipped. In the figure above, the blue channel is clipped in its highlights.

The best way to learn to use these controls is to experiment using your own images. Here are some primary guidelines for adjusting the controls:

Exposure Compensation (EV): If your image is too bright, tone down the EV. If it's too dark, first try Fill Light to brighten the image shadows. [❀]

FIGURE 5-43: Watch your histogram while you fiddle with the various sliders.

Fill Light: For most images, it is best to stay below a value of 50. Consider lowering the EV, and then turn the Fill Light up. Fill Light also helps open up shadows.

Shadow Contrast: It's usually best to increase this setting, giving more depth and contrast (punch).

Highlight Contrast: Use this to tone down aggressive highlights.

Again these four sliders work hand-in-hand. Work with all of them. Let's consider some examples.

Example 1: Image Shadows Are Too Dark

Figure 5-44 is a little dull because it was shot in overcast light.

The Fill Light feature is a key tool for working with your images. Figure 5-45 shows the adjustments we made. Figure 5-46 shows the result.

Example 2: Deep Shadows

Much of the detail in Figure 5-47 is lost in the deep shadows.

Before trying RawShooter, we spent a lot of time achieving the correct tonality for this image (both in the RAW converter and later by masking in Photoshop). Using RS, it took us about 30 seconds (really!) to make the adjustments shown in Figure 5-48 and get the results shown in Figure 5-49.

FIGURE 5-44: Dull overcast shot (Canon 1D Mk. II)

FIGURE 5-42: The adaptive exposure and tonality controls in RawShooter

Exposure compensation	0.30
Fill Light	27
Shadow contrast	30
Highlight contrast	-33

FIGURE 5-45: The tonality adjustments we made to brighten the picture

FIGURE 5-47: Typical shot with deep shadows (Canon 1DS Mk. II)

FIGURE 5-49: The resulting image after adjusting the shadows

Exposure compensation	0.26
Fill Light	25
Shadow contrast	34
Highlight contrast	-22

FIGURE 5-48: The tonality adjustments we made to open up the shadows

FIGURE 5-50: Overexposed Canon 1D
Mk. 11 shot

FIGURE 5-51 The tonality adjustments we
made to reduce overexposure

FIGURE 5-52: The resulting image
after correcting the exposure

Example 3: An Overexposed Shot

The shot in Figure 5-50 is overexposed and looks washed-out.

In Figure 5-51, you can see that we reduced the exposure slightly and the highlight contrast significantly. The corrected photo (Figure 5-52) shows why we wanted to take the photo in the first place.

SATURATION AND HUE

FIGURE 5-53: Saturation and Hue sliders

The Saturation and Hue sliders (Figure 5-53) let you perform minor tweaking. We usually set both sliders to zero.

SHARPNESS AND DETAIL

FIGURE 5-54: Sharpness and Detail sliders

RawShooter achieves a very natural sharpness. Both top-of-the-line debayering (demosaicing) and normal sharpening are utilized. Figure 5-54 shows the slider controls. [⚡]

Sharpening: This slider is normally left at 0, which means RawShooter's default level of sharpening (rather than no sharpening at all) is applied. This default level delivers a very natural sharpness with few sharpening artifacts. We accept this default and do any final minor sharpening in Photoshop using either USM (unsharp masking) or EasyS.

Detail Extraction: This slider allows the user to set RawShooter's bias or threshold for fine detail or noise. The higher you set this value, the more fine noise will be left undetected and vice versa.

Sharpening Comparison

The next three figures show how RawShooter's sharpening compares to Capture One (previously our favorite program for detail rendering). Figure 5-55 shows the full image sized for the page. Figure 5-56 shows a detail magnified to 100 percent of actual size and sharpened with Capture One and then with EasyS in Photoshop. Figure 5-57 shows the same 100 percent detail sharpened by RawShooter with a very light application of EasyS.

RawShooter's default sharpening is amazing. Images seem to be more three-dimensional and have a more natural look.

NOISE REDUCTION

Simply removing noise is easy; removing noise **and** keeping detail is the real challenge. Removing noise in nearly real time is even more difficult.

We have not used RawShooter enough to fully evaluate this tool, particularly because we do not take many high ISO shots. Still, RS may

be the first RAW converter that is good enough for most of our photos without using third-party noise removal tools.

The developers invested a lot of work into noise removal because their tonality controls allow you to brighten shadows quite a lot. When you do that, you also pull out noise, which is found primarily in the shadows. Opening up shadows usually means that you need effective noise removal. The two sliders shown in Figure 5-58 deal with the two most common types of noise:

- Luminance noise (detail noise). Easy to see and remove on single colored surfaces, but otherwise often blends in like fake details.
- Color noise (shown as off color pixels).

BATCH PROCESSING

When all of the parameters are set, you can add an image to the batch queue. Processing is done in the background while you work on the next image. Whether you convert images individually or use batch processing depends both on your style of post-processing and on the number and kind of changes required.

At any time you can view the batch queue and add, stop, or remove batch jobs. Figure 5-59 shows the batch queue and controls.

5.5: Advanced Image Corrections

Although RawShooter is still a new application, it already has some advanced image corrections features.

Noise (Luminance and Color Noise): Noise suppression in RS works quite well. You may not need specialized noise removal tools.

Sharpening: For optimal sharpening, we apply some sharpening in RS and then use other

FIGURE 5-55: The Full Canon 1DS image, shot with a 70–200 mm f/2.8 lens, tripod, and mirror lockup

FIGURE 5-56: A detail at 100 percent magnification with Capture One and strong EasyS sharpening

FIGURE 5-57: A detail at 100 percent magnification with RawShooter and very light EasyS sharpening

FIGURE 5-58: The noise reduction controls in RawShooterning

FIGURE 5-59: RS image batch queue

tools in Photoshop (Smart Sharpen or EasyS Sharpening Toolkit) to sharpen further.

═══

5.6: Extra Workflow Support

═══

Finally, let's recap the most important features that RawShooter provides for workflow support:

Batch Conversion: You can convert any selection of images at any time in the background.

Background Processing: RawShooter processes all conversions in the background. This is very convenient when you're working on a large number of images. However, it slows down your foreground processing a bit.

Apply Settings from One File to Other Files: This can be done easily. (See Chapter 10 for more information.)

Snapshots for Different Conversion Settings: Snapshots are very powerful elements of RS. You can save the current settings by creating a new snapshot. Snapshots are permanently stored with your settings.

Save/Restore Settings: You can save your current settings, load them again, and reset to RS defaults.

Camera Default Settings: RS allows you to define default correction settings (it calls them **bias parameters**) for each camera model you use. Figure 5-60 shows the bias parameters you can set.

Undo/Redo: Snapshots allow you to go to and from current settings to previous settings.

Keyboard Shortcuts: For crucial and often-performed operations, keyboard shortcuts can save a lot of time. All of the shortcuts we discussed are important. Check your manual for others.

Support for the Scroll Wheel: Click in any numeric field and use the scroll wheel on your mouse for fine-tuning.

FIGURE 5-60: The processing bias parameters you can apply to a given camera model

RGB Value Samplers: RS has a color sampler you can set to show the RGB values of the indicated pixel while you're editing an image.

═══

5.7: RSP — RawShooter Premium

═══

RawShooter Essentials (RSE) by Pixmantec is a free version of RawShooter. RawShooter Premium (RSP), however, costs about $100 USD. Is it worth the money? [✿]

Figure 5-61 shows the basic RSP window. At first glance it's not that different from RSE. On closer inspection, however, you will find several new and useful additions. We'll discuss these in the context of the typical photographer's workflow.

IMPORTING AND INSPECTION

We begin by importing new shots from a camera or flash card. For that purpose, RSP offers an integrated downloader.

Next we rank and prioritize our images. Here, RSP allows us to compare up to

four images side by side. This helps find the images that we will spend our time optimizing.

Other additions include the RGB readout (sticking close to the eyedropper) and a loupe. You activate the readout and loupe from a pop-up menu (shown at right) reached via the right mouse button. In addition, when your preview is larger than the preview window, you navigate using the navigator icon (shown at the lower-right side of Figure 5-61).

RSP's other tools for image inspection are essentially the same as RSE's.

Image Corrections

Image correction and optimization is the usual next step. RSP adds two additional tools here: one for straightening and one for cropping . It allows free-form cropping as well as cropping within a ratio that you define.

The Correct tab shows some new tools, including three more subtabs: Detail/Noise, Curve/Levels, and Color.

FIGURE 5-61: Basic RSP window with the folder browser open

FIGURE 5-62: RSP's Detail/Noise tab

FIGURE 5-63: RSP's Curve/Levels tool

Detail/Noise

New with Detail/Noise is hot pixel/pattern noise suppression (see Figure 5-62). Pattern noise is exhibited by some compacts and budget DSLRS, but we usually leave this set at zero. (The tool performs some image smoothing as well.)

Curve/Levels

RSP's most important enhancement, as compared to RSE, is probably Curve/Levels (see Figure 5-63). These are actually two different tools in one panel. (When you use these tools, always try to check the effect on your image and in the histogram.)

Unlike similar tools in Photoshop and other Curve/Levels tools, these tools only work in RGB mode and not on the different channels. We have not found this to be a problem because we correct colors via WB and the RSP color tools. [⚡]

Levels

The three triangles shown toward the bottom of Figure 5-63 are sliders. They function as follows:

- **Black Point slider:** Use to correct the darkness of the darkest pixels. For example, in Figure 5-63 the black point is set to 10. This means that all pixels with a value of 10 or lower will be set to 0 (zero), and all brighter pixels will be darkened

proportionally. If your original image has pixels below 10, you will clip that data to black, which can sometimes make sense in the shadows.

- **White Point slider:** With this slider you correct the brightness of the lightest pixels. For example, in Figure 5-63, the white point is set to 251. This means that all pixels with a value of 251 or higher will be set to 255 and all darker pixels will be darkened proportionally. If your original image has pixels higher than 251, you will clip data. (This makes sense only if your image has very small specular highlights. Be very careful not to blow out the highlights.)

- **Gamma/Brightness slider:** Use this slider to brighten or darken your image. Values below 1.0 brighten the image and higher values darken it. (This is the opposite of Photoshop.) [❀]

USING LEVELS

Use the following guidelines with your images to try to find the level settings that will produce your idea of what your image should look like.

First, set the black and white points. Set the black point so that shadows aren't blocked dark but enough black depth is left in the image. Use the white point to ensure that highlights are

FIGURE 5-64: RSP's Color tab

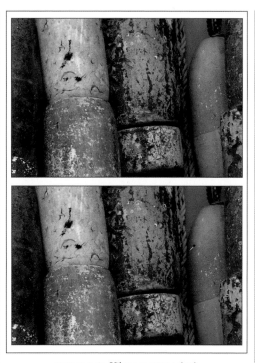

FIGURE 5-65: Vibrance set to 0 (top);
Vibrance set to +5 (bottom)

bright enough but at the same time not blown out (the highlight should still maintain some structure). Finally, optimize brightness with the (gray) gamma slider.

Color Tab

The Color tab (Figure 5-64) allows you to perform minor saturation and hue tweaking. (We usually set both sliders to 0.) The new Vibrance slider offers an interesting way to enhance the saturation in your images. Color Balance allows you to remove global color casts.

You should always get the contrast right before even thinking of changing the saturation or vibrance. [⚡]

Example of Vibrance Usage

We photograph a lot in overcast conditions because harsh sunlight creates such high contrast that most images would get lost. An ultralight overcast would be ideal as the perfect "soft box," but this is rarely the case in our area.

The downside to photographing in overcast light is that it makes colors appear dull. Here, a very moderate positive Vibrance can make a difference, as shown in Figure 5-65.

Some photographers will love this tool, and some may not like it at all. Give it a try, use modest settings, and be sure to experiment with negative settings as well. [❀]

FIGURE 5-66: RSP's Batch tab

NOTE:
You will most likely find that you often need Photoshop to perform selective (masking of a limited color range) color corrections.

NOTE:
Sharpening and noise removal are best done using a magnification of 100 percent or more. This is why the sliders are grayed out at lower values (though still fully effective).

Create FastProofs... [×]

Size and format

Max width	Max height	Unit	DPI	File format
512	512	Pixel ▼	72	JPEG ▼

RGB working space Meta data Quality

sRGB IEC61966-2.1 ▼ EXIF ▼ High ▼

☑ Embed profile ☐ Extract JPEG Prepend filename

☑ Apply sharpening FP_

Output location

◉ Save proofs in subfolder along side the RAW file(s)

Subfolder name Proofs

○ Different location Choose folder...

☑ When finished open folder in Explorer [Create] [Cancel]

FIGURE 5-67: Setup for RSP's FastProof function

Rename selected images [×]

Renaming mask YM$D_$O_$C

Custom counter 3

ⓘ **Variable substitutes**

$O : Original name, $Y ($nY) : Year, $M : Month, $D : Date
$N ($nN) : File number, $C ($nC) : Custom counter
(n : digit)

Old name	
DSC_0563.NEF	
DSC_0568.NEF	20050118_DSC_0568_0001.NEF
Zu hell.CR2	20050711_Zu hell_0005.CR2

Total files 3 [Rename] [Cancel]

FIGURE 5-68: Batch-renaming dialog of RSP

BATCH PROCESSING

RSP's batch processing features (shown in Figure 5-66) are similar to those in RSE. In our experience, RSE's basic batch processing is good and one of the fastest we know of. Unlike RSE, when batch processing in RSP, you can scale your image.

FASTPROOFS

You will sometimes need to produce proof sheets from your RAW files quickly. FastProof is the tool of choice here, allowing you to generate JPEG or TIFF files from all selected RAW images.

To use this tool, select the images you want to proof and click to bring up the FastProofs dialog shown in Figure 5-67. Here, you may define the image size, image file format (JPEG/TIFF), DPI, color working space, whether sharpening should be applied, whether a prefix should be added to the filenames, and a destination folder. These options are very similar to the ones you may set for your batch queue conversion.

The conversion is performed using RSP's default parameters (snapshots and current settings are ignored). RSP may be used to open the destination folder for image inspection when the conversion is finished. (Windows Explorer is used to display the folder.)

FastProofing offers a very quick way to perform batch conversion. You may use the images generated as pictures for a web presentation, for mailing, or for a fast inspection. (The slideshow function may be better suited for fast inspection because it allows you to rotate, flag, prioritize, and mark images for deletion in the slideshow. Too, a slideshow will present images using current image settings.)

Batch Renaming

When a batch operation is performed, simple file renaming is often required. Renaming can be done with one of many renaming utilities (such as Rname-it or Downloader Pro), or when using RSP, you

may rename your raw files when you import them with the Downloader. You can also rename your files by selecting the file you want to rename and clicking to bring up the dialog box shown in Figure 5-68.

You can also use a variable as part of your filename. If you set the cursor in the Name field, RSP will display the scheme for the variables, which is the same as the renaming function on image import.

5.8: Conclusion

As of this writing, RSP has been out now for about three months, and we have worked with it a lot. It's not the only RAW converter we use, but it became our 'Reference RAW converter,' the converter we compare other converters with. It's one of the fastest converters around – without sacrificing image quality. It's really a pity there is no Mac version of RSP (to some extent, RAW Developer may be a Mac counterpart). The part of the total photographers' workflow it covers, it does well. We use it in conjunction with Photoshop and Extensis Portfolio for the asset management part, and the interactions work reasonably for these three applications.

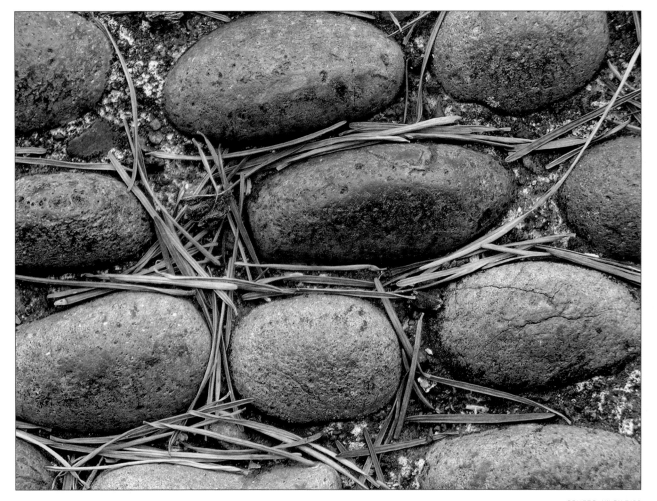

CAMERA: NIKON D100

Here we take a preliminary look at Apple's Aperture, the newest RAW converter covered in this book. Aperture is special because it looks at typical tasks (these days called **workflow)**, including how a photographer handles digital images and the integration of different tools needed for the digital workflow.

════

6.1: Aperture Is an Integrated Application

════

Unlike other applications, which require you to use separate applications (such as Photoshop in conjunction with Camera Raw and Bridge), Aperture combines these features in one integrated application, in a way that reflects how a photographer typically works. It combines the features of an image downloader, a RAW con-

verter, an image editor, a light table, a printing application, and an asset management system. Its asset management system includes image browsing, administration, retrieval, and backup.

Aperture is demanding of your hardware; it requires a fast G4 or G5 processor and at least 1GB of main memory (2GB is recommended, as with Photoshop). Because Aperture makes heavy use of your graphics card processor, you must have one of the newer graphic cards (see www.apple.com/support/aperture) in order for Aperture to run. Use Aperture's Compatiblity Checker (www.apple.com/aperture/binary/Aperture_checker.dmm to verify that your system is Aperture compatible.) A high-resolution monitor is highly recommended, and two monitors are even better.

As with most Apple applications, Aperture's graphical user interface (GUI) is well designed, intuitive, and innovative (see Figure 6-1). Still, you will find that it will take some time to learn

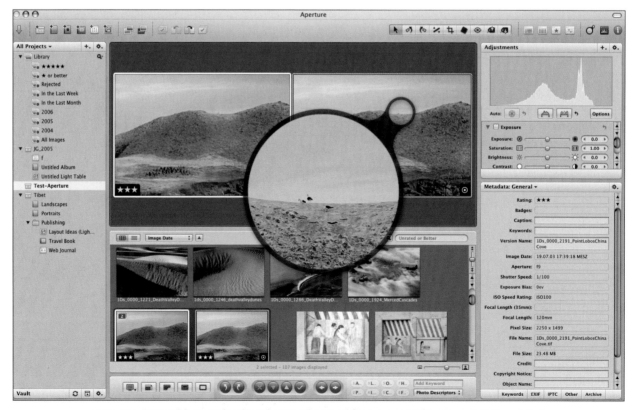

FIGURE 6-1: Aperture's basic window shows the project browser *(left)*, image icons in filmstrip mode *(bottom window)*, two images side by side for comparison *(top windows)*, the loupe for close detail inspection and adjustment, and metadata GUDS *(right)*.

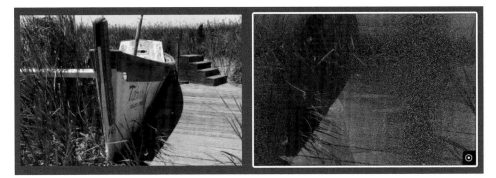

FIGURE 6-2: RGB image *(left)* and display of image *(right)* when converted to CMYK in Photoshop

to efficiently handle Aperture because of its many functions and features.

Although Aperture's hardware requirements are demanding, it does some things surprisingly quickly, such as file browsing, though we must be cautious in our remarks here because our systems are very fast (a Quad G5 with 4.5GB of memory).

6.2: Supported File Formats

Aperture supports JPEG, JPEG200, TIFF (with some restrictions concerning layers and alpha channels), PSD, GIF, PNG, and RAW files. Its spectrum of support for RAW formats is somewhat restricted, but it can handle all RAW images that iPhoto and Apple's Preview can handle. (RAW format decoding is actually done inside Mac OS X.) As such, in order to support more formats, Apple will have to provide a Mac OS X update.

Aperture only supports DNG images produced by cameras whose native RAW format is also supported, and, as of version 1.01, Aperture cannot properly handle CMYK files. You may import CMYK files, but as soon as you modify them in Aperture, they are converted to RGB. For example, we launched Photoshop from Aperture with an RGB image and converted it to CMYK in Photoshop. As you can see in Figure 6-2, the saved image in Aperture (or at least the preview) was totally off!

If you require a CMYK image, you must perform the conversion outside Aperture. Too, images

in Lab mode will show up as "Unsupported Image Format". We hope that both issues will be resolved soon. At the very least, Aperture should provide a preview of those files.

6.3: New Concepts

With Aperture, Apple has introduced a few new and welcome container types designed to help you to organize your photos. These include **projects**, **folders** (which differ from operating system folders), **albums**, **stacks**, and **vaults**, as well as **libraries**, **master files**, and **versions**.

Projects: A **project** is the basic container for images. You must import a photo into a project before you can use it with Aperture. You may import (download) images directly from a digital camera, a card reader, a normal folder, or an iPhoto library. The imported files are considered **master files**; they will be left as unmodified originals until you delete them.

When you modify an image using Aperture controls or filters, the modifications are stored as a **modification set**. Modification sets are usually very small (about 4 to 15K) when compared to a master file. The result is a new **version** of the file, which links to the master file and modification set.

When you pass an image to an external application for editing (such as

Photoshop), Aperture passes on a copy of your master as TIFF or PSD. The resulting saved image is stored as both a new master and a new version.

Folders: You may use a **folder** to further structure the content of your projects. A folder may contain images from other projects and other subfolders. (Use ⌘-⇧-N to create a new folder.)

Albums: You use **albums** to group a collection of image versions for presentation. There are three types of albums: **normal** (static) (top icon), **smart** (middle icon), and **light table** (bottom icon). Normal albums are ones that you organize by hand; smart albums result from specific search criteria; and light table albums allow you to place your pictures on a virtual light table. This scrollable light table may be larger than your screen, and you may freely resize and stack images on it.

Library: All projects, folders, albums, and so on are kept in a **library**. The library is the database and container for Aperture objects; it is essentially the Aperture universe. When viewed from the Mac OS Finder, an Aperture library is a huge file (it's actually a **package**).

Individual objects (images, folders, albums, and so on) are only easily accessible via Aperture. You must export these objects if you wish to make them accessible to the Finder or other applications (although there is a way around this, as we'll explain a bit later). ❀

NOTE:
If your Aperture library becomes corrupted (e.g., it is out of sync), rebuild it by pressing ⌥-⌘ when starting Aperture.

Vaults: A **vault** is a copy of an Aperture library that is used for backup. You may have several vaults, and Aperture can update and synchronize them with the original library (for example, if any have been offline previously). Vaults must reside on a disc (or other kind of random access memory). You can burn vaults from their media to DVD, but only outside of Aperture. You can also restore a library from a vault.

Stacks: A **stack** is usually a collection of similar photos and may be used to stack several photos of the same scene or person from a shooting. While you will probably use only the best image from a stack, it may be helpful when inspecting all images from a shoot to heap the images into one stack (see Figure 6-3). (You may add images and extract images from a stack.)

You may select one of the images in your stack as the top one (called the **pick**). When you do, the icon of this **pick** is used as the top icon of the stack when the stack is **closed**.

Stacks have an internal order. When unfolded or opened, their images are

FIGURE 6-3: An open stack. When you close a stack, only the leftmost icon (shown above) is visible, with a number indicating that the stack has four images.

placed from left to right according to the top-to-bottom order. You may **demote** and **promote** images in a stack order using buttons or keyboard shortcuts. [⚡]

When you import photos, Aperture offers an Auto-Stack feature (shown above), which stacks photos based on their time-stamp or exposure settings, which are derived from EXIF data. You may define the maximum time gap. (Open the Auto-Stack HUD using ⌥-⌘-A.)

Nondestructive editing: Recall that Aperture saves master files and stores all modifications as versions. As a result, you may end up with several versions of an image (or master file). While this feature is not new to RAW converters (RawShooter offers snapshots, which perform a similar function), Apple extends this feature to JPEGs and TIFFs as well as RAW files.

Nondestructive editing is primarily intended for use with files imported from your digital camera or scanner, but it may be used for other files as well.

Aperture's nondestructive editing feature does place some restrictions on image editing. For example, there are no layers and there are very few selective corrections. Therefore, you may choose to edit a copy of your images within a tool like Photoshop and then bring the modified image back into Aperture to be handled as a new version.

6.4: Aperture Setup

Once you have installed Aperture, call up the Preferences dialog (shown in Figure 6-4), and tell Aperture where to save your library. (The default is inside the Pictures folder of your home directory.) Because all imported files are copied into this library, save it on a hard disk with plenty of free space. (You will have to restart Aperture to make this change effective.)

While in Preferences, choose the external editor that you want to use for picture editing (Photoshop, for example) and the file format (TIFF or PSD) that Aperture will use to pass images to this editor. You can also use the Preferences dialog to select an email program for Aperture to use for sending email, as well as the format that images will be converted to before they are attached to email.

Use the Export Presets dialog (see Figure 6-5) to configure your presets for Image Export (**Aperture** > **Presets**) and define the naming scheme to use for exported files in the Naming Presets dialog (see Figure 6-6).

—[⚡]—

NOTE:
If you have several versions of an image, each version forms a stack. By default, the latest image becomes the pick of the stack.

FIGURE 6-4: Select the location of your library, and choose your external editor in the Preferences dialog box.

Export Presets

Export Preset Name
JPEG – Original Size
JPEG – 50% of Original Size
JPEG – Fit within 1024 x 1024
JPEG – Fit within 640 x 640
TIFF – Original Size (8-bit)
TIFF – Original Size (16-bit)
TIFF – 50% of Original Size
TIFF – Fit within 1024 x 1024
PNG – Original Size
PNG – 50% of Original Size
PNG – Fit within 1024 x 1024
PNG – Fit within 640 x 640
PSD – Original Size (16-bit)
PSD – 50% of Original Size (16-bit)
Email Small – JPEG
Email Medium – JPEG
Email Original Size – JPEG

Image Format: TIFF–16
☑ Include Metadata

Image Quality: ──────○─ 10

Size To: Percent of Original
50.0%

Gamma Adjust: ○───────── 1.00
ColorSync Profile: sRGB Profile
☐ Black Point Compensation

☐ Show Watermark
Position: Top Left
Opacity: ─────────○── 0.5
Image: Choose...

Cancel OK

FIGURE 6-5: Define your list of export formats for images.

Naming Presets

Name
Custom Name with Index
Version Name
Version Name and Date/Time
Version Name with Sequence
Version Name with Index
Image Date/Time
Custom Name with Counter

Example: [FileName]_1 of 5_[Name] 1

Format: Master File Name Sequence # Version Name Counter
Enter text above & select elements below to customize format

Include: ☑ Version Name ☐ Date
☑ Master File Name ☐ Time
☑ Sequence Number ☐ Index Number
☐ Custom Name:
☑ Incrementing counter starting at: 0
of digits: 2

Cancel OK

FIGURE 6-6: Preset for naming files

6.5: Importing and Sorting Your Images

It may take awhile for Aperture to import your images. During the import, Aperture will show the status with a small rotating clock, as shown above. Once the import is finished, Aperture will show the Import Complete message, shown below:

Import Complete
28 images have been imported into the project named 'Test-Aperture'

OK

Before deleting your photos from your camera or memory, consider creating a **vault** on an external disk as a backup, just in case.

Next, inspect your newly imported images (using stacks to make room in your filmstrip window); then assign priorities (from 1 to 5 stars plus **Reject**) to your images, and begin to sort out those images that are not good enough to keep. (Most RAW converters, such as Bridge/ACR, Capture One, and RawShooter, offer similar features.)

You will see buttons that allow you to increase and decrease your ratings of individual images. You may also add keywords and other metadata to one or several images using a simple batch and classify images (to make it easier to sort them later) by attaching terms like **people**, **wedding**, and so on (you can edit the existing terms or add new ones). You can also lift metadata from one image using the Lift tool (top left icon) and then **stamp** it onto other images using the Stamp tool (bottom left icon).

EDITING AND ADJUSTING IMAGES

Use the **loupe** (a flexible magnification glass) to optimize individual images. Unlike most other RAW converters, Aperture allows you to view several images side by side. 🌸

Aperture offers most of the same controls and operations as other RAW converters. You will find *White Balance* (color *Temperature* and *Tint*), *Exposure* compensation, *Saturation*, *Brightness*, *Contrast*, *Levels*, and the ability to set the *Black*, *White*, and *Gray* points. There is no Curves tool, however!

The histogram (Figure 6-7) displays either luminance or color channels, which you can select from the Adjustments Action pop-up menu.

To activate warnings for highlight clippings press ⌥-⌘-H.

An RGB readout, showing the RGB values below the eyedropper, is missing.

As with most modern RAW converters, you will find tools for noise reduction and sharpening (see Figure 6-8). Both tools provide basic functionality but lag behind today's more advanced filters: there is no threshold slider in the sharpening filter, and you may not perform noise reduction on individual color channels.

You will find a **Highlights & Shadows** tool, but you won't be able to use Aperture to correct for chromatic aberrations, vignetting, and lens distortions.

Aperture's Adjustment panel (shown in Figure 6-8) provides a **Cropping** and a **Straighten** tool. It even allows **red-eye removal** and offers a **Spot** and **Patch Tool**, two tools for working with RAW files that are not yet found in many other RAW converters. While these tools are not as sophisticated as those in Photoshop, they may be applied to other images as well using the Lift and Stamp tool.

FIGURE 6-7: The Adjustments window

FIGURE 6-8: More adjustment controls

The Adjustment panel also contains Monochrome Mixer (similar to Photoshop's **Channel Mixer**), which provides several color filters in its drop-down menu. There is an additional control for sepia toning, but beware that using it will *not* produce a dual-tone image (black and white plus a spot color); it will instead produce an RGB image with a sepia component that is a mix of RGB!

To keep the Adjustments panel out of the way, Aperture uses HUDS (**Heads-Up Displays**), which you may show or activate (via the drop-down list) or hide or deactivate. Most offer adjustment sliders as part of the **Adjustment HUD**.

Recall that the Lift tool lets you "lift" settings from one image and apply them (stamp them) to other images. If you have performed several corrections, however, you can only lift all corrections, not individual ones. There is an Undo operation for most corrections and modifications.

Most operations may be undone by clicking the icon to the left or redone by choosing Redo. This allows you to easily switch between before and after views.

WORKSPACE ADAPTION

The Aperture workspace is very flexible, with five basic modes as shown above. They are, from left to right, as follows:

- **Viewer Mode:** Offers a pull-down menu with several variations.
- **Zoom Viewer**

- **Show Master Image**
- **Full Screen** (shown in Figure 6-9)
- **Toggle Primary Only**

You may hide or display single parts of the basic window and, as with Bridge and most modern RAW browsers, you can control the size of your preview icons.

Use the viewer icons (shown above) to quikkly switch between views that are optimized for (icons from left to right): A fast first inspection, icon view, rating, and adjustments.

You can select images to create a Web Gallery, a Web Journal, or a Slideshow, or call up Mail and attach selected (scaled-down and converted to JPEG) images. (A **web journal** is a kind of web gallery that offers more flexible, free-form placement of images and additional text blocks.) The web gallery, web journal, and slideshow offer more options than you would expect from the first version of a software package.

You may also order prints (Apple has affiliations with some photo services) or produce a book (which will also be printed by a service provider). For both of these, you will need an Apple account.

6.6: Structuring Your Images

Projects are not the only way to structure your image sets. You can also use folders and albums, both of which may have elements from several projects. (For example, an album might hold all of the best shots taken in a particular year, all of a customer's images, or just the final selection for a presentation.) You can also use Folders for special collections.

When you duplicate a master, edit an image using Photoshop or another editor, or open or

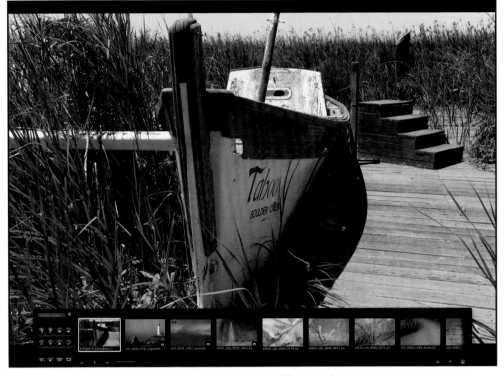

FIGURE 6-9: Aperture in Full Screen mode

close a stack, you normally do so from the icon list (or filmstrip). [⚡]

When using Aperture, corrections cannot be performed on individual channels or colors; they must be performed on the whole picture. While this has been the standard for RAW converters, it places a severe restriction on general image editing. Therefore, when using Aperture, you will probably still have to use another image editor in many cases.

6.7: Printing Images

Aperture offers most of the settings that one would consider important for printing, as shown in Figure 6-10. For example, you can select the correct profile for printer, ink, paper, and driver settings, with color management handled by ColorSync. You can print one image or several as a contact sheet. However, when printing several

images to a page, you cannot place or size individual images.

Onscreen Proofing will show you the colors that an image will have when it is printed on a particular output device. (You should choose your output device/printer profile before you activate Onscreen Proofing.)

6.8: Exporting Images

You will need to export your images from Aperture if you need CMYK images, if you need images in unsupported formats (like Lab mode), if you want to use your images in a DTP file, or, if you need to preserve critical layers produced outside of Aperture, (see Figure 6-11).

To export images, select one image, several images, or even a whole project, and then right-click to select Output and then either Export Version or Export Master.

—{⚡}—

NOTE:
With some images, most notably TIFFs *with deactivated alpha channels, we noticed a severe color difference between the icon in the filmstrip and the image preview in the adjustment window; the latter was sometimes much too dark. When these images were opened in Photoshop, the copy passed to Photoshop was too dark as well. (Aperture is not recognizing that the alpha channel has been deactivated).*

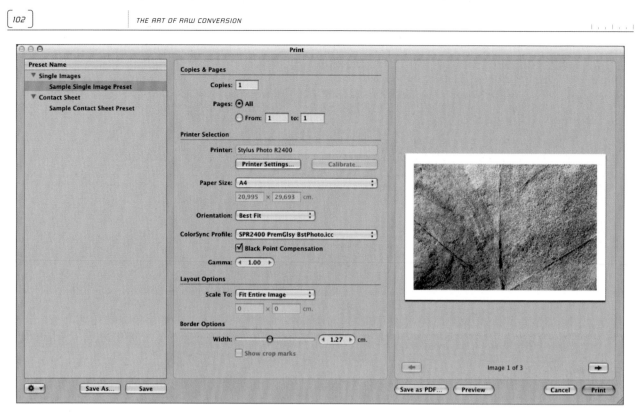

FIGURE 6-10: Aperture's Print dialog

FIGURE 6-11: There are several output methods

When exporting a version, you may choose from several file formats that have been previously defined in Aperture Preset, or you can define a new export preset using Edit (see Figure 6-12). Aperture will render the image in the chosen format.

When rendering is performed on a RAW master file, the color spaces defined in **Aperture > Presets > Image Export** (see Figure 6-5) is used as the destination color space. (Version 1 of Aperture stripped all EXIF metadata from the file, though Include Metadata was activated in the preset for Image Export. This was corrected by an Aperture update.)

When you export as master, the master is exported as is (with no format conversion); the only option you can determine is the name of the exported file.

FIGURE 6-12: Dialog for image version export

6.9: Searching

Like most digital asset management systems, Aperture offers image retrieval and searching. Its search function is similar to that of Adobe Bridge.

Figure 6-13 shows Find HUD (called up by ⌘-F). As you can see, you can combine several search criteria by using AND (select Any) or OR (select All in the Match drop-down menu). A rich selection of additional criteria, as shown in the figure, helps you refine your search.

Images matching the search criteria may automatically be placed into a new container. If you choose New Smart Album (see Figure 6-14), you are saving a set of search criteria, and the contents of the album will change when more images meet the search criteria. As you enter your search criteria, the number of icons shown in the filmstrip is reduced as your criteria are matched. �

NOTE:

When you close Find HUD, the view is frozen. This may lead to confusion when you no longer see the restricting criteria and only see some of your total project (or album or other) images. When you can't see any (or you see only a few) icons in your filmstrip, you may have to call up the Find dialog and reset the search criteria.

FIGURE 6-13: Aperture's Find HUD allows you to combine several search criteria using either All (AND) or Any (OR).

FIGURE 6-14: Aperture's New Smart Album

6.10: Conclusion

Aperture is a brand-new product, so we still have plenty of investigating to do. But to the extent that we've mastered the application, our conclusions follow.

First, you may have noticed that we haven't commented on the overall quality of Aperture's RAW conversion. We simply didn't convert enough RAW images with Aperture to make a meaningful assessment. We can say, however, that every maker of a RAW converter, image browser, asset management system, or image editor for photography should take a very close look at Aperture.

Aperture is resource hungry and has some severe deficiencies: It is slow when applying several corrections or filters to RAW conversions or when stamping lifted metadata or settings to several images. Also, noise in dark areas of RAW images seems to be much stronger than with Adobe Camera Raw, RawShooter, and Capture One.

Aperture will not replace Photoshop in the near future, and it will definitely take Apple some time to rectify all of its shortcomings. Too, some of Apple's design decisions may not have been the best ones (e.g., embedding basic RAW conversion into the operating system, though Microsoft may do this soon, as well).

Aperture's closed environment is a problem. When beginning to use it, we wanted to bring all of our images into it. Unfortunately, older RAW images can't be imported because their format is not supported, and Aperture won't adequately handle our CMYK or Lab mode images. Also, when an image workspace outgrows a single hard disk, one must trick Aperture into handling this because its library is one large file. The same is true for backup vaults: As of version 1.01, Aperture could not handle offline media. You cannot offload the images in a project to offline media, delete the images, and still keep the preview icons and metadata in your Aperture database.

We may be asking too much from the first version of Aperture, but Apple is entering a maturing market with much competition. Apple has been able to integrate many features into one application, but it really should quickly improve several functions and open the Aperture universe to other applications and parties. A plug-in architecture might help increase productivity using third-party filters and other plug-ins, while Apple spends more time improving its critical tools.

Aperture does have a scripting interface, and as of this writing there were already some Automator scripts for it. For example, Hot Folder (www.automator.us/aperture) imports an image into an Aperture project as soon as you drop an image into it. This scripting interface is used by some other applications as well, such as Annoture (www.tow.com/annoture), which allows the transfer of metadata from iView Media Pro (a digital asset management system) to Aperture projects and vice versa.

Aperture has many very nice features, including the loupe, which can be used on both the preview image and the icons. We like the ability it gives you to structure your photos using projects, folders, and albums. We also like the light table albums, the clear and appealing GUI, the many keyboard shortcuts, and much more.

CAMERA: CANON 1DS MK. II

Because the previous two chapters dug deeply into the details of Adobe Camera Raw and RawShooter, you already have a good idea of how RAW converters work. For the programs we'll cover in this chapter (Phase One's Capture One, Eric Hyman's Bibble, Canon Digital Photo Professional, and Nikon Capture), we will shorten our descriptions and focus on their main features and some of their specialties. This does not mean we consider them to be less valuable. Of course, our coverage of these tools is not meant to replace their manuals.

═══

7.1: Phase One's Capture One Pro

═══

Capture One Pro by Phase One has been available for some time, and it has a generally good reputation. The company is well known for its P-series of digital camera backs for medium-format cameras, such as the Contax or Hasselblad.

Capture One comes in different versions that support unique function levels and vary in price (Capture One Pro costs about $500). We use Capture One Pro, which is available for both Windows and Mac OS. [❀]

Capture One has three main features that make it a state-of-the-art RAW converter:

- Excellent image quality
- Great RAW converter workflow
- Good range of supported digital cameras

Figure 7-1 shows the Capture One interface.

Capture One is fully aware of color management, an essential quality for doing any serious color work. Capture One DSLR is a "full-service RAW converter." This means you can accomplish nearly all operations on your final image using this tool. (You can't, however, do any retouching, such as cloning or lens and perspective corrections). [⚡]

Capture One DSLR implements a highly productive workflow for the RAW files it supports. The best way to appreciate Capture One is by learning how it works.

─── [❀] ───

NOTE:
Some of the dialog boxes we illustrate here may differ in other versions, but those differences are inconsequential for the features used in our workflow.

─── [⚡] ───

NOTE:
Capture One RAW conversion is not based on the Canon or Nikon SDK. It uses its own algorithms developed for their high-end digital backs.

Figures 7-2 and 7-3 show the settings we use in the Preferences and Color Management Settings windows. The most important Preferences settings are listed here:

DSLR Noise Suppression: We set this at low or medium/low for lower ISO images.

Disable Sharpening on Output: With this box checked, Capture One simulates sharpening in the preview, but it does not apply sharpening to the output. We chose this because we do our sharpening later in Photoshop, but we still want a preview that appears sharp.

Automatically Open Developed Images: We disable this feature, which opens the image in Photoshop (the associated application for TIFFs), because the files will be visible in the Photoshop file browser.

Activate the Separate RGB Channels for a Histogram: You can activate this setting in the Preferences dialog box.

The important Color Management settings are listed here:

Camera Profile: Capture One offers generic profiles for supported cameras.

Working Space: We use Adobe RGB (1998) for both output and proofing. Note that you can also choose a working space for images destined for the Web.

Monitor Profile: Here you need to choose (selecting from the list of installed profiles) your correct monitor profile. (Capture One checks for a mismatch to the system monitor profile.)

CAPTURE ONE RAW FILE BROWSER

Once you've set your preferences, the first step in the conversion process is to select the images to work on. Figure 7-4 shows Capture One's file browser. At first glance, it appears to be a nice but typical image browser.

There are some major differences from other tools we've looked at, however:

FIGURE 7-1: Capture One DSLR

FIGURE 7-2: Preferences setup in Capture One DSLR

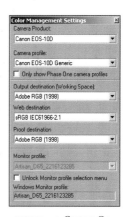

FIGURE 7-3: Capture One
color management setup

FIGURE 7-4: The Capture One image browser in Landscape mode

- Pressing F8 toggles the browser from Portrait to Landscape mode (allowing the maximum space for image preview).
- The Capture One browser does not use original RAW files for previews. Instead, Capture One creates its images in the background. Once these previews are created, you can switch from one file to another in almost real time. The downside of this approach is the large amount of disk space needed for the preview cache. (It can be cleaned using the Preferences dialog.) Capture One was the first RAW converter to use this technique. As of this writing, ACR, RS, and Bibble also use this approach.

- Capture One allows users to define permanent project folders. Doing so makes it easy to access all of your current project folders quickly. The preview images in these permanent folders remain even after you empty the cache.

IMAGE PROCESSING

Image processing in Capture One is a five-step workflow:

Inspect

The first thing you should do with an image is review its photo and capture information using the Capture tab, which is shown in Figure 7-5.

The Capture tab has two elements:

- The histogram (again, it's best to set this for three channels)
- The data recorded by the camera (e.g., ISO, Exposure Time and Aperture, Lens Used, and Flash) 🌸

Gray/White Balance (WB)

The main tool used for white balancing is the eyedropper. As in other converters, you select a gray area within the image and click the eyedropper. Capture One will warn you if the spot you've chosen is not the best reference point for gray correction.

If there is no neutral gray in the image, you can use the controls on the White Balance tab, as shown in Figure 7-6. These include Color Temperature and Tone Balance sliders, as well as color cast corrections.

As always, white balancing is much easier if have you have taken a shot of the scene with a gray card or ColorChecker (we have one with us at all times) using the same light. You can save and restore WB settings, which means you can also save sample settings for a given set of same-light conditions (if you shoot in known light, such as a studio).

Capture One also provides automatic correction. As with all automatic corrections, the results may not be optimal. Decide for yourself.

Exposure

The Exposure tool is the most important correction tool after the White Balance tool. Here, you can correct ±2.5 EV (exposure value).

The histogram and preview image (select the Exposure tab in the toolbar to display them) let you inspect all areas of over/underexposure. Especially important are the RGB channel histograms, because overexposure often occurs in only one channel. Besides EV, the Exposure tab (Figure 7-7) lets you correct contrast and tweak saturation. (Try to apply these in moderation.)

Tone Curves

In addition, Capture One includes a variety of tone curves, which you can also select from the Exposure tab. Figure 7-8 shows the drop-down list.

NOTE:
For no apparent reason, this feature has been removed in the most recent versions of Capture One. The newer versions show this information in a popup window when you select a thumbnail.

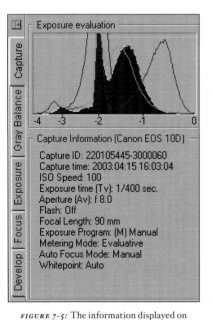

FIGURE 7-5: The information displayed on the Capture tab

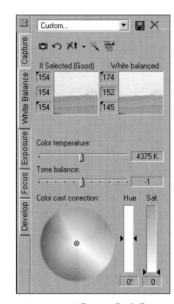

FIGURE 7-6: Capture One's Gray Balance tool

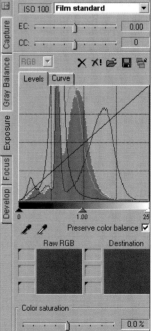

FIGURE 7-7: Capture One Exposure

For most situations, the standard tone curve Film Standard will do. When an image needs greater shadow detail, try using Film Extra Shadow. The Linear Response curve is used mainly for profiling purposes.

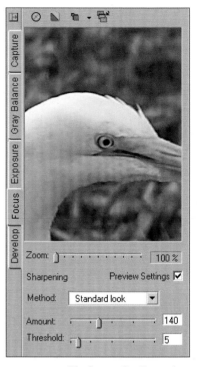

FIGURE 7-8: Capture One offers some predefined tone curves.

The more we use Capture One's Curves tool, the more useful we find it—especially for recovering some of the shadow detail. With most other RAW converters (except RS), we leave shadow recovery to Photoshop.

Focus and Sharpening

The Capture One sharpening tool (Figure 7-9) is a classic Unsharp Mask (USM). Refrain from over-sharpening your images. As mentioned earlier, we leave our own sharpening to do later in Photoshop.

FIGURE 7-9: The Capture One Focus tab

THE DEVELOP TAB

The Develop tab (Figure 7-10) lets you choose the usual output settings for an image (or a set of images), including the size and resolution, file format, and bit depth. When you click the **Develop** button (or the Insert key while you are viewing any tab), the RAW conversion is performed. Once again, Capture One demonstrates its focus on workflow. RAW processing is done in the background, and Capture One is free for further interactive image corrections.

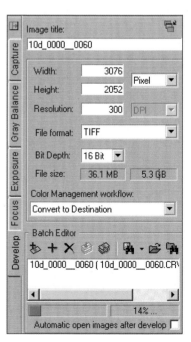

FIGURE 7-10: Capture One Develop tab

MORE CAPTURE ONE FEATURES

There is much more to Capture One than we've had space to cover here. In our personal workflow, we are quite pleased with the basic functionality as outlined. Downloading a trial version and studying the Capture One Help file are good ways to learn more about it. Here are two more important features:

- You can create custom camera profiles (or buy third-party profiles) and use them in Capture One.
- You can export preview images.

Because we use so many different cameras and RAW converters, when we use Capture One, we try to stick to the basics, which are:

- Get the white balance right.
- Optimize the exposure.

7.2: Bibble

Bibble, from Bibble Labs, is one of the most popular RAW converters. We have used different versions of Bibble for more than four years. The previous version, Bibble 3, wasn't updated for a long time; however, Eric Hyman has created a completely new version 4, and it was worth the wait. (Eric Hyman is Bibble's author, and Bibble is his cat's name.) Bibble 4 supports most digital SLRs available today, as well as some consumer digicams, and it runs on Windows, Mac OS, and Linux. Bibble's goal is to provide satisfactory image quality along with excellent workflow. Figure 7-11 shows the highly customizable interface as we use it, with thumbnails in Filmstrip mode.

FIGURE 7-11: The main window of Bibble 4 (Windows version)

BIBBLE SETUP

When you're setting up Bibble, you'll use the Preferences and Color Management windows.

Preferences

Figure 7-12 shows the General Preferences as we've set them. We recommend unchecking the **Fit to Screen** option. Doing so will speed up the workflow significantly.

A couple of items need to be set up in the Cache preferences. We recommend using a large cache folder (at least 1GB) to store lots of data.

FIGURE 7-12: Preferences setup in Bibble 4.*x*

FIGURE 7-13: Cache setup

FIGURE 7-14: Bibble Color Management setup

(See Figure 7-13.) For other settings, refer to the Help file.

Color Management

Bibble is fully color managed. You can add your own custom profiles and change settings on an image-by-image basis. Figure 7-14 shows the Color Management setup options.

A BIBBLE 4.*x* WORKFLOW

Bibble is highly customizable. For browsing within a folder, we suggest using a view setup like Figure 7-15. Hiding the folder tree gives you a larger image area.

Bibble 4 supports all of the tools you need to efficiently convert RAW files (it works on JPEGS, too).

- White Balance (WB)
- Picture Options (holds crucial parameters)
- Curves/Histogram
- Sharpen/Noise
- Color and Color Management

White Balance (WB)

There are two ways to correct white balance in Bibble:

- You can set the color temperature. To do so, you can use the **Temperature** slider (Figure 7-16 left) or select one of the presets from the pull-down menu (Figure 7-16 right).

- You can select a point that should be neutral gray using the eyedropper. This technique was demonstrated in Chapters 4 and 5 with Camera Raw and RawShooter. As we've said, the best way to use a one-click eyedropper is to take a shot with a ColorChecker or gray card and use that reference gray to correct other shots made in the same light.

Whichever method you choose, keep in mind that finding a pleasing white balance is inherently subjective.

FIGURE 7-16: *(left)* Set the Color Temperature using the sliders. *(right)* Set the Color Temperature using the Color Temperature presets.

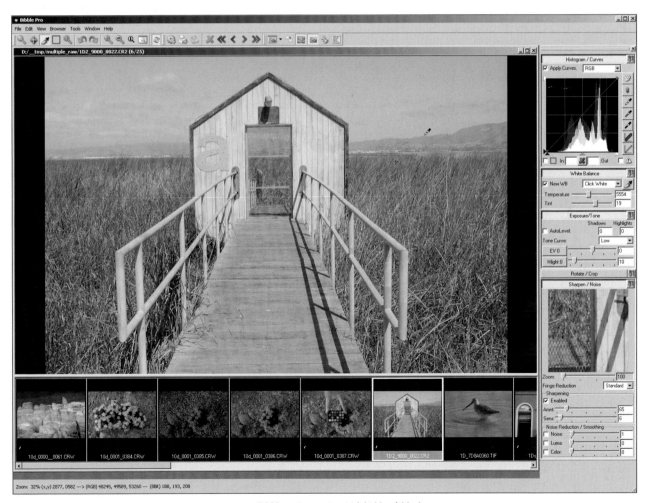

FIGURE 7-15: Bibble 4.*x* image view with hidden folder browser

PICTURE OPTIONS

Picture Options is a crucial dialog, and it has more controls than we have space to discuss here. The most important controls are listed here:

- Exposure (EV)
- Tone Curves
- Auto Levels
- Highlight Recovery (Hlight)

Exposure (EV): Figure 7-17 shows the Exposure/ Tone controls. When you're correcting exposure, make a habit of carefully watching the image and its histogram to avoid data clipping in the highlights and/or shadows. Check out the new Hlight feature, which allows you to recover some highlights.

FIGURE 7-17: Bibble's EV compensation controls

Tone Curves: Bibble 4's tone curve presets (Figure 7-18) are useful for adjusting contrast. The differences are subtle, but they can make a huge difference in tonality.

![Dropdown showing tone curve presets: Not so Low selected, with list Camera, Colorimetric, Really Lw, Low, Not so Low, Normal, Not so High, High]

FIGURE 7-18: Bibble's Predefined Tone curves

Auto Levels: Depending on the image, these corrections may be acceptable or too strong. We always leave highlight clipping at zero (you can define default settings for new images). Sometimes, Auto Levels delivers the snap that you desire.

Tone Curve Adjustment (RGB Tab)

Bibble 4 provides a powerful Curves tool with the option of a full RGB histogram. (See Figure 7-19.)

FIGURE 7-19: Curve adjustment

Color Adjustment (RGB Tab)

Be cautious when you're using the Hue slider (Figure 7-20). Using the Saturation slider might make more sense. We usually lower the saturation rather than making it stronger. As we explained in Chapter 3, you should consider a more selective saturation enhancement and do it in Photoshop.

![Color panel with sliders for Red, Green, Blue, Hue, Sat all set to 0]

FIGURE 7-20 Color rendering

Sharpening/Noise

As stated previously, we prefer to do sharpening in Photoshop using one of the many sharpening tools available there. Most often, we use Bibble's Sharpening tool (Figure 7-21) at the low level or turn it off entirely.

FIGURE 7-21: The Sharpen/Noise tool

Fringe Reduction is designed to lower fringes (mostly green or magenta) that occur at high-contrast edges. This helps reduce artifacts caused by chromatic aberration (CA). If your image displays fringes, you must use a high magnification to recognize them. Do your fringe reduction here.

Normally we keep Noise Reduction turned off or set to a very low level. If your image clearly requires further noise removal, use a dedicated tool, such as Noise Ninja in Photoshop. Photoshop CS2 ships with a new noise-reduction filter (see Chapter 9).

WORKFLOW STREAMLINING FEATURES

Bibble provides for a good workflow. Here are some elements that help with that:

- Fast thumbnail conversion
- Fast image preview
- Easy real-time image corrections
- Application of settings to other selected files
- Background rendering of images

Bibble 4 does a better-than-average job in all these areas.

Batch Queue is another handy feature of Bibble 4. Figure 7-22 shows our standard settings for running a conversion in the background and then launching the converted files into Photoshop. Note that you can maintain multiple queues for different purposes, launching them with different shortcut keys. We attached this queue to the letter *P*. When we press P, the image will be converted in the background, and the result will be opened in Photoshop. We attached another queue to *T*, which does the same conversion but does not open the file in Photoshop.

MORE BIBBLE FEATURES

There's a lot more to Bibble 4 than we can cover here. However, some of its other interesting features are listed here:

Work Queues: You can group files from different original folders into virtual groups and then work with them as though they belonged to the same folder. When working on a project, you can

FIGURE 7-22: Batch Queue settings

create different work queues and collect *keeper images* in these queues arranged by subject. You might, for example, have separate queues for:

- Landscape
- Wildflowers
- Wildlife/Birds

Print Queues: We have not used this feature yet, because we usually print from either Photoshop, Qimage, or Image Print.

7.3: Canon Digital Photo Professional (DPP)

Canon Digital Photo Professional (DPP for short) is a free tool that ships with the new Canon DSLRS: 1DS, 1D, 1D/1DS Mark 11, 20D, and 350D. It is also designed to support future Canon digital SLRS. DPP is Canon's answer to third-party tools that have a much better workflow than the previous Canon utility.

FIGURE 7-23: The Canon Digital Photo Professional interface

Its conversion quality is good, and its workflow is adequate. It runs under Windows and Mac OS. However, DPP is not quite as elegant to use as ACR, Capture One, RawShooter, or Bibble 4. Figure 7-23 shows the Canon DPP interface.

SETUP

As with other RAW converters, you need to do some initial setup in Preferences, both General and Color Management.

General Preferences

Figure 7-24 shows our selections on the General Settings tab. With DPP, Operating mode is one of the most important settings. Standard is the best compromise between working speed and output quality; it gives the same quality on output as Quality Priority.

Color Management Setup

Figure 7-25 shows the Color Management tab. DPP does not detect a system monitor profile automatically, so you need to select it manually. This is essential for an accurate color preview on your monitor.

We use Adobe RGB as a working space, as we do with all tools.

A DPP WORKFLOW

When working with DPP, you'll begin by browsing the thumbnails in the main window, as shown earlier in Figure 7-23. Once you've made your selection, you'll see an image-editing window that resembles either Figure 7-26 (with multiple RAW files selected) or Figure 7-27 (for editing a single image). Both windows include a panel where you make your settings for the RAW conversion.

As shown in Figure 7-28, this pane has two tool tabs:

- RAW Image Adjustment
- RGB Image Adjustment

FIGURE 7-24: The General Settings tab in DPP Preferences

FIGURE 7-25: The Color Management Settings tab in DPP Preferences

FIGURE 7-26: Multiple images selected for editing

FIGURE 7-27: Editing a single image

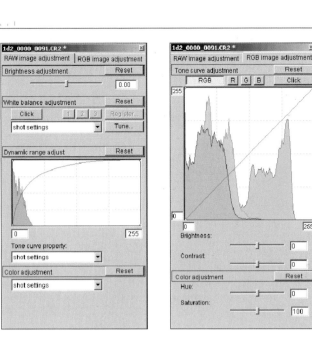

FIGURE 7-28: Bibble uses different tabs for RAW conversion and RGB handling.

FIGURE 7-29: The RAW Adjustment panel

The RAW Image Adjustment Tab

This pane (Figure 7-29) contains the key controls for adjusting your RAW files: [⚡]

- White Balance (WB)
- Brightness (EV)
- Color Adjustment

White Balance (WB)

As in all RAW conversion, correcting the white balance is a crucial basic step. As usual, you can do this either using a Color Temperature slider (Figure 7-30) or presets (Figure 7-31), or by clicking a neutral gray point within the image (Figure 7-32).

When you have a gray area inside your photo, correcting WB by clicking on a gray object within the photo (e.g., a gray card or ColorChecker) is the method of choice for obtaining the best objective WB correction. When shooting nature photographs, we are often more interested in the subjective color temperature than absolutely accurate color values. Our photos seldom have well-defined gray areas to use for this method.

FIGURE 7-30: The Color Temperature slider

FIGURE 7-31: Color Temperature presets

FIGURE 7-32: Setting the white balance gray point

---[⚡]---

NOTE:
This tab also includes a Dynamic Range Adjust tool, but we find its histogram difficult to interpret and prefer to use the one on the RGB tab.

Setting Exposure

While correcting EV, watch the image and histogram closely to avoid data clipping (both highlights and shadows). Unfortunately, the histogram that works better for this purpose is on the RGB Adjustment tab; the histogram here appears to display linear data. Therefore, it is probably better to correct exposure by looking only at the image. Figure 7-33 shows the Brightness Adjustment slider.

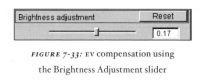

FIGURE 7-33: EV compensation using the Brightness Adjustment slider

Color Rendering

We leave the Color Adjustment drop-down (Figure 7-34) set at either Shot Settings or Faithful Settings.

FIGURE 7-34: Color rendering

The RGB Image Adjustment Tab

On this tab, we use the Tone Curve Adjustment and Color Adjustment tools.

Tone Curve Adjustment

DPP's Tone Curves Adjustment (Figure 7-35) is an extremely powerful curves tool. We use this tool sometimes to correct the black/white points. The Tone Curve Adjustment tool allows you to adjust:

- Brightness
- Contrast
- All normal curves functions

In our workflow, we always leave our image slightly "soft" and make our final adjustments in Photoshop using layers.

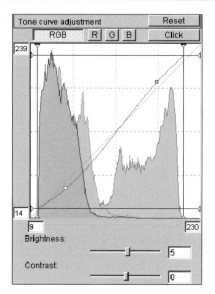

FIGURE 7-35: Tone curve adjustment

Color Adjustment

The Color Adjustment tool (Figure 7-36) has two sliders, Hue and Saturation. Be careful when you use the Hue slider. Sometimes using the Saturation slider makes more sense. Often, we make saturation lower rather than stronger. As we discussed in Chapter 3, it's better to do more selective saturation enhancement in Photoshop.

FIGURE 7-36: Color adjustment

SAVING CONVERTED FILES

DPP offers two ways to save converted files. You can save a single image (Figure 7-37) or a batch of images (Figure 7-38). With either method, you need to select Embed ICC profile.

We choose the second option because it allows you to:

- Convert multiple files at one time.
- Select a standard target folder.
- Continue working on another file while DPP is converting the previous file in the background.

While the images are processing, the status window shown in Figure 7-39 appears. Unfortunately, there is no way to set DPP so that this window closes automatically. 🏵

FIGURE 7-37: Saving a single converted file in the Save As window

FIGURE 7-38: Using the Batch Settings window to save

FIGURE 7-39: Processing dialog of DPP

7.4: Nikon Capture

Nikon Capture (NC) is Nikon's RAW conversion utility, and it is available for Windows and Mac OS. Although it offers diverse image operations, it does not modify the original image. Instead, it stores all operations as a command sequence. Therefore, you may undo or modify these operations at any time without losing quality (but the settings are stored in the same file). Nikon Capture is as full-featured as other RAW converters, but like them, it does not substitute as an image editor, such as Photoshop. We've illustrated this discussion with Nikon Capture 4, but most of the details also apply to Nikon Capture 3. Figure 7-40 shows the Nikon Capture interface.

Although it must be purchased separately, you need to buy this tool if you are serious about converting Nikon RAW files. In our judgment, however, the quantity of windows and panels in a Nikon Capture screen can be a bit confusing.

FIGURE 7-40: Nikon Capture

🏵

NOTE:
We found a bug (or maybe a "feature") in our current version. When an image already exists in the target folder, that image will not be processed. EV would, in this case, use a different name (e.g., xxxx(2).tif).

The kit includes both a Windows and a Mac OS version.

When you install Nikon Capture on a system with Photoshop already installed, NC places an import filter in the Photoshop plug-in folder that prevents the Photoshop file browser from recognizing Nikon RAW files import and redirects data to Nikon RAW plugin instead. If you prefer to open NEF files (Nikon RAW files) using Camera Raw, you can remove this plug-in (called Nikon NEF Plugin) from your Photoshop Plug-in folder.

SETUP

To set up Nikon Capture after installing it, use the General and Color Management tabs of the Options window.

General Options

You can launch converted files directly into Photoshop, as shown in Figure 7-41. That is why we suggest selecting the Photoshop application here.

FIGURE 7-41: Selecting the Photoshop directory

Color Management

The Color Management tab (Figure 7-42) allows you to select your preferred working space and monitor profile. We use Adobe RGB (1998) as our working space. NC 4 will select the system monitor profile automatically.

You must restart Capture to make the monitor profile active.

FIGURE 7-42: Color Management settings

A NIKON CAPTURE WORKFLOW

Once you have opened an NEF photo in Capture 3 or 4, you'll work in the following sequence.

The Advanced RAW Window

Adjusting the settings in the Advanced RAW dialog box (Figure 7-43) correctly is essential. Here are some hints to help you:

Exp Comp: With Nikon Capture, performing your EV compensation is more efficient using a combination with the Curves tool.

Sharpening: This can be set to Low or Normal, but Normal sometimes introduces unwanted holos.

Tone Comp: We usually set this to Medium Low or, on a photo with strong contrast, to Less Contrast.

- For Color mode, we use our working space Mode II, which is Adobe RGB.
- We rarely use the Hue Adjustment or Saturation Compensation tools in Nikon Capture. If we need to correct these, we use Photoshop later.

FIGURE 7-43: The Advanced RAW window

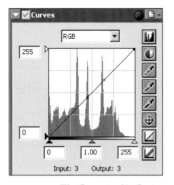

FIGURE 7-44: The Curves tool in Capture

FIGURE 7-45: EV +0.4

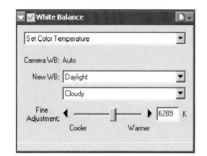

FIGURE 7-46: Upsizing in Capture

Curves

The Curves tool (Figure 7-44) in Capture is quite powerful, and we prefer its interface to that of Curves in Photoshop. Capture lets us view the histogram. However, we try to minimize our work in the Capture converter and leave the rest to Photoshop.

Now let's return to the EV Compensation slider in the Advanced RAW dialog box. Starting with the histogram shown in Figure 7-45, setting an EV of +0.4 would result in the histogram shown in Figure 7-45.

With a light overexposure, you would instead use a negative EV value for compensation. Play with the slider until you don't see any more spikes at the far right of the histogram. If necessary, set the Tone to Less Contrast to recover any lost highlights.

Size and Resolution

Most users will not need this dialog box. We would use this option, upsizing to the equivalent of 12 megapixels, if we were planning to print a photo larger than 17 inches wide. Upsizing a photo at this early stage helps minimize the degradation that occurs if the image is upsized later in the workflow (as is often done). The settings shown in Figure 7-46 allow us to print up to 21 inches wide at 240 ppi with no serious problems. [⚡]

White Balance (WB)

Once you've corrected the exposure, your other main task in Capture 4 is to correct the white balance. As with other RAW converters, you can do this either by setting a color temperature or by sampling one or more points in the image.

Setting the Color Temperature: Figure 7-47 shows how we usually use this dialog box. First we select a preset light source, such as Daylight (which can be Sunny, Cloudy, or Shade), and then we fine-tune the color with the Fine Adjustment slider.

FIGURE 7-47: Setting white balance using the Color Temperature

{⚡}

TIP:
Experiment with this method to see if it works for you. It might not be the right choice. (Avoid using it if you print photos smaller than 17 inches wide.)

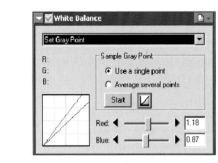

FIGURE 7-48: Setting white balance using a gray point

Sampling a Gray Point: Figure 7-48 shows the Set Gray Point option. Correcting the WB by clicking on a gray object in a photo (e.g., a gray card or ColorChecker) remains the method of choice when you need the best objective WB correction and you have a gray area inside your photo to use for a reference. In most photographs, we are more interested in subjective color temperature than absolutely accurate color values. Most of our photos contain few well-defined gray areas to use with this method.

SAVE AND LOAD SETTINGS

Once you have established settings, save them.
To save your settings:

From the main menu, click **Setting**, select **Image Adjustments**, and click **Save**.

To recall your settings later:

From the main menu, click **Setting**, select **Image Adjustments**, and click **Load**.

7.5: Iridient Digital: RAW Developer 1.4

RAW Developer by Iridient Digital (www.iridientdigital.com) for Mac OS X (see Figure 7-49) is a commercial-quality RAW converter that is well worth evaluating. (You can download a trial version from the website.) Its $70 USD price tag is quite reasonable considering its quality and the number of cameras it supports (a remarkably up-to-date list).

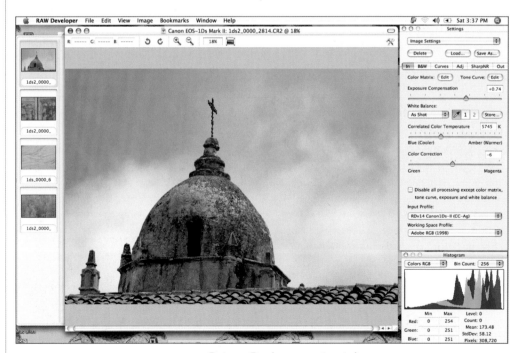

FIGURE 7-49: Basic RAW Developer correction window

When Iridient notified us of version 1.4 and claimed clean colors, we wanted to give it a short test spin. It often takes only a few checks to put new converters to rest because they fail to meet minimal requirements for the digital workflow. This time it was different; we liked what we saw.

First, we really liked the colors, and the details weren't bad at all. As stated throughout this book, working with colors a very complex topic. To our eyes, the colors from RAW Developer looked at least as good as anything seen from other RAW converters, and all this from the default camera profiles provided with the software.

RAW Developer's feature set is quite impressive.

INPUT TAB

The Input tab includes the following features (Figure 7-50):

- Exposure compensation
- White balance with many different modes. The As Shot WB worked great, as did Click WB. (D2X owners should read the docu-

mentation to learn how to enable the color temperature settings for this camera.)
- Camera input profile. (The default is shown here, but you can create your own.)
- Working space profile. We use Adobe RGB as our working space (the default is ECI-RGB).
- You can also edit your own tone curves (see Figure 7-51) and save them, but be careful when modifying this curve because it is adapted to your camera model.

You may use gamma control to lighten or darken your overall image, but we prefer to do this in the gamma control of the Curves tab (see Figure 7-53).

B&W TAB

RD offers more ways to create B&W from color images (see Figure 7-52) than any other RAW converters we have seen, but only Custom Tone and

Channel Mixer give you fine control via sliders. Channel Mixer will be the more flexible solution in most situations.

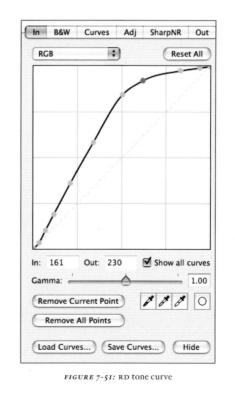

FIGURE 7-50: RD Input tab

FIGURE 7-51: RD tone curve

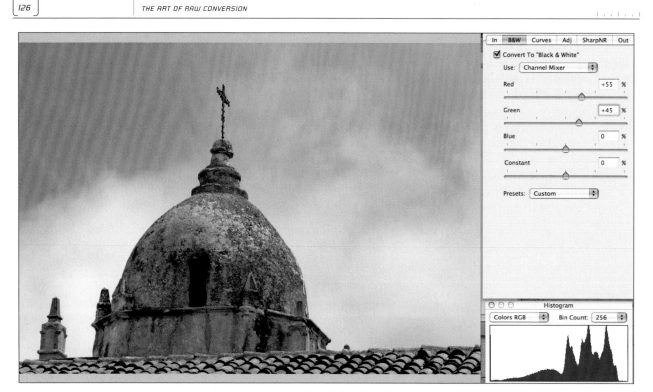

FIGURE 7-52: B&W tab of RAW Developer

The result (output) of a B&W conversion in RAW Developer will still be an RGB image. If you need a grayscale image, you will have to convert it in Photoshop (**Image** > **Mode** > **Grayscale**).

CURVES

The RD Curves tab (Figure 7-53) also allows you to work in Lab mode, which is quite useful when trying to avoid color shifts. The Gamma slider allows gamma brightness correction on top of the curves.

As in Photoshop, you may save curves and recall (load) them later.

ADJUSTMENT TAB

While there are several useful controls in the Adjustment tab (see Figure 7-54), RD lacks adaptive controls like Shadow/Highlight in CS2 or RSP's Fill Light.

Still, RD is quite adequate with its set of tonality adjustments.

FIGURE 7-53: RD Curves tab

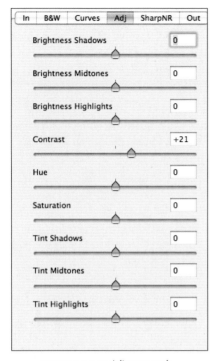

FIGURE 7-54: RD Adjustment tab

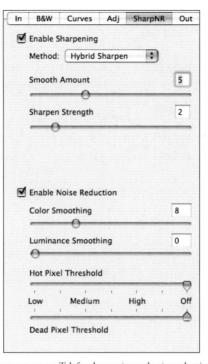

FIGURE 7-55: RD Tab for sharpening and noise reduction

SHARPEN/NOISE REMOVAL TAB

Figure 7-55 shows the tab for sharpening and noise removal. We used its default sharpening.

According to the RAW Developer manual, "Hybrid sharpening uses a combination of low pass/high pass image convolution filters to achieve increased sharpness and offers two slider controls for adjustment. Smooth Amount can be used to adjust smoothness or to reduce noise levels in an image. Higher values for Smooth Amount will allow less noise, but also reduces the effectiveness of the Sharpen Strength control. The Sharpen Strength setting is used to adjust sharpening level. Higher values give a sharper image."

Overall, we liked the details and also the program's low tendency to produce halos. (We did not use noise removal because most of our images were in the low ISO range.)

OUTPUT TAB

Other than changing the output profile in the Output tab (see Figure 7-56), we used the default.

FIGURE 7-56: RD Output tab

FIGURE 7-57: RD Job Queue

(We rarely upsize or downsize within a RAW converter.) The crop and arbitrary rotate tools are located here as well.

You can either process and save an image or hand it over to a batch queue. Once it's in the queue, you can process additional images. (It would be nice to have a function to open converted files directly in Photoshop.) You may show the batch queue (**Window** > **Show Job Queue**, Figure 7-57), stop the batch processing, and resume it later to ensure a smoother foreground editing of your images.

BATCH SETTINGS

The Batch Settings dialog (see Figure 7-58) allows you to define what RD will do in its batch phase. You can define the file format, the color

FIGURE 7-58: RD Batch Settings dialog

depth, and the kind of compression used with the converted file. You can save these settings and they will appear in the format list of the Batch Settings dialog.

EXTRA FEATURES

In addition to the features already discussed, RD features multiple undo/redo which can come in very handy.

MISSING FEATURES

There is no method for image comparison, something that is very useful when you want to select the best photo from several similar shots.

7.6: Conclusion

RAW Developer is a very serious RAW converter that we plan to follow in the future. If you are on a Mac, check it out. It is good to have an alternative RAW converter handy because no single RAW converter, we know of, produces optimum results for all images all the time. Performance is good—even with large RAW files (e.g., Canon DMark II). The minimal and recommended requirements are far below those of Apple's Aperture, and its price is much less, but it hasn't the rich functionality Aperture offers (e.g. no asset management features). However, we are honestly impressed and surprised how much we like this tool.

8

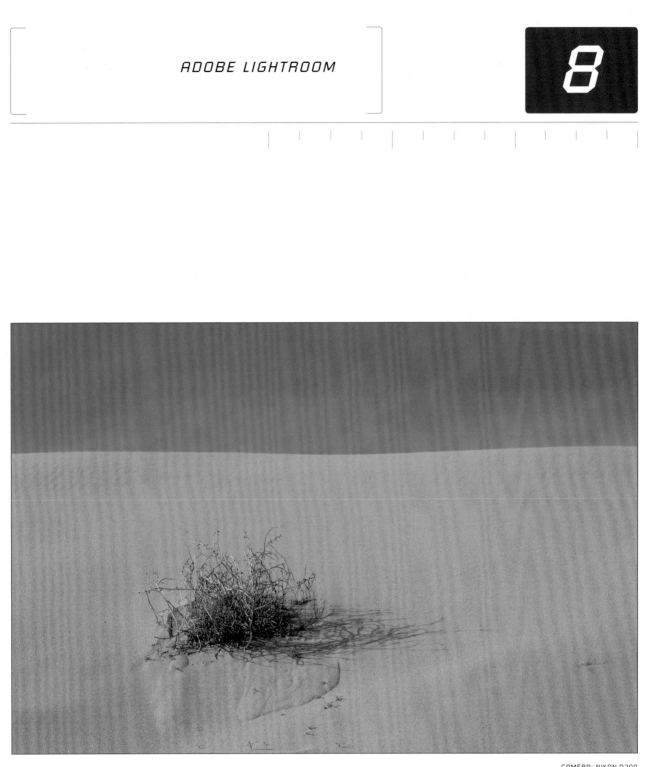

CAMERA: NIKON D200

Shortly after Apple introduced Aperture in December 2005, Adobe responded with a public beta of Lightroom 1 for Mac, a technology preview which, as of this writing, was only available for Mac OS X 10.4. (A Windows version will probably follow in mid 2006, and the final version 1.0 at the end of 2006.)

Lightroom and Aperture have many similarities—primarily, that they are the first tools to focus on the digital photography workflow from start to finish. This workflow includes, at minimum:

- Download and import
- Organization (folders, collections, albums, etc.)
- Inspection (light box, as large as possible)
- Editing
- Publishing (including print, Web, e-mail, documents, etc.)
- Slideshows (presentation)
- Archiving (CD, DVD, etc.)

8.1: Lightroom Is an Integrated Application

Like Aperture, Lightroom is highly integrated and includes a downloader, a RAW converter (based on Adobe Camera Raw), an image editor, a light table, a printing application, and an asset management system offering image browsing, administration, and retrieval. (Backup and archiving were still missing in the beta.)

Resource-wise, Lightroom is far less demanding than Aperture, and does not require a special graphics card. This is welcome news, especially for people who work on laptops. Lightroom follows a basic workflow pattern that provides four modes, which are actually four independent modules displaying their graphic front-end in a common, single window. These modes are **Library** (the import module

NOTE:

As of this writing, Lightroom could not properly handle CMYK and Lab-mode images.

Library | Develop | Slideshow | Print

and image browser), **Develop** (for image corrections), **Slideshow,** and **Print**. Each mode displays a specific panel that may be faded in or out independently. You may switch from module to module with a click of the corresponding icon in the Lightroom window (see Figure 8-1).

As with Aperture, Lightroom has its own repository (database) that holds all metadata, links, administrative information, and, optionally, images. But one important difference between Lightroom and Aperture is that Lightroom allows you to import images by reference. This gives you the option to maintain your images using your own image folder organization or to store them in the Lightroom library. We prefer to store our images outside the Lightroom library according to the structure we describe in Section 3.2.

SUPPORTED IMAGE FORMATS

Lightroom's RAW converter is based on Adobe Camera Raw, but unlike Photoshop and Bridge, you do not see ACR directly. Lightroom acts as a front-end, which gives ACR a somewhat different look.

As in ACR, Lightroom's RAW converter supports a very broad range of RAW formats, including most up-to-date DSLRs. Also, as with Aperture, Lightroom supports TIFF, JPEG, PSD, and DNG. [✿]

SETTING UP LIGHTROOM

Lightroom's default preferences and presets should fit the workflow of most photographers. However, we recommend setting up a suitable location for the Lightroom Library—specifically, a disk with plenty of free space. Set this preference in the Preferences dialog, as shown in Figure 8-2.

The other Preferences option, in addition to Location, is Cache Size. We recommend leaving this set at its maximum, for optimal speed.

FIGURE 8-1: Basic Lightroom window in Library mode with Loupe view active

FIGURE 8-2: Determine the location of your Lightroom Library. You may have several libraries with different names.

NOTE:

Lightroom's downloader imports real files into the Lightroom library. Therefore, we employ an external downloader application and rename images during this step.

8.2: Photo Workflow in Lightroom

Let's have a look at how Lightroom tackles the various workflow tasks:

PHOTO DOWNLOAD AND IMPORT

There are two ways to import images into Lightroom:

- Download from CF/SD cards
- Import from existing files

File Handling ✓ Reference files in existing location

 Copy files to Lightroom Library
 Move files to Lightroom Library

 Copy photos as Digital Negative (DNG)

We recommend only importing from existing files. Because Lightroom allows you to import photos by reference (see Figure 8.3), your files stay in their original location and Lightroom doesn't touch them.

The downside to importing by reference is that if you move, remove, or rename files outside of Lightroom, Lightroom may not be able to find them. But Lightroom usually fails gracefully, and it seems that moving files on the same disk is not a problem under Mac OS X. If Lightroom can't find your files, it will give you a chance to point it to the correct image location yourself. Importing only by reference requires a bit of planning and organization, but if you use the organization we discuss in Section 3.2, it can be highly effective. [❁]

Overall, importing in Lightroom is fast, but generating previews is not. When importing images, Lightroom generates several preview images: one full-size and (depending of the image size) four or five smaller (each ¼ the size of the previous one). You will see an indication of the background preview processing at the upper right corner of the AL window; when you click on this window, a separate status window pops up and gives more information, as shown at the top of page 133.

FIGURE 8-3: Import files via reference to the original location

Activity Viewer

Checking Library Thumbnails
Processing medium thumbnail for DSC_0686—

PHOTO ORGANIZATION

The core of any well-behaved photo organization program is a catalog/library, or **repository**. This specialized image database stores originals, previews, and metadata and is an aide to fast searching. Some programs, like Photoshop Bridge, use only primitive files for this task and, therefore, should never be used as real photo organizing applications; but both Aperture and Lightroom use a real database.

Aperture's primary import unit is called a **project**; Lightroom calls this a **shoot**. The shoot holds information about the images, as well as references to the original files. Lightroom also has **collections,** which perform nearly the same functions as Aperture's *albums*.

As of this writing, the sophisticated search functionality and metadata handling of Aperture's **smart albums** are far more advanced than Lightroom's respective capabilities. However, when it comes to organization, Lightroom wins, hands down, because it is so open.

WHAT ABOUT STACKS?

As of this writing, Lightroom did not support stacks. But, we are fairly confident that it will incorporate them in the future, since stacks are becoming a **must-have feature** in most photo organization programs.

BROWSING AND LIGHTBOX

Lightroom offers three ways to view photos, and you can switch from one to another using the above icons. The function of each is as follows:

- **Grid view** (displays thumbnails from tiny to large, as shown in Figure 8-4)

FIGURE 8-4: Grid view

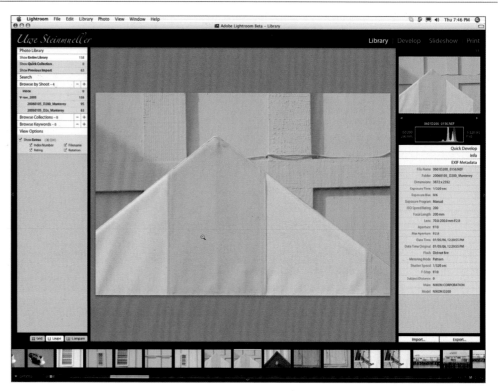

FIGURE 8-5: Loupe view (fit image to window)

NOTE:
All toolbars and the Filmstrip can be hidden by clicking the corresponding ■ *; they will then operate in auto-hide mode. In this mode, the panel will pop up when you get close to the corresponding window edge with your cursor.*

- **Loupe view** (fits an image to the window or 100% magnification, as shown in Figures 8-5 and 8-6)
- **Compare view** (allows you to compare images, as shown in Figure 8-7)

In Grid view, you can resize your preview icons using the slider (top left icon) at the lower right side of the preview window and resize the icons (bottom left icon) of the Filmstrip using the buttons. [■]

To make things simple, the Preview window offers only two zoom modes: "fit to window" and 100%. To switch between the two, just click on the image. We rarely need more than 100% view of an image, and when we do, we use Photoshop. (As is the case with Aperture, Lightroom is not a Photoshop replacement.)

Aperture's Light Box feature is clearly more sophisticated than Lightroom's, but in most cases, Lightroom provides all you really need. [⚡]

FIGURE 8-6: The Preview window in loupe view (1:1 means 100% magnification)

FIGURE 8-7: Compare view

8.3: Photo Editing— Develop Mode

Lightroom's Quick Develop mode is probably ahead of Aperture, because it uses an improved version of Camera Raw that allows you to edit JPEG, TIFF, and PSD files.

Lightroom offers three kinds of image editing:

1. A very fast and simple correction using Quick Develop (see Figure 8-8). Here, only five corrections are possible: White Balance (just a view preset), Exposure, Brightness, Contrast, and Saturation. Rather than sliders, there are only less (⊲) and more (⊳) buttons. In this mode, you may select several images and perform corrections on all of them simultaneously. You can also copy these settings to your Lightroom clipboard and apply (paste) them to other

FIGURE 8-8: Quick Develop panel

images from there. Quick Develop also allows you to enter metadata and apply a rating to the selected image by clicking on

NOTE:
Lightroom is not designed to use two monitors, but we came up with a workaround. Both of our monitors are 1600 × 1200, and we stretched the Lightroom window so that the editing palettes were on the second monitor. In this way, we could display images in full screen and keep the editing palettes on a second monitor.

the **Rating** icon. Lightroom will show some of the EXIF data in this panel, as well. (You may have to scroll to see it all.)

FIGURE 8-9: The closed corrections tabs in Develop mode

2.　Standard Lightroom corrections are available in Develop mode (see Figure 8-9).

3.　Sometimes, you may want to call up an external application like Photoshop to do more advanced corrections. Lightroom will pass along a copy of your image for that purpose and will treat the returned image as a new version.

DEVELOP

Lightroom's Develop mode offers all of the corrections and settings that Camera Raw offers, though its interface is somewhat different (see Figure 8-10). The Basic tab contains the well-known ACR 3.*x* settings for White Balance, Saturation, Exposure, Brightness, and Contrast, as shown in Figure (8-11).

　　The Detail tab offers the ACR 3.*x* settings for Sharpening and Noise Suppression, as well as Lens Corrections. You will also find ACR's Camera Calibration tab here.

　　The histogram is ACR's, and not only shows the RGB channels, but also histograms for

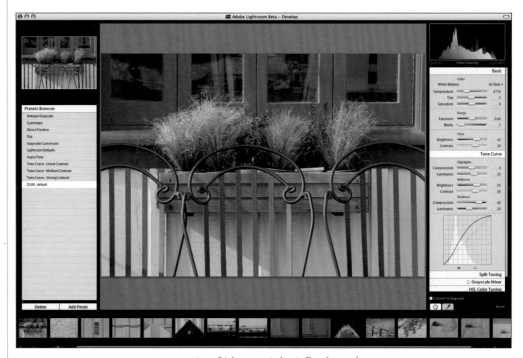

FIGURE 8-10: Lightroom window in Develop mode

FIGURE 8-11: Basic tab

FIGURE 8-12: Detail and Lens Corrections tab

combined colors: R+G+B in white, R+G in yellow, G+B in cyan, and R+B in magenta.

The following features are new and are discussed in more detail below:

- Tone Curve
- Split Toning
- Grayscale Mixer
- HSL Color Tuning
- Preset Browser

TONE CURVE

This feature may confuse some users. It is a curve that can be tuned by using eight sliders:

- Three pairs control highlights, midtones, and shadows
- Two sliders (below the diagram) allow you to define highlights, midtones, and shadows

This tool is powerful because it keeps the curve from excessively clipping the highlights and shadows and avoids negative slopes. Also, it helps you to concentrate on the three important regions in a picture: highlights, midtones, and contrast. (You may wonder where the "real" curves are. Lightroom may add curves in a future release, but we find curves not terribly intuitive and very easy to mess up.)

GRAYSCALE MIXER

The Grayscale Mixer allows you to create nice black and white images. The sum of the RGB sliders should add up to 100% and the sum of CMY to 200%. Remember, however, that the result of this conversion is still an RGB image and not a grayscale image.

FIGURE 8-13: Lightroom Tone Curve

FIGURE 8-14: Grayscale Mixer

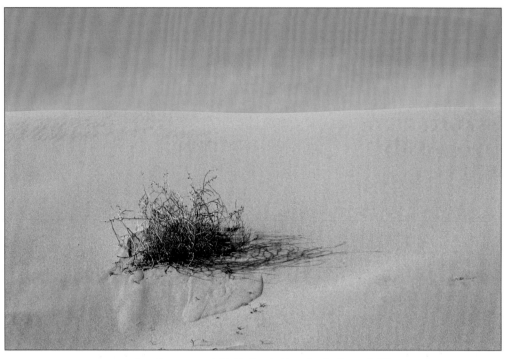

FIGURE 8-15: Image converted to black and white using the Grayscale Mixer

SPLIT TONING

The Split Toning control allows you to tune hue and saturation separately for highlights and shadows. For example, you could use this tool to slightly reduce the blue cast you often see in shadows of an image or to tune up the colors of the lighter parts of your image.

Split Toning	
Highlights	
Hue	140
Saturation	0
Shadows	
Hue	25
Saturation	17

FIGURE 8-16: Split Toning control

HSL COLOR TUNING

At first, we were a bit overwhelmed by the 18 sliders in HSL Color Tuning, but they turned out to be easy to master and make perfect sense. The three blocks of corrections (hue, saturation, and luminance) allow for very fine tuning. The Luminance sliders allow you to selectively correct colors without a color shift, and the corrections don't shift the image brightness (luminance), either.

HSL Color Tuning	
Hue	
Reds	6
Yellows	-6
Greens	0
Cyans	0
Blues	0
Magentas	0
Saturation	
Reds	0
Yellows	0
Greens	0
Cyans	0
Blues	0
Magentas	0
Luminance	
Reds	0
Yellows	0
Greens	0
Cyans	0
Blues	0
Magentas	0

FIGURE 8-17: HSL Color controls allow for very fine color tuning

We recommend that you begin your color tuning with the R, G, and B sliders, and then use the sliders of the complementary colors Y, C, and M.

PRESET BROWSER

Lightroom's Preset browser lets you define your own presets. You will find it in a window to the left of the preview. From this list, you may select a preset, which is a collection of settings. If you click **Add Preset**, a dialog box appears (Figure 8-18), where you may define which of the current settings to include in the new preset.

This feature is particularly useful because you can define your own settings based on selected operations.

COPY, PASTE, AND SYNCHRONIZE SETTINGS

You may copy specific settings from a currently selected image to the Lightroom clipboard by clicking the **Copy Settings** button (only visible in Library mode), as shown in Figure 8-19. When you do, the dialog window shown in Figure 8-20 appears (without the name field), and you may select which settings you want to copy. Then, select the images you want the settings to be applied to, and click the **Paste Settings** button. If you use **Synchronize** instead, the dialog shown in Figure 8-20 will appear again, this time allowing you to choose which settings from the first selected image you want to apply to other images.

═══

8.4: Slideshow

═══

To produce a slideshow, select the images in the Filmstrip or Grid view window that you want to include in the show. Then click **Slideshow** to activate Slideshow mode (see Figure 8-21). Lightroom offers a large number of settings for a slideshow, allowing you to define the background color, shadow casts, settings for the identity plates, the amount of time that each image is to be displayed, and what the transition

FIGURE 8-18: Preset browser

FIGURE 8-19: Copy settings to the Lightroom clipboard

FIGURE 8-20: When adding a new Preset, you may select which setting to include in the preset.

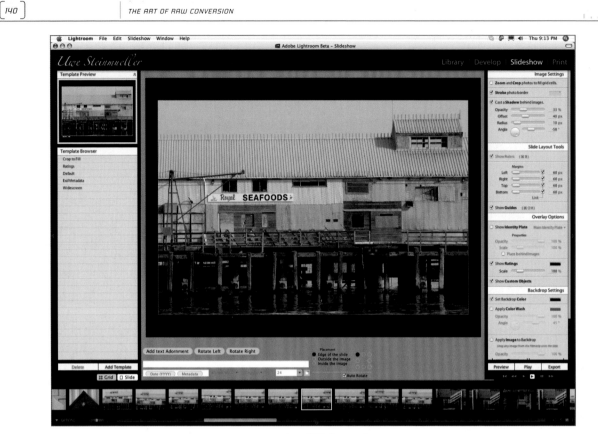

FIGURE 8-21: Slideshow mode

should be. You may add text to the individual images in the field below the Preview windows.

You can use the Player module (above) to preview your slideshow inside the Lightroom Preview window, or **Play** the slideshow in full-screen mode. You can also **Export** the slideshow (see Figure 8-22) to HTML, PDF, and Flash. While the Flash version is quite effective, its file size is much larger than HTML or PDF. The Export dialog even allows you to upload a slideshow using FTP.

Lightroom offers slideshow templates and a template browser, where you may view a preview of a currently selected image displayed in the selected template format. You may also add your own templates.

FIGURE 8-22: Export dialog for Lightroom's slideshows

While Lightroom's slideshow is nice, we would choose Aperture if our goal was to generate a solid professional web gallery.

FIGURE 8-23: Template browser for the slideshow

8.5: Printing

Though Photoshop provides a serious print dialog, it is missing some options for fine art printing. Lightroom, on the other hand, is on track to offer greater support for this. It offers a large number of print settings (see Figures 8-24 and 8-25) and, unlike Aperture, settings for rendering intent. (Use either **Perceptual** or **Relative** colorimetric for photos.)

When you set the print resolution with Lightroom, it will up- or down-scale your image as necessary. You can also apply some on-the-fly, output-specific sharpening to your original image.

Like Slideshow and Develop mode, Print mode offers you templates, a template browser with a small preview, and the ability to save your settings as a new print template.

FIGURE 8-24: Lighthroom in Print mode

FIGURE 8-25: Lightroom's various print settings

If you want to print a contact sheet with several small images on a single page, use **Enable Draft Mode Printing**. This setting speeds up printing considerably because images are taken from previews instead of regenerated from the originals. This option may also be useful when printing to PDF or when you don't require maximum image quality.

8.6: Image Organization Once More

As mentioned earlier, Lightroom's image-structuring methods are not as rich as Aperture's. Lightroom's library is its universe, where the basic structure is a **shoot**. Like a folder in an operating system, a shoot may contain other shoots (like subfolders).

When importing images from a folder, you can activate an option that commands every subfolder to create a new (sub-) shoot with the name of the subfolder. (This option is active by default.) But an image may be part of only one shoot, and there is (as of yet) no way to create links or aliases to images in other shoots.

The second structure is **collections**. There are two types of collections: **named** and **Quick Collection**. (There is only one Quick Collection.) To create a new named collection, click the [+] button of the **Browse Collections** tab of the Library panel (or press ⌘-N). Once you have created a new collection, you may select images in the filmstrip or grid view window and drag them to the corresponding Collections tab.

Images may be part of several collections, because collections just contain links to the images. To add an image to the Quick Collection, select the image and press B.

SELECTION AND SEARCHING

Minimum **Rating** ———————●————— **3**

When Library module is active, you can define which images are shown in the filmstrip and Grid view via the Photo Library panel (see Figure 8-26). You can choose to show the **Entire Library**, only the current **Quick Selection**, a **Previous Import**, only those images with a minimum Rating (see **Search** tab), or a specific shoot or sub-shoot. You may also restrict images to those associated with a certain keyword.

═══

8.7: More Lightroom Features

═══

DRAG & DROP

Like Bridge, Lightroom allows you to drag and drop images from the filmstrip or Library windows onto a Mac application or into a DTP document—a very useful feature.

LIGHTROOM REPOSITORY

As mentioned earlier, Lightroom is based on a repository or library. All preview icons and images are stored in the library, together with links to the images and their metadata. Images may be stored in an external folder or in this library, and you can choose where you'd like to store your images every time you import.

As of this writing, the default location for the Lightroom database is in **~/Picture/Lightroom** (~ is the shortcut to your home directory).

To place the database on a disk with more space, you will have to copy it to the new location, delete the old directory, create an alias to that new folder in the default location (~/ **Picture/Lightroom),** then rename your alias **Lightroom.**

Photo Library	
Show **Entire Library**	6722
Show **Quick Collection**	25
Show **Previous Import**	3302
Search	

Minimum **Rating** ———●———————— 0
☐ Show **Hidden Photos**

Browse by Shoot ~ 81	−	+
Browse Collections ~ 4	−	+
Grand Canyon		
Page		
Sarah		
Wedding_Sarah		
Browse Keywords ~ 8	−	+
Frosty Day		
Grand Canyon		
Madeira		
Monterey		
USA		
Winter 2006		
View Options		

☑ Show **Extras** (⌘⇧H)
 ☑ Index Number ☑ Filename
 ☑ Rating ☑ Rotation

FIGURE 8-26: In the Library panel you select which images will be visible in the filmstrip and in Grid view

If you want to create a new library in a different location, create an empty folder at that location, and start Lightroom with the ⌥ key pressed. Lightroom will come up with a file dialog allowing you to select your new library folder, at which point it will create a new library and store all subfolders there.

KEYBOARD SHORTCUTS

As with Aperture, Lightroom provides several keyboard shortcuts for navigating, rating, and many other functions that can speed up your workflow (see Figure 8-27). But also, like Aperture, not all of these shortcuts work on foreign language keyboards.

Library Shortcuts

View Shortcuts

~	Toggle between Grid and Loupe
Esc	Return to previous view
Return	Enter Loupe or 1:1 view
E	Enter Loupe view
C	Enter Compare mode
G	Enter Grid Mode
Command + Return	Enter Quick Slideshow mode
F	Cycle to next Screen Mode
Command + Shift + F	Return to Normal Screen Mode
L	Cycle through Lights Out modes
Command + Shift + H	Turn cell extras on and off

Panel Shortcuts

Tab	Show/Hide the side panels
Shift + Tab	Hide/Show all the panels
Command + F	Activate the search field
Command + Option + A	Show/Hide the Activity window
Command + /	Return to the previous module

Ratings Shortcuts

1-5	Set ratings
0	Reset ratings to none
], [Increase and Decrease the rating

Image Shortcuts

Command + Shift + I	Import images
Command + [,]	Rotate left and right
Command + E	Edit in Photoshop
Command + - , =	Zoom in and out
Z	Zoom to 100%
H	Hide image
	There is a checkbox in the Search panel to show hidden images.
Command + R	Reveal in finder
Delete	Remove from Library
Command + Delete	Move image to OS Trash
	Also removes from the Library
Command + Shift + C	Copy Camera Raw Adjustments
Command + Shift + V	Paste Camera Raw Adjustments
Command + Right/Left Arrow	Next/Previous selected image
Command + Shift + E	Export Image

Quick Collection Shortcuts

B	Add to Quick Collection
Command + B	Show the Quick Collection
Command+Shift+B	Clear Quick Collection

FIGURE 8-27: Some of the Lightroom's keyboard shortcuts

8.8: Conclusion

Like Aperture, Lightroom is an exciting new application and, from a photographer's point of view, an important step in the right direction. We like its large and up-to-date list of supported RAW formats and the quality of RAW conversion. We also like its **import by reference** feature and its modest requirements concerning CPU power, main memory, and graphic card. These will be important for people using a somewhat less powerful system or who want to work on a laptop.

Once Aperture and Lightroom have matured, they should be able to replace a number of current applications, including an image downloader (and renaming function), a RAW browser, a RAW converter, and, for many photos, even Photoshop. Lightroom will also take over the functionality of today's asset management systems (at least as long as only one photographer is involved) and should provide functions for backup and archiving.

Aperture and Lightroom have begun a race to integrate several photography applications in one product. The question is: Which will be the first to convince the most photographers to entrust their images to the application's repository? For now, we'll wait and see.

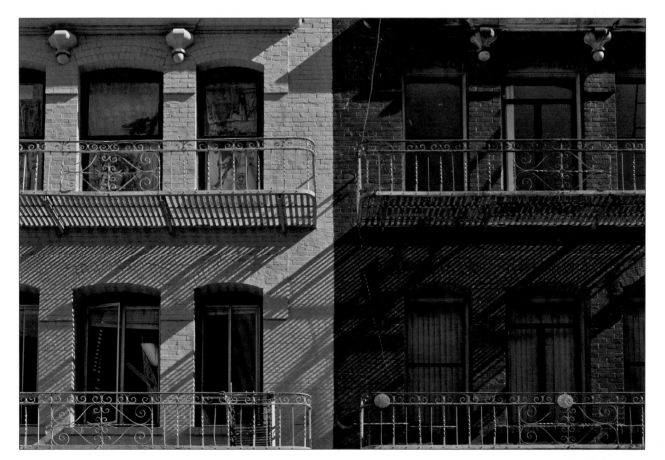

CAMERA: SIGMA SD10

In this chapter, we move from RAW conversion to the final image corrections that are usually best performed (or which, in some cases, can only be performed) in Photoshop.

While you may never look closely at your image's minor shortcomings, cameras and lenses (even the more expensive ones) are far from perfect, and digital photos can show several kinds of defects. This chapter will show you what these defects are and how to fix them. As you evaluate your own shots, this information should help you decide whether to live with a particular problem or work on it to improve it.

We will cover some of the more important image defects including: [❀]

- Image blur (a lack of sharpness, which can be caused by the lens, and can be introduced by the camera's antialiasing filter)
- Noise
- Chromatic aberration
- Lens distortions
- Vignetting
- Rotation (camera tilt)
- Perspective corrections
- Dust spots

You should tackle only those problems that you think detract from your images.

Why didn't people bother with these types of problems with film? Well, in fact, professional photographers did bother, but they had a hard time correcting these problems. Fotunately, there are many good ways to minimize these flaws in your digital images. In fact, Photoshop CS2 adds three new tools to help reduce all of the above defects:

- Smarter Sharpen
- Reduce Noise
- Lens Correction (which corrects many types of defects created by lenses)

9.1: The Art of Sharpening

All digital photos require some sharpening because the antialiasing (AA) filters in most digital SLRs blur the image a bit to decrease color aliasing. (See Chapter 1 for more on this.) Sharpening is one of the most difficult and subjective topics in digital photography, but the tools designed to correct it continue to improve.

The sharpening process has a built-in contradiction: Although enhancing the contrast at an image's edges gives the impression of improving sharpness, some smaller details may be lost during the process. (This is why it is important for you to keep a targeted viewing distance in mind for the final output.)

You can perform sharpening in (at least) three stages of your workflow:

In the camera: You cannot perform sharpening in the camera if you're shooting RAW files. We don't recommend sharpening in the camera when shooting JPEG or TIFF files if you plan to optimize later in Photoshop.

In the RAW converter: We rarely sharpen in the RAW converter; mostly, we sharpen only the preview without sharpening the image itself. You can sharpen the image slightly in the RAW converter and then perform more sharpening later in Photoshop. (RawShooter seems to do a better job of sharpening than other RAW converters, so when using it you can apply a bit more sharpening.)

In Photoshop: This is our preferred method, because it offers a great deal of control and allows you to restrict sharpening to certain areas of the image. There are quite a few good sharpening plug-ins for Photoshop.

Even when using Photoshop, a three-step sharpening process may be the best approach, as follows:

1. Give your image a slight overall sharpening to improve it.

2. Selectively sharpen areas of your image that can be improved and which should be in focus.

3. Perform a final sharpening as one of the very last steps before you output the image. This sharpening should be done when the picture has been scaled for output, and it should be adapted to the output method. For example, a digital slideshow needs almost no sharpening, while an image printed on an inkjet printer or an offset printer will need much more sharpening because of the dithering used in those printing processes. (Both processes use varying patterns of dots to simulate tonality.) On the other hand, output to a lightjet or a dye sublimation printer requires less sharpening. Part of this final sharpening can even be done by a **raster image processor (RIP)** if you use one and the RIP supports it (e.g., Qimage).

It is difficult to judge sharpening on a screen. In fact, a photo that looks hopelessly oversharpened on the screen might be exactly right for some inkjet printers. [⚡]

PHOTOSHOP UNSHARP MASK

The classic tool for sharpening in Photoshop is Unsharp Mask (USM), and nearly all techniques are a variation of it. Therefore, in order to understand the issues that surround sharpening, you need to understand how Photoshop Unsharp Mask works as well as its inherent limitations. [☉]

For example, Figure 9-1 shows a rock formation without sharpening.

To improve this image, begin by opening the **Filter** > **Sharpen** > **Unsharp Mask** dialog box (Figure 9-2). (Always check the **Preview** option.)

As you can see in Figure 9-2, there are three factors that control Unsharp Mask: Amount, Radius, and Threshold.

Amount defines how much edge contrast enhancement will be applied. The optimal amount

FIGURE 9-1: Sample image (unsharpened)

depends very much on your image. Begin with a value of 50 to 100 percent and carefully watch the effect in your image. (You should set your image to an enlargement level of 100 percent or greater.)

Radius determines the number of pixels that will be used to build the new edges, with higher contrast. Often 0.5 to 1.0 is a good range of values, although the optimal value will depend on your image's resolution. The higher the resolution of your image, the higher the radius may be.

Threshold defines how great the difference in color or tonality values between adjacent pixels needs to be in order for the tool to recognize an

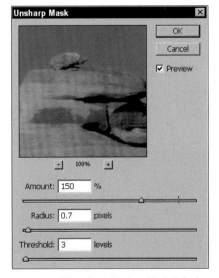

FIGURE 9-2: Photoshop's Unsharp Mask dialog box

"edge" and apply sharpening. Setting an appropriate threshold will prevent oversharpening and amplifying noise.

The right settings for your image will depend very much on the resolution of the image (measured in *points per inch* or *pixels per inch* (**ppi**), depending on the output medium). The higher your image's resolution, the higher the value you can select for the Amount and Radius. As with any tool that uses multiple controls, you will need to determine the optimum balance between these three factors.

Figure 9-3 shows the image after applying the settings shown in Figure 9-2.

Using USM is tricky because you can sharpen too little or too much. When oversharpened, the image is severely damaged by light or dark halos, as you can see in Figure 9-4.

Because your approach to sharpening a particular image is also a function of the image's resolution and printing technology, it can take a long time to find the optimal settings, and you will need a lot of experience to guide you. Too, USM has an inherent limitation: all of its settings are applied globally to a given image. But in a portrait, for example, you probably want the skin to look smoother and the hair to be more crisply defined. To do this, you must sharpen the two areas differently.

Because there is no simple "one size fits all" solution for sharpening, there are a huge number of different sharpening techniques (most based on edge masking) and multiple Photoshop plug-ins designed to make sharpening easier.

THE TWO-STEP APPROACH

The two-step approach is a simple way to begin sharpening:

- Do a little sharpening in the RAW converter.
- Do your final sharpening in Photoshop.

We don't really do any sharpening in the RAW converter, preferring to use the EasyS Sharpening Toolkit in Photoshop (not that RAW converter sharpening is bad; the Photoshop sharpening tools simply offer more control).

PHOTOSHOP CS2: SMARTER SHARPEN

Photoshop CS2 provides a better sharpening tool than plain USM, called Smart Sharpen (Figure

FIGURE 9-3: The sharpened image

FIGURE 9-4: This oversharpened Image shows strong halos.

FIGURE 9-5: Photoshop CS2 Smarter Sharpen

9-5). The name reflects both the advanced algorithms behind the tool and the greater degree of control it provides.

Smart Sharpen's Advanced mode allows you to tune the sharpening for shadows and highlights. In general, you shouldn't sharpen the extreme shadows (because doing so would exaggerate the noise typically found in shadows), nor should you sharpen the bright highlights.

OTHER SHARPENING TOOLS

We use several advanced sharpening tools in our daily work. Here are a few of our favorites. [⚡]

- **Our own EasyS Sharpening Toolkit** (http://www.outbackphoto.com/workflow/wf_66/essay.html): This tool is inexpensive and very flexible, and it doesn't tend to create halos.
- **Focus Magic** (www.color.org): This is good to use when you want to sharpen more blurred areas.
- **Focus Fixer** (www.fixerlabs.com): This is very similar to Focus Magic.

9.2: Noise Reduction

Small sensors at any ISO setting, and larger sensors at higher ISO settings, can show different kinds of noise (mostly in shadows because the signal to noise ratio gets very low). For more information on noise in digital images, read Dick Merrill's tutorial "Digital Photography Essentials #4: Noise" (http://www.outbackphoto.com/dp_essentials/dp_essentials_05/essay.html). [⊙]

There are several types of noise:

- Fine and coarse (which is difficult to remove)
- Luminance noise (detail noise)
- Color noise (false color pixels in homogeneous colors)

The detail in Figure 9-6 shows both luminance and color noise.

Fortunately, several good programs do a great job of reducing noise (the best work as Photoshop plug-ins as well as stand-alone tools). But, before you make any changes to your image with one of these programs, you should decide whether noise is really a problem in your prints. For example, at smaller print sizes, noise may not be noticeable. Too, if you reduce noise too much, you'll lose detail and also create a sort of "plastic" look in your images.

Figure 9-7 shows how our image in Figure 7-6 looks after using a noise removal filter. The image is certainly improved.

FIGURE 9-6: Shows luminance and color noise

FIGURE 9-7: After noise removal

FIGURE 9-8: The Photoshop CS2 Reduce Noise tool

NOTE:
Because noise can be stronger in some channels (usually the blue one), you might find it worthwhile to use the Per Channel tab and to begin by removing noise in the blue channel. This technique may preserve more details in your red and green channel.

PHOTOSHOP CS2: REDUCE NOISE

One overdue improvement in Photoshop CS2 is its very-usable noise filter, Reduce Noise (shown in Figure 9-8).

REDUCING NOISE IN SHADOWS

Because noise is primarily present in the shadows, it can be very useful to remove the noise in a new layer and then use a Layer Mask so that the noise removal only affects the shadows. In order to implement this technique, we created the Tonality Tuning Toolkit (www.outbackphoto.com/workflow/wf_61/essay.htm available for Windows and Mac os).

OTHER USEFUL NOISE REMOVAL FILTERS

We also find the following noise filters very useful:

- NoiseNinja (); (www.outbackphoto.com/workflow/wf_25/essay.html)
- NeatImage (); (www.neatimage.com). Available in a Standard and a Pro edition. This is an excellent tool.
- Noiseware (); (www.imagenomic.com). Available in a Standard and a Pro edition.

- Helicon Filter Pro (); (www.shareup.com/Helicon_Filter_pro_download-21227.html). This is a superb freeware tool.

If you work with 16-bit images (our recommendation), you'll probably need to buy the Pro versions of these tools.

9.3: Chromatic Aberration (CA) and Purple Fringing

Chromatic aberration (CA) is a problem that occurs with nearly all lenses, but whether it will be noticeable in the final image will depend on the quality of the lenses used. Consumer-class digital cameras show more CA than high-end ones with the best lenses. The chromatic aberrations usually appear as purple/green fringing, which is stronger in the corners of the image. The fringing occurs because lenses have different focal planes for different colors. Although chromatic aberration is more likely to occur with lower-quality lenses, it can also occur with the best lenses when they are used with full-frame sensors.

Purple fringing results in aberrations that are purple in color, and which are due to leaks in the imaging sensor. (The Sony F828, for example, shows both strong chromatic aberrations and purple fringing.)

FIXING CHROMATIC ABERRATION

Figure 9-9 shows chromatic aberration as magenta and green borders at opposite sides of high-contrast edges. In the image at the right, you can see how Adobe Camera Raw (versions 2 and 3) fixes CA. (As we discussed in Chapter 4, the sliders for fixing CA are located on ACR's Lens tab.)

Photoshop CS2: Lens Correction

Beginning with Photoshop CS2, you can fix chromatic aberration outside of Camera Raw by using the Lens Correction filter

FIGURE 9-9: Chromatic aberration *(left)* and
the corrected image in Camera Raw 2/3 *(right)*

FIGURE 9-10: The new Lens Correction filter in Photoshop CS2

(**Filter** > **Distort** > **Lens Correction**). Figure 9-10 shows its controls applied to an image.

If you don't use Adobe Camera Raw and you haven't yet upgraded to Photoshop CS2, you can use the Photoshop plug-in Debarrelizer (www.theimagingfactory.com/data/pages/products/products1.htm), to correct lens distortions and chromatic aberrations, as shown in Figure 9-11.

FIXING CHROMATIC ABERRATION AND PURPLE FRINGING

In the following example, we'll show you how to use Panorama Tools to correct the chromatic aberration and purple fringing in a shot we took using a Sony F828. To get a free version of Panorama Tools visit the site www.ptgui.com, which should offer a link to download Panorama Tools, as well as a user-friendly front-end to it as well. [⚡]

Figure 9-12 shows the original file, which has not been sharpened or CA corrected.

1. Because this technique relies on layers, use Photoshop to create a new layer containing the result of flattening all the current layers.

—[⚡]—

NOTE:
Panorama Tools is primarily intended for stitching together the component images of a panorama, but its correction tool Radial Shift will fix fringing.

FIGURE 9-11: Removing chromatic aberration in Debarrelizer

FIGURE 9-12: The original photo with strong chromatic aberration and purple fringing

FIGURE 9-13: Correcting radial shift in Panorama Tools

FIGURE 9-14: After using Panorama Tools

FIGURE 9-15: Selectively reduce a narrow range of color

FIGURE 9-16: The result after applying Hue/Saturation

FIGURE 9-17: Purple fringing can also be reduced using the Selective Color Options

2. In Panorama Tools, go to **Correct Options** and choose **Radial Shift** to display the dialog box shown on the right in Figure 9-13. To remove some CA, enter the settings shown. (The parameters may vary with the focal length.)Figure 9-14 shows the corrected image. This step removed some of the purple and even more of the green CA fringing.

 We'd like to reduce the purple even more (as mentioned earlier, the Sony F828 exhibits both lens CA and sensor-based purple fringing).

3. To do so, return to Photoshop and use its **Hue/Saturation** tool to reduce the purple (Figure 9-15).

 While these settings do leave desaturated areas in the picture, the result is not as bad as the purple fringing in the original (see Figure 9-16).

4. This step is optional. You can additionally (or alternatively) reduce magenta using **Selective Color Options** in Photoshop (Figure 9-17).

9.4: Distortion

You may be surprised to see how much distortion even good lenses can show. The good news is that you will hardly see the distortion in images that have no straight horizontal or vertical lines. However, when you photograph architecture, the distortion can be quite annoying.

Fortunately, there are tools to make two kinds of corrections:

- **Visual corrections** based on barrel or pincushion distortions
- **Profile-based corrections** that use measured profiles for camera/lens combinations

Whenever possible, you should use a tool that is profile-based because the correction will be automatic and more correct, though the other tools will also help you achieve a pleasing result.

PROFILE-BASED CORRECTIONS

Our favorite tool is the free PTLens plug-in (www.epaperpress.com/ptlens), but, as of this writing, it is only available for the PC. For Mac OS, however, you can buy LensFix (www.kekus.com) at a very reasonable price, which is based on the same technology.

The following example demonstrates how PTLens works. In Figure 9-18, the horizontal and vertical lines of the wall and windows make the barrel distortion quite noticeable.

PTLens can correct this automatically, based on the camera/lens combination. Figure 9-19 shows the information PTLens displays for the window image. PTLens tries to obtain as much info from the image EXIF and the camera profile as possible; as you can see in Figure 9-19, it detected most of this information automatically, but we had to select the lens/telephoto converter manually.

The resulting image (Figure 9-20) looks much better.

FIGURE 9-18: Strong barrel distortion

FIGURE 9-19: PTLens user interface

FIGURE 9-20: Corrected image

FIGURE 9-21: Distortion caused by a Canon 15 mm fisheye lens

FIGURE 9-22: PTLens has corrected the distortion automatically, based on its profile for the lens.

In some cases PTLens can even be used to correct distortion created by a fisheye lens, like the shot in Figure 9-21 which is corrected in Figure 9-22.

PHOTOSHOP CS2: LENS CORRECTION

The correction performed by Photoshop CS2's Lens Correction filter (Figure 9-23) may be not as perfect as the one in PTLens, but in most cases it will do the job. (Remember, in the old

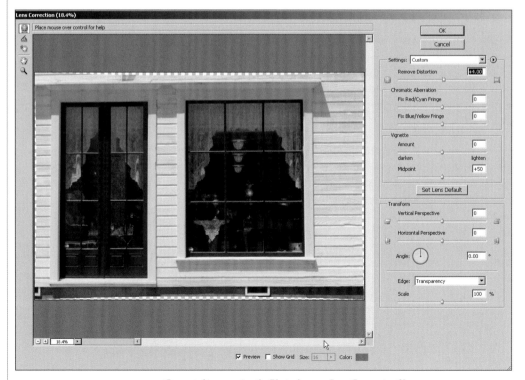

FIGURE 9-23: Corrected image using the Photoshop CS2 Lens Correction filter

days you couldn't make any corrections at all.) To make this correction, we set the Transform sliders (Vertical Perspective and Horizontal Perspective) to zero.

FIGURE 9-24: Severe vignetting

9.5: Vignetting

Vignetting describes the darkening of an image's corners in a photo. We rarely encounter this problem in our shots, but vignetting can occur both with wide-angle lenses at open aperture and in some flash photos (see Figure 9-24). (We exaggerated the effect in this photo for demonstration purposes; the real image had only minor vignetting.)

Vignetting can be fixed in ACR (as discussed in Chapter 4) or with the CS2 Lens Correction tool. Figure 9-25 shows how we fixed the camera image with the Lens Correction tool.

The Midpoint setting for this tool defines how far from the middle of your image the vignetting correction should start. However, in some cases, this approach may not be enough, because some lenses display asymmetrical vignetting behavior. (As always, try not to overcorrect the images. These photos still appear lifelike.)

NOTE:
Deliberate vignetting can be used to add a creative touch to your image. By slightly darkening the outer border of your photo you can lead your viewer to focus on the middle of the frame, where you usually want them to look. To do this, use a negative value for Amount. However, because this effect will create a circular darkening, we usually prefer to use a darker frame produced in Photoshop.

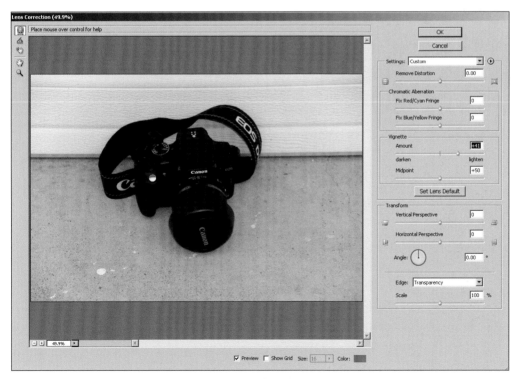

FIGURE 9-25: Quick fix performed in Lens Correction

—[⚡]—

NOTE:

If you must align an image, crop it after you align it.

9.6: Correcting Tilt and Perspective Corrections

Tilt and perspective distortion are two common problems.

FIGURE 9-26: Perspective distortion

ROTATION (CORRECTING TILT)

As you learned in Chapter 4, some RAW converters, such as the ACR 3.*x* Straighten tool and the latest versions of Capture One, help to correct tilt directly. For all the other converters, you can use Photoshop and the CS2 Lens Correction filter.

The Photoshop tool works in 16-bit mode, so if you choose to work with an 8-bit image, you should make the correction in the RAW converter first. If you prefer to correct your image in Photoshop, stay in 16-bit mode until the tilt is correct (and other corrections are done as well), and only convert to 8-bit mode afterward (by choosing **Image** > **Mode** > **8 Bits/Channel**). [⚡]

PERSPECTIVE CORRECTIONS

Figure 9-26 shows an image with classic perspective distortion as well as minor lens barrel distortion.

As shown in Figure 9-27, both distortions can be corrected in one step with the PS CS2 Lens Correction filter (**Filter** > **Distort** > **Lens Correction**).

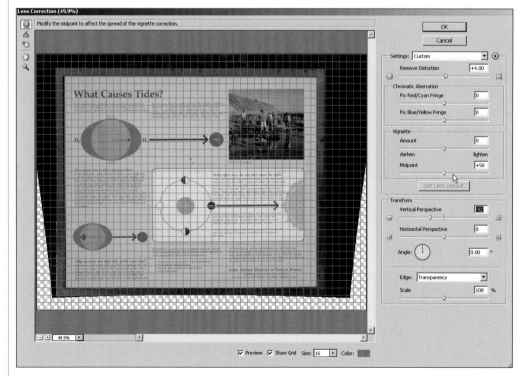

FIGURE 9-27: Using the Lens Correction filter to fix perspective distortion

FIGURE 9-28: Final corrected picture

For this correction, you must enable the grid in the filter. Figure 9-28 shows the final image after a crop.

9.7: Removing Dust Spots

Sometimes the CCD (charge-coupled device) or CMOS (complimentary metal-oxide semiconductor) sensors collect dust. These spots are easy to see in brighter parts of the image, such as the sky. You can use the Photoshop Clone tool to fix dust spots by copying over the spot with a similar area of the image. This is a familiar technique that has been discussed in many basic Photoshop tutorials.

Photoshop 7 introduced a more sophisticated Clone tool called the Healing Brush, which melds the source and target areas together and often produces a more pleasing result than the Clone tool. For example, Figure 9-29 shows a sample dust spot that we can fix with the Healing Brush.❀

1. Select the **Healing Brush** tool in the Photoshop Tools palette. Press Alt and the source cursor will appear as in Figure 9-30. (It can be hard to spot if the color of the cursor is close to the background color.)

2. Click in the area that you want to sample for use in replacing the target (in this example, the dust spot).

3. Drag to create a brush that is slightly bigger than the dust spot.

4. Position the brush over the spot, and click the mouse button (Figure 9-31).

We rarely use the Clone tool anymore to remove unwanted parts from a photo but, as our friend Phil Lindsay says, "it's true that the healing tool is great, but there are still instances in which the Rubber Stamp may work better—especially if the two regions have grossly different colors."

FIGURE 9-29: Spot caused by dust on the sensor

FIGURE 9-30: Selecting the source for the Healing Brush

NOTE:
This particular example is not an easy one to fix, because the dust spot sits on top of a cloud pattern. Our cloned replacement could be improved to better reflect the original pattern.

FIGURE 9-31: (*left*) Apply the Healing Brush; (*right*) The corrected image

THE PATCH TOOL

The Patch Tool uses the same algorithms as the Healing Brush, and can be used to remove, or move, areas in your picture. We'll use it to remove the same dust spot.

1. [icon] Select the Patch tool.

2. Select the area you want to remove. As shown in Figure 9-32, it works like a lasso.

3. Drag the selected area to an area in the picture that has a pattern you can use to replace the source area (Figure 9-33)

The result (Figure 9-34) is close to what we achieved using the Healing Brush.

FIGURE 9-32: Making a selection with the Patch tool

FIGURE 9-33: Move the selection to a replacement source

FIGURE 9-34: The result after applying the Patch tool

Sometimes, you will need to use the Healing Brush to make final touchups to the patched area. In such cases, use the Patch tool first, and then clean up the borders with the Healing Brush.

USING SELECTION WITH THE HEALING BRUSH

Figure 9-35 shows an image with a spot on the CCD sensor. (Actually, residue from trying to clean it with compressed air. Ouch!) As you can see, it would be difficult to use the Healing Brush to fix this problem because the spot doesn't occur in a nice, uniform part of the image.

Here is an approach that will work:

1. Work at about 400 percent magnification so that you can see fine detail.

2. Drag a rectangular marquee to select the area that you want to *protect* from the Healing Brush, and invert the selection (Figure 9-36).

3. Because we have protected an area, the Healing Brush is restricted to the selection and will not interfere with the areas that are not selected (the window, in this case).

4. After some more work, we get a final result that looks like Figure 9-37.

The result is not perfect, but the imperfections will not be noticeable in smaller to midsize prints. This is a good example of how the Healing Brush can save your day.

FIGURE 9-35: A major spot

FIGURE 9-36: A Protect window

FIGURE 9-37: The "healed" image

BATCH PROCESSING
TECHNIQUES
FOR RAW FILES

10

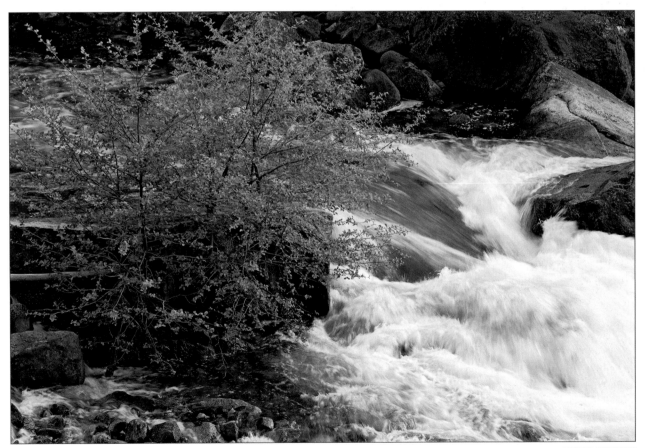

CAMERA: CANON 1DS

NOTE:

*If you don't have the time or patience to create your own master image, you can use the RAW converter's default settings to do so. In most cases, the resulting photo will be better than if it had been processed in-camera (after all, your computer has far more processing power than the chip in your camera). Too, while the camera's internal processing program (its **firmware**) is infrequently updated, your RAW converter is probably updated more frequently in order to utilize new innovations and better algorithms. Also, some of your RAW converter's default settings may be adjusted to correct or compensate for many of your camera's imperfections under specific shooting conditions.*

NOTE:

Most RAW converters can be configured to open a converted image in Photoshop automatically, though it's usually not practical to do so with batch processing. We suggest disabling this option.

When shooting digitally, most of us take and process at least twice as many pictures as we do with film. For this reason alone, processing photographs individually is inefficient and usually not a viable option, and in most cases you'll want to batch process most of your images. All the RAW converters described in this book allow you to do just that, though some are easier to use and more efficient than others.

10.1: A Basic Batch Processing Pattern

The basic sequence for batch processing is quite similar for all of the converters discussed in this book:

1. Inspect your files and sort them into those you want to keep and those you want to delete. This usually reduces the number of files by about ⅓ to ½.

2. Sort your "keeper" files into groups. For example, you might group together all images that have similar lighting conditions; those with similar contrast and color; or images destined for different conversion or output settings. To do this, you apply tags to the images, using your raw converter's image browser (for example, see the description for RawShooter on page 86).

3. Next, use your RAW converter to process either the first or the most typical picture in a group, making sure to achieve optimal results. This image will be your "master" or reference image for the batch conversion. [❁]

4. Save the RAW conversion settings you've made for the master image so you can apply them to all files with the same or similar characteristics. Some converters, including Adobe Camera Raw (ACR), Capture One, and RawShoooter, allow you to apply subsets of these settings, as well.

5. Select all files in the group, and apply the same settings to them.

CONVERSION OPTIONS

When you are applying settings for RAW conversion, most converters give you several options:

- Use the default settings for the camera profile (which you may or may not have modified from the original defaults).
- Use the original camera profile settings (those shipped with the converter) if they differ from the current defaults.
- Use settings you've previously applied to the individual files.
- Use the settings from the previous conversion.
- Use the settings of a (temporary) reference image. This is the option we use in our batch workflow.
- Use some other saved settings.

Some RAW converters offer additional options for batch processing. For example, some allow you to produce several output files from each source file, such as a high-resolution 16-bit TIFF files for use in fine-tuning and printing, as well as a low-resolution JPEG files for use in a web presentation.

Most RAW converters allow you to choose whether to perform the batch processing in the background (while you continue editing more files) or at a later time. Because processing many large files eats up a lot of CPU and memory resources, it may make sense to add files to a batch queue and process them later. Don't be surprised if your computer slows noticeably while background processing (dual-processor machines help considerably here). [⚡]

MANAGING AND RENAMING YOUR CONVERTED FILES

When batch processing, you can usually choose to write the output files to the same directory as the source files or to a different one. We prefer the latter, since it separates our working file set from the valuable original RAW files.

Most RAW converters offer an effective way to name or rename output files. In practice, however, we rename our files before they are even seen by a RAW converter. (See Chapter 3 for a discussion of the naming stage of our conversion workflow.)

Save your converted RAW files to a different folder than the one that holds your originals, so that the converted files won't mix with your current folder in the browser display. By saving to a different folder you also eliminate the risk of accidentally overwriting the source files, although most converters will prevent your doing so.

You can move or copy your converted files back to the source folder manually or with the converter's batch renaming feature. When renaming, be sure to define a logical naming scheme if your RAW converter doesn't do so as part of the conversion process (most do).

If you need to rename your files, you can use one of several renaming utilities (such as Rname-it or Downloader Pro, both mentioned in Chapter 3), though most RAW converters offer file renaming. For example, in Bridge, use **Tools > Batch Rename** to open the Batch Rename dialog box (see Figure 10-1). Bridge's renaming scheme is quite flexible, and allows you to include text, date, various sequence numbers, and some EXIF metadata in the filename. It will also allow you to copy a file or move it to a different folder. [⟳]

Batch processing has certainly become a more important feature of digital imaging software. For example, while Photoshop CS1 required you to write your own Photoshop action to open a file, make the various changes in Photoshop, and save them, Photoshop CS2 is preconfigured for batch processing. There are similar batch-processing enhancements in newer versions of other RAW converters, as well.

10.2: Batch Processing with Adobe CS Applications

Adobe Camera Raw, Bridge, and Photoshop CS are designed to work together, but the batch conversion process differs depending on whether you're using Photoshop CS1 or CS2. We'll begin with the process for CS1 users, then follow with the CS2 process, which is quite a bit simpler.

BATCH PROCESSING WITH ADOBE CAMERA RAW AND PHOTOSHOP CS1

To convert multiple RAW files efficiently with Photoshop CS1, you must create your own Photoshop action. This action should open a file in ACR, apply all the settings for the ACR workflow (select the output resolution, depth, color space, size, and so on), begin the conversion, set the target format, and finally save the file using the appropriate image mode.

When saving the file, be sure to select the correct output file format and settings for that format. (If you're not familiar with Photoshop actions, see the following procedure for creating an action. For more details, see the Photoshop Help system).

[⟳]

NOTE:
Apply IPTC metadata to your RAW files (e.g., from ACR/Bridge) to avoid having to assign this data to your converted files.

FIGURE 10-1: The Batch Rename dialog box in Bridge

CREATING AN ACTION IN PHOTOSHOP

A Photoshop **action** is a sequence of steps (such as opening a file or setting a new image mode), which are sometimes called **scripts**. Actions are very useful tools for handling repetitive tasks in Photoshop, and creating an action can be as simple as recording the different Photoshop steps in your task.

To create a new action, open the Actions panel (shown below) by choosing **Window** > **Actions**.

Before you begin, have a look at the basic recording tools in the Actions button bar. Their functions are shown from left to right, below:

■ Stop recording

■ Record (red while Photoshop is recording an action; green when the recording is stopped)

▷ Replay action

▢ Create a new action set

▢ Create a new action

🗑 Delete an action or action step

To create an action for batch processing RAW files:

1. ▢ Create a new action set by clicking this icon, then enter a descriptive name for this action set, like so.

2. ▢ Select the new action set in the Action Panel, and click this icon to create a new action.
 ▢ Once you start this process, all of your steps will be recorded until you click this icon.

3. A dialog appears, asking for a name for the new action. Let's call it *16-bit raw conversion*:

4. Open any RAW file (**File** > **Open**). It doesn't matter which file you open, because its name will be replaced by the file you select as the source when you run the action.

5. When Adobe Camera Raw appears, set all of the workflow options you want to use for your batch conversion. From the ACR **Settings** menu, select the appropriate conversion settings set you plan to use in your batch. (See Chapter 4 for more information on ACR workflow options and conversion settings.)

6. Click **Open** to begin the conversion. The converted image should open in Photoshop.

7. In Photoshop, set the image mode you want to use and, if you plan to make individual image corrections once the batch conversion is complete, add prototype adjustment layers.

8. Choose **File** > **Save As**. In the **Save As** window, select the appropriate file format (TIFF, for example), and set all of the options and modes for your intended file format. (The filename you give here will be overwritten when the actual batch processing is performed.)

9. Click OK to close the Save As dialog, then close the image window in Photoshop.

10. ■ Click this icon to stop recording and complete your action.

11. ▷ Review the steps in your action by clicking this icon for the action in the **Action Panel**. You should see all the steps and values you've chosen. (Photoshop allows you to add, delete, or replace steps at this point, as documented in the Photoshop Help.)

12. ◉ Now save your action set. Select the **Action Panel**, right-click on this icon and select **Save Actions**.

RUNNING THE ACTION

Once you've created an action, you can run it. To begin batch processing with Photoshop, select **File** > **Automate** > **Batch**. You should see the dialog box shown in Figure 10-2.

This dialog has four sections:

Play: Used to select the action and action set

Source: Used to select the source files

Destination: Used to specify where the processed (converted) files should go

Errors: Used to handle errors

FIGURE 10-2: The Batch dialog box in Photoshop

The Play Section

Select the action set. An **action set** is a collection of different actions grouped into a set. For an action to be listed in this pulldown menu, it should reside in the Photoshop default script folder.

In addition to the action you've just created and the predefined scripts shipped with Photoshop CS2, you can load additional scripts into Photoshop by activating the Action Panel (**Window** > **Action**). Once in the Action Panel,

choose **Load Actions** from the dropdown menu. Then, from the Batch dialog's **Set** menu, select the specific action you plan to use to process your source files.

The Source Section

In the Source section, you specify which files to process and how the processing should be done. There are various source selections:

For this RAW conversion, you will only need Folder or File Browser (or Bridge, if you are using CS2). (Dedicated actions may be useful with CS2 as well.) Select the Photoshop browser (or Bridge if you're using CS2) to process the files selected in file browser.

If you select **Folder**, all files in the selected folder (and optionally all files in its subfolders) are processed, in which case you must select the source file folder by clicking **Choose**. In any case, you should use the settings shown in Figure 10-3.

Override Action "Open" Commands suppresses the open dialog box as each source file is processed, but will still open each file. If you leave this unchecked, the action will open only the file that was in use when the batch script was recorded.

Include All Subfolders is optional and will recursively process all source subfolders, as well. (We rarely use this option.)

FIGURE 10-3: Recommended settings to suppress Open and Warning dialogs

Suppress File Open Options Dialog suppresses the File Open dialog when opening individual source files.

Suppress Color Profile Warning suppresses the warning dialog that appears if there is a mismatch between the converted file's color profile and Photoshop's current working space.

The Destination Section

Specify your file destination in the Destination section, which may be the same folder as the source files or a different one (you select by clicking Choose). Select **Folder** as the destination to define a naming pattern for the destination files.

The Errors Section

In the Errors section you specify what to do if an error occurs while processing the files. You can choose to stop the processing (useful when debugging scripts) or log the errors to a log file while continuing to process the next source file.

FIGURE 10-4: Batch conversion using Photoshop CS2's Image Processor

The second option is preferable in a final, well-tested script.

BATCH CONVERSION WITH BRIDGE

If you use CS2 and Bridge to perform a standard batch RAW conversion, you don't need to build a Photoshop action. The steps below will guide you through this simpler process. The pictures will eventually display in Photoshop, yet no actions are required and the images will be saved automatically.

1. Select the files you want to convert with Bridge.

2. Select **Tools** > **Photoshop** > **Image processor** to bring up the dialog box shown in Figure 10-4.

3. If you click the **Open First Image to Apply Settings** box, Photoshop will open ACR when you click **Run**. In ACR, you can apply the settings to all selected files. If you don't use this option, the current settings of the individually selected files are used.

4. Select the destination for the converted RAW files.

5. Select one or more file formats for the converted files. You can generate JPEGs, PSDs, or TIFFs simultaneously, and even resize the converted images.

6. You can select an additional Photoshop action to apply to the converted file. The default action offers several different workspaces but you should always include the ICC profile of your destination color workspace. (You can also embed a copyright notice in the image.)

7. Save the current settings of this dialog box or load previously saved settings.

8. Click **Run** to begin the conversion process.

If you selected Open First Image to Apply Settings (see area 1 of Figure 10-4), the ACR Open dialog will pop up, within which you can select a RAW file. When the file opens in ACR, you can set up various options for image optimization.

Click **Open** in ACR to begin the conversion and apply the settings to the file selected in the Open dialog and to all files previously selected in Bridge.

USING PREDEFINED SCRIPTS WITH PHOTOSHOP CS2 AND BRIDGE

You can also use one of Photoshop CS2's preconfigured scripts to perform batch conversions. If you test the scripts and like them, you simply select the files to be converted in Bridge and call the conversion function.

To select batch conversion in Bridge, select **Tools** > **Photoshop** > **Convert To**, as shown in Figure 10-5. You can select one of the preconfigured destination file formats such as JPEG, PDF, TIFF, and so on.

You'll see a dialog box like the one in Figure 10-6, where you can enter settings specific to the selected file format (such as Quality for JPEG or the option to embed an ICC profile). You can also select more conversion parameters from this dialog; for example, click **Output** to select a destination folder and various renaming options.

If none of the preconfigured scripts meets your requirements, or if you need additional scripts, you can design your own Photoshop actions and include them in the Bridge (or Photoshop) default script folder. Use the process described in the box titled "Creating an Action in Photoshop," earlier in the chapter, to do so. 🏵

SIMPLE PHOTOSHOP CS2 BATCH CONVERSION USING BRIDGE

If you choose to begin your conversion from Bridge, the process is very similar:

1. Select the files you want to convert within Bridge.

2. Double-click the previously selected files or by entering ⌃/⌘-R to bring up ACR in Filmstrip mode.

3. Select the file you want to use as the reference for your settings and make all your corrections to it and the other images.

4. Select all of the film strip files by using the shift key, or click the **Select All** button in the upper-left corner.

5. The ACR **Save** button will change to **Save *n* Images**, reflecting the number of images you selected.

6. Click **Synchronize** to apply the settings to all selected files.

> 🏵
>
> *NOTE:*
> *These predefined conversion scripts are available only in the complete CS2 suite. If you're using only Photoshop or an additional component of the suite, the menu shown in Figure 10-5 may look different.*

FIGURE 10-5: Batch scripts in Bridge (as part of the CS2 suite)

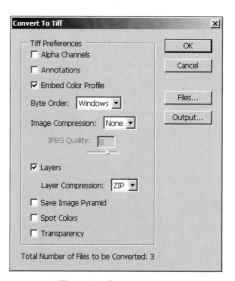

FIGURE 10-6: The options for converting to TIFF using the built-in Photoshop CS2 script

Save Options

Destination: Save in New Location ▼ ────────── [Save]

[Select Folder...] D:_tmp_workfiles\x_acr_tmp\ [Cancel]

File Naming
Example: 10d_0001_0385.tif

[Document Name ▼] + [▼] +

[▼] + [▼]

Begin Numbering: []

File Extension: [.tif ▼]

Format: [TIFF ▼]

Compression: [None ▼]

FIGURE 10-7: The Save Options dialog box in Adobe Camera Raw

Preferences [X]

Exposure Evaluation	Preview Cache	
Power and Portability	Miscellaneous Settings	Save Options
Process settings	Capture Options	1394 and Camera settings

Naming
Default name: [Untitled]

TIFF extension: [.tif] JPEG extension: [.jpg]

Name delimiter: [-]

☑ Use capture name as default name
☑ Include last 5 digits of capture number in filename
☑ Include 3 digits for duplicated filenames

Sample name:
My Image-01234.tif
My Image-01234-001.tif

☑ Include capture information in TIFF Caption
☑ Include EXIF information ☑ Embed thumbnail (TIFF)
Artist: [Juergen Gulbins]
Copyright: [Juergen Gulbins]

Processing settings
☐ Do NOT rotate the image (according to orientation)
☑ Disable Sharpening on output
☐ Perform processing on single processor
Banding suppression: DSLR noise suppression:
Low High Low High

[OK] [Abbrechen]

FIGURE 10-8: Batch setup in Capture One Pro

7. Click **Save *n* Images**. The Save Options dialog box (Figure 10-7) should appear.

8. Click **Save** to convert the selected files. ACR will display the processing status in the lower-right corner of the ACR window, just above the Save button.

═══

10.3: Batch Processing with Capture One Pro

═══

Capture One Pro pioneered improved workflow with RAW files as one of the first RAW converters to provide advanced batch processing. Although Capture One DSLR was one of the first utilities to provide batch processing, it has fallen somewhat behind the new releases of competing converters. However, it is still fast when compared to some converters and delivers very satisfactory image quality. We prefer to use Capture One in Filmstrip mode when batch processing.

Before running a batch process in Capture One, go to **File** > **Preferences** > **Process Settings**, and set the basic parameters shown in Figure 10-8. [⚡]

To control batch processing, use the **Batch Editor**, located in the Process tab of the Capture One main window (Figure 10-9). Here you'll find icons to control the batch queue, along with progress information about the state of the queue.

Process

Color Management workflow:
[Embed Camera Profile ▼]

Batch Editor
P8083158 (P8083... Stop Process
P8083160 (P8083160.ORF)
P8083163 (P8083163.ORF)

7% ...

Automatically open processed images ☑

FIGURE 10-9: The Batch Editor in Capture One Pro

[+] Adds the current image (or all selected images) to the batch queue, but does not initiate file processing.

Adds the current image (or all selected images) to the batch queue, and initiates the file processing.

─── [⚡] ───

NOTE:
Capture One allows you to include a copyright notice within the output files without calling up the ITPC metadata dialog.

Removes a selected item from the batch queue.

Begins processing the queue. The Progress bar at the bottom of the sections shows how much has been completed (see Figure 10-9).

Stops processing the batch queue. Items that haven't been processed remain in the queue.

Opens files recently processed via a dropdown list.

Allows you to select a different destination folder.

Opens the current processing folder for inspection.

When an image is added to the batch queue, the Process tab settings (such as Resolution, Depth, Size/Scaling, and File format) and all conversion settings you made in the Capture, White Balance, Exposure, and Focus tabs (as discussed in Chapter 7) are copied, using the image name as part of the conversion job ticket.

As in Photoshop, Capture One also provides a renaming function. To set it up, click the top icon. To begin renaming, make your file selection in the browser and click the bottom icon.

———

10.4: Batch Processing with RawShooter

———

Setting up batch processing in RawShooter is relatively simple, especially in Filmstrip mode. The processing settings are grouped under the **Batch Convert** tab, as shown in Figure 10-10.

Once you've applied the proper conversion settings (on the **Correct** tab, as discussed in Chapter 5), select the file(s) you want to process, check your workflow parameters using the **Batch Convert** tab, and click **Add**. This creates job tickets for the batch conversion and adds them to the batch queue.

Processing begins when you click **Go**. (While the batch queue is active, the button will toggle to **Stop**.) Once you begin processing the batch queue, all items in the queue are processed until you stop batch processing by pressing **Stop**. A status bar shows the progress of the individual conversions. Each item is removed from the batch queue as it is processed and, as with all other RAW converters, the original RAW files are not be modified.

The **Naming and Output Location** command opens a dialog box where you can specify the name and output location for your converted files. Use **Locate** to use your operating system's file browser to open the destination folder containing the converted files.

FIGURE 10-10: The Batch Convert tab in RawShooter

10.5: Smooth Batch Processing

No matter which RAW converter you use, a few general pointers will help you to make your batch process painless:

- Be sure that your source files are correctly selected before you begin a batch process. Either select them with the file browser or Bridge, as appropriate.
- Be sure that you have enough disk space for your converted files.
- Select a file-naming scheme for your destination files that won't overwrite files with identical names.
- Disable the Open and Save (or Save As) dialog boxes as well as the warnings, as shown in Figure 10-3. (You won't need to see these warnings if you've set up the process correctly.)
- If you create your own batch scripts by recording Photoshop steps, make sure that the steps you record set all parameters and settings (such as resolution, depth, space, output size or scaling, and output file format) that will be needed in the images to be converted, even if some of those settings are already correct in the sample image. Otherwise, the next time you call the script, you might be using different settings, and the result could be unpredictable.
- Thoroughly test any scripts that you use for your batch conversion. Be sure to test scripts under varying conditions as well; for instance, in cases where the output file already exists.

DIGITAL NEGATIVE (DNG) FORMAT

CAMERA: OLYMPUS E-20P

As of late 2005, every digital SLR manufacturer had its own proprietary RAW format, and most had several slightly different RAW formats for their different camera models. This can be a real nuisance for photographers who use more than one camera, and it requires that developers of RAW processing software provide a broad, ever-increasing range of conversion routines as part of their software. Every time a new camera hits the market, those developers must evaluate its specific RAW format and adapt and enhance their converters as necessary. Likewise, print shops, studios, and anyone else who needs to output digital data, need to accommodate the large variety of RAW formats, which can make processing costly.

This chapter looks at what may prove to be a viable solution: Adobe's Digital Negative (DNG) format.

===

11.1: DNG and Its Potential

===

Having implemented Adobe Camera Raw (ACR), Adobe has had rich experience with RAW conversion. After all, ACR is the leading RAW converter, with support for over 60 RAW formats as of this writing.

Adobe takes a two-step approach with ACR in order to support the many RAW formats. First, ACR converts the proprietary RAW data into a universal internal RAW format; it then converts from this intermediate format to either JPEG or TIFF.

Adobe has begun to specify a generalized format for RAW photo data, beginning with the introduction of the Digital Negative Format (DNG) at the Photokina exhibition, in 2004. DNG is designed to provide a universal container for RAW photo data, and it is partly derived from TIFF EP (a format underlying other RAW formats, as well).

DNG is designed to store three kinds of data:

- The actual RAW data read from the camera sensor
- The metadata, such as EXIF and ITPC
- The camera manufacturer's proprietary data (Adobe calls it *private data*)

Although it was introduced and is controlled by Adobe, DNG is a relatively open format in that it is well specified and documented, and its specification is published (the same is not true for most of the proprietary RAW formats). However, that openness ends where extensions and the development of DNG are concerned; two aspects of the format that have, to date, been controlled strictly by Adobe.

DNG holds three promises for the future:

- It could be used as an exchange format for RAW photo data in order to provide RAW files to anyone who cannot (or does not want to) process a camera's proprietary format.
- It could be used as an archival format for RAW photo data. For example, if the camera-specific proprietary RAW format used to shoot an image were no longer supported, or if the conversion to a standard format were no longer optimized (which might occur as the general optimization of the RAW data using the Bayer pattern continues), RAW files archived as DNG would probably remain accessible.
- DNG could replace some proprietary RAW formats or preclude the introduction of additional new ones, thereby reducing the jumble of different formats that professional photographers and image processors need to handle.

While not all of these predictions will come true immediately, DNG is a promising newcomer, and some advantages are already obvious. Consider the following.

DNG AS AN EXCHANGE FORMAT

Rather than handing off photos in a proprietary RAW file format, it could soon become standard practice supply your data in DNG format (unless JPEG or TIFF is the appropriate format).

To make it simpler to use DNG as an exchange format, Adobe offers a free RAW-to-DNG converter here: www.adobe.com/products/dng/main.html, for both Windows and Mac OS. All cameras supported by ACR are supported by the DNG Converter, and the Converter can convert entire folders, too (we'll walk you through a conversion later in this chapter). As the range of formats

supported by Adobe Camera Raw is extended, support should also extend to the DNG Converter.

Most RAW converter providers are beginning to support DNG as an exchange or archival format, including Phase One (with Capture One) and RawShooter. Too, most software companies that support the RAW file format for asset management systems either already support DNG or will do so soon. Of course, if your favorite tool does not yet support your specific RAW format, you can convert it to DNG using the DNG Converter, which will allow you to include those images in your picture database or use them with a special filter or other tool designed for working with RAW files.

There is yet another advantage to using DNG. Because it maintains a clear internal separation between photo data and metadata (see Chapter 12), if you change settings when correcting an image with a RAW converter such as ACR or RawShooter, you don't need to save the new settings in a separate sidecar file; they can be included in the DNG RAW file without modifying the original photographic information from the sensor readouts.

DNG AS AN ARCHIVAL RAW FORMAT

Just as PDFs have solved many document archiving problems, DNG may become the answer for archiving RAW photo data. As with PDF, however, DNG may not solve all problems, and it may not be the best solution in every case, though it is worth considering as a long-term archival format for RAW photo data.

If you're planning to use DNG for archival storage, bear in mind that it is a very new technology. The Digital Negative specification provides for all pixel information stored in current RAW formats and for all additional, proprietary metadata that many manufacturers include. However, the current release of Adobe's DNG Converter may, in some cases, ignore some of the proprietary metadata and include only basic information required for creating a high-quality image file. For safety's sake, if you're using the current release of the Adobe DNG Converter for archival purposes, be sure to save your camera's original RAW files in addition to your Digital Negative files.

DNG AS A NATIVE CAMERA RAW FORMAT

When DNG was first introduced by Adobe, many photographers wondered whether camera manufacturers might adopt DNG as their native camera RAW format. Smaller companies and new entries into the market will likely be the early adopters, because companies like Canon, Nikon, and Minolta have invested too much in their proprietary formats and tools to switch any time soon. In fact, early in 2005, Hasselblad and Leica (both relative newcomers to digital) announced their commitment to support DNG as a native camera RAW format. (Leica did so with its R9 digital back, introduced in July 2005.)

DNG will not be the only solution to the dilemma of multiple RAW formats, and we will likely see a real RAW format standard defined by a standards organization, such as ISO or ANSI. When that effort gets underway, Adobe will probably propose DNG as a standard. Today, however, DNG is an important step toward reducing the variety of RAW formats, and it will likely be enhanced and extended over the years. ❦

11.2: Using the Adobe DNG Converter

Adobe DNG converter's interface is shown in Figure 11-1.

As you can see, the interface is simple. (Keep in mind that it converts an entire folder of RAW files, not just a single file.)

In section 1 of the dialog box, you specify the folder that holds the RAW input files you want to convert and in section 2, you indicate where the generated DNG files will go. The parameters in section 3 define the naming convention for the newly generated DNG files. Section 4 lists the default conversion parameters; if you need to change any of them, click

❦

NOTE:
Because DNG is in a state of flux, as of this writing, we do not recommend converting all your RAW data to DNG and then deleting the original files (even though DNG files may include your original RAW data). We do recommend using DNG to exchange RAW files with other parties.

FIGURE 11-1: The DNG dialog for converting a complete folder of RAW files

FIGURE 11-2: The DNG Preferences window

Change Preferences to display the Preferences dialog box (Figure 11-2).

Here's an explanation of the options:

Compressed: Always use this option because the compression is lossless and it reduces the file size anywhere from 10 to 65 percent.

Image Conversion Method: The conversion can be performed by retaining the original RAW data (usually from a Bayer pattern sensor) or by converting to a linear picture. In most cases, the first method is preferable. As improvements to the Bayer pattern interpretation (*demosaicing*) are made, you will still retain the original data and you'll be able to apply any improved algorithm to it later. Linear conversion actually interpolates the Bayer pattern (except in the case of RAW files produced by a camera with a Foveon-based sensor), which can cause the loss of some data from your RAW negative. Too, linear conversion increases file size by anywhere from 60 to 300 percent, because the linear version

holds RGB data, while native RAW stores only one pixel value per sensor element.

Original Raw File: You can choose whether or not to embed the complete and original RAW file into a DNG file, essentially making DNG a wrapper for your RAW data. This would allow you to extract the original file from the DNG file later on. (To launch the Extraction tool, click **Extract** at the bottom of the conversion dialog box.)

Clicking **Convert** initiates the batch conversion. The DNG Converter is quite fast, but, as with other RAW converters, it will take time to convert many large files. Progress is indicated in the status window shown in Figure 11-3. To stop the conversion click **Stop Conversion**.

Like the original RAW files, DNG files can be used as input for RAW converters. If you attempt to open a DNG file using Photoshop, it will launch Adobe Camera Raw to convert from DNG to the standard image format, as described in Chapter 4. [⚡]

11.3: Advantages and Disadvantages of Converting to DNG

When we tested the DNG Converter, DNG files could be opened by Photoshop CS1 (also known as Photoshop 8) and Photoshop CS2 (also known as Photoshop 9).

- As of this writing, Capture One, Nikon Capture 4.1, Canon Digital Photo Professional, and Bibble did not support DNG. However, many viewers and digital asset management systems that support RAW files also support DNG (such as ThumbsPlus, Extensis Portfolio, and iView Media Pro), but you may need to download an updated version of their RAW converter plug-ins in order to have that support.
- Because DNG files use lossless compression, they are usually smaller than the original RAW files. We found that, when converted, Nikon .NEF files tended to gain about 10 percent, while Olympus .ORF files (from an Olympus E-20P DSLR) were reduced to about one-third the original Olympus file size. This factor is worth considering when storing your files on a CD or DVD, or when transferring RAW files via the Internet. That said, if compression is not activated, the DNG file can be up to twice the size of the original RAW file. For this reason alone, we do not recommend turning off compression.
- DNGC does not yet support *hot folders*. (When a new file is added to a hot folder, an action is initiated. In this case, it would initiate the conversion of a new RAW file to a DNG following a predefined pattern.) So each time new RAW files are imported, you must call up the DNG Converter. You can automate this step using a script, but it would be nice if it were automatic.

Converting from a proprietary RAW format to DNG is clearly an additional step in your workflow. So far, all RAW formats supported by the DNG Converter are also supported by Adobe Camera Raw so there is currently no real advantage to using DNG locally. The real advantage will come with exchanging RAW data.

FIGURE 11-3: The DNG Conversion Status window

CAMERA: NIKON D100

In previous chapters, we mentioned the various kinds of **metadata** (literally, data about data) that can be embedded in an image file, whether in RAW or a converted format. This chapter takes a closer look at the types of metadata that digital photographs can include, how to work with metadata in Adobe Camera Raw and Bridge, and how you can streamline file sorting and retrieval by using metadata effectively. (☙)

12.1: Metadata for Photographs

In digital photography, metadata describes an actual photo taken; it provides some sort of description of the data we normally consider the "content" of a file. Metadata may be embedded along with the image data in the actual data file, or it may be stored separately in a discrete file or in a database.

RAW files, TIFFs, and JPEGs can include several types of metadata:

- File attributes
- EXIF information
- IPTC information

They can also include:

- RAW conversion settings (such as those embedded in XMP)
- JPEG comments
- Preview icons and images
- Keywords
- Classification data, and so on (partly stored in an image database)

FILE ATTRIBUTES

The first type of metadata we'll consider is the type found in any computer file: the file attributes. The computer's file system stores metadata such as filename, file type (given by its extension), file creation and modification date, access rights, file size, and so on. (See Figure 12-1, which shows the file properties displayed in Adobe Bridge.)

Metadata ╲ Keywords	⊙
▽ **Camera Data (Exif)**	▲
Exposure	: 1/320 s at f/4
Exposure Program	: Normal
ISO Speed Ratings	: 80
Focal Length	: 17 mm
Max Aperture Value	: f/2.0
Software	: 29-1104
Date Time	: 04.08.2004, 14:21…
Date Time Original	: 04.08.2004, 14:21…
Flash	: Did not fire
Metering Mode	: Pattern
Orientation	: Normal
Make	: OLYMPUS OPTICAL…
Model	: E-20,E-20N,E-20P

FIGURE 12-1: The file properties displayed in Bridge

In a digital photograph, this metadata is first generated by the camera. It is later generated by the operating system, the RAW converter, and possibly other applications. Unlike EXIF and other metadata that we'll discuss shortly, this metadata isn't used to manipulate the digital image itself, so only the filename and type (and to a lesser extent, its creation date) are of practical value to the photographer. (Some cameras include some of this information, such as the creation date, as part of the filename.)

EXIF INFORMATION

The EXIF (EXchange Image Format for digital still cameras) data is created by the camera. It describes the settings that were used when the picture was taken. As you've seen in previous chapters on various RAW converters, this information includes the camera make and model, aperture and shutter speed, ISO settings, type of lens, focal length used, and whether a flash was active. It also includes the date and time the shot was taken, as well as the metering mode used, white balance and color space settings, the camera program used, and the resolution of the photograph. It may even contain the location where the shot was taken based on GPS data. (The Nikon D2X, for example, has an optional GPS module available that can be used to record

current GPS coordinates to be stored with the EXIF data of the camera.)

EXIF can store many other kinds of data as well, and the EXIF specification allows additional proprietary fields. All of these values are recorded when the picture is taken, and they are embedded in the data file, whether it is JPEG, TIFF, or RAW. Figure 12-2 shows EXIF information (called **camera data**) in Bridge.

This EXIF data is valuable to the photographer. It is also used by the RAW converter, by optimizing applications such as the lens-correction software PTLens and DxO (www.dxo.com), and by the firmware of photo laser printers (lightjet printers) when automatically optimizing pictures for output. [⚡]

There is usually little need for a user to change the information in EXIF. Consequently, Adobe Camera Raw, Capture One, and DPP do not offer change functions. If the date and time are not set correctly, however, you may want to eventually correct them. If so, consider using a specialized application, such as Exifer (www.cerious.com) or ACDSee (www.acdsystems.com).

Metadata	Keywords
▽ **File Properties**	
Filename	: P8042765.ORF
Document Kind	: Camera Raw
Application	: 29-1104
Date Created	: 04.08.2004, 14:21...
Date File Created	: 11.03.2005, 12:03...
Date File Modified	: 05.08.2004, 00:21...
File Size	: 9.47 MB
Dimensions	: 2572 x 1920
Resolution	: 240 dpi
Bit Depth	: 16
Supports XMP	: Yes

FIGURE 12-2: EXIF data in Bridge

IPTC (INTERNATIONAL PRESS TELECOMMUNICATION COUNCIL)

IPTC metadata is designed to be used by DRM (*Digital Rights Management*) systems (it does not embed a watermark into the file, however). It has been used for some time by photographers shooting press-related material. It was defined by the International Press Telecommunication Council, and it allows you to include copyright notices, author, title, a short subject description, and keywords to aid retrieval.

Although IPTC fields are present in files output by the camera or RAW converter, they are usually empty and must be filled in by the user. Photoshop provides a function to do just that.

ADDITIONAL METADATA

While there are well-accepted standards for EXIF and IPTC, you may find many other kinds of information encoded as metadata.

XMP

Adobe has defined XMP (Extensible Metadata Platform) for the metadata exchange between applications. XMP is widely used in Adobe applications, such as Acrobat, Photoshop, Illustrator, InDesign, and others. It is based on XML and is an open format (its specifications are published, and it is supported by the IETF). You can embed XMP data in your data file or store it in a separate file. XMP is quite flexible and may contain predefined fields, as well as user-defined ones.

With Adobe Camera Raw, the settings for RAW conversion are embedded in an XMP file. Photoshop (and Version Cue) may even include a version history in the XMP file of a picture. Other RAW converters store such information using a different format. For example, as discussed in Chapter 5, RawShooter stores these settings in files with the file extension .rws (inside a subfolder named .RWSSettings in the folder containing the RAW files) in a binary format. RawShooter allows you to have several settings files for one RAW file, and you can choose which settings to use for a particular conversion.

Further metadata about your photos can be stored in a separate database, as is often the case when you manage pictures using one of the many **digital asset management system** (DAMS) such as Extensis Portfolio, iView Media Pro, ThumbsPlus, or professional document or content management systems. DAMS tools like these usually allow you to add keywords, categories, and further classifications, which they normally store only in their database.

[⚡]
TIP:
With most photo services, you can disable this optimization by explicitly suppressing automatic optimization with your print job, or by setting an EXIF flag to indicate that the picture was previously optimized by some other application. For example, Photoshop sets this flag automatically when the image is modified.

If you use a DAMS to manage your images, be sure that your DAMS imports the EXIF and IPTC fields, as you will likely use them when searching within a database. Searching a database is much faster than opening individual files to read data. (See "Retrieving Files by Searching for Metadata" later in this chapter for more information.)

Overlapping Metadata Fields

There are some overlapping fields within different metadata sets. For example, both IPTC and EXIF provide fields for the title (or name) of your picture. With JPEGs (but not RAW files), you can also include the name as a comment.

Always choose one place, and only one place, to store this data. Redundancy often leads to conflicts and errors.

ICC Profiles

The ICC profile is another type of metadata that we've already touched on. ICC profiles define how the color (pixel) values of the image are to be interpreted (see Chapter 13).

As of this writing, ICC profiles are not part of RAW files with most digital cameras. They must be attached (embedded) to photographs when they emerge from the RAW converter, and they should stay with the file thereafter. Files containing embedded ICC profiles are called *ICC tagged files*. All of the RAW converters we've discussed handle EXIF and IPTC metadata and tag-converted files with the appropriate ICC profile. Again, as of this writing, XMP use is mainly restricted to Adobe applications. All of this metadata can be quite useful and important to you, and its usefulness will increase over time as more and more applications take advantage of the information. Bridge, for example, lets you search and sort files by much of the metadata mentioned (not only with photo files, but other Adobe application files, as well).

If you browse your picture files using the Photoshop CS1 file browser or Bridge (bundled with Photoshop CS2, as discussed in Chapter 4)

and change the white balance of a RAW data file (even without actually converting the RAW file), those changes will be saved and stored as XMP data. This data (RAW conversion settings) may be stored as separate "sidecar files" or in a central metadata database of Photoshop/Bridge. Because they consider RAW files to be sacrosanct (never to be modified), ACR, Bridge, and RawShooter store any additions or modifications of metadata separately from the RAW file. (In DNG format, metadata such as conversion settings can be embedded because DNG provides a clear, well-defined structure for accomplishing this. See Chapter 11.)

For displaying, editing, and working with metadata, Bridge, ACR, and Photoshop are the most advanced of the set of applications we deal with in this book.

12.2: Working with Metadata in Adobe Camera Raw and Bridge

Adobe applications are using metadata more frequently. The Photoshop file browser and Bridge both display some metadata as part of the image icon list and even more as part of the metadata preview window. The (almost) complete range of metadata is displayed when you call up the File Info window.

In Bridge or the Photoshop CS1 file browser, you can customize which metadata is displayed, along with thumbnails and the type of metadata that is visible, in the metadata panel of the browser (shown earlier in Figure 12-1). This customization is done via **Edit > Preferences**. (in Mac OS, use **Bridge > Preferences**). To customize information display with the preview icon, select **General**. As shown in Figure 12-3, only three fields will fit in this display.

Figure 12-4 shows thumbnails displayed with the Filename, Date Created, and Dimensions metadata options.

To determine which metadata is displayed in the much larger metadata area of the file browser, go to **Edit** > **Preferences** > **Metadata** (Figure 12-5). Again, the metadata fields are grouped by file properties, IPTC data, and EXIF data. Additionally, you can activate the edit history display. Labels and ratings associated with a picture file are part of the file's metadata, as well.

ENTERING AND APPLYING IPTC METADATA

As stated previously, almost all IPTC data must be entered manually. To do so, choose **Edit** > **Preferences** > **Metadata** in the file browser (Figure 12-5). Click on one of the IPTC fields marked by a symbol, and enter the value for that field. Once you've filled in all of your fields, press **Enter** to write the data into the file.

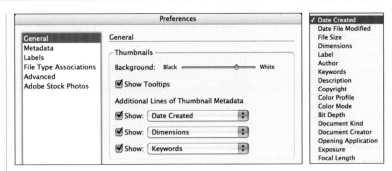

FIGURE 12-3: Customizing the way metadata is displayed in Icon View mode

Alternatively, you can call up the Metadata window by right-clicking the mouse button and selecting **File Info**. [❀]

IPTC Keywords can be grouped into sets. If you apply a set to a file, all the keywords of that set are included in the metadata. You can, however, select only one or more keywords of the set and apply them. If you delete a keyword or a keyword set from the keyword panel, or if you change the keyword name, the keyword data of the files to which those keywords were previously assigned will not change.

TIP:
Although keywords are part of the IPTC set, you must use the ***Keywords*** *panel to enter and edit them in Photoshop or Bridge.*

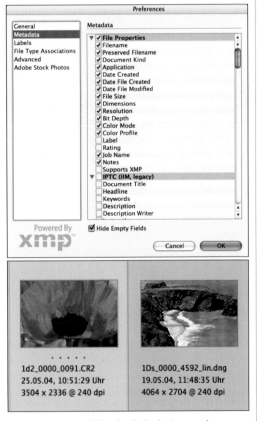

FIGURE 12-4: Thumbnails displaying metadata

FIGURE 12-5: Customizing the metadata in Icon View mode

⊙ To rename, delete, or create a new keyword or set, use the menu of the keyword panel or call up the menu by right-clicking while the cursor is over a keyword field.

| New Keyword |
| New Keyword Set |
| Rename |
| Delete |

If you select several files (preview icons) and edit the IPTC or keyword metadata, new values are applied (added) to all selected files. The panel in this case will usually display the message "Multiple values," indicating that the data values differ between the selected files.

If you want to apply the same IPTC data (for example, copyright, URL, and address) to several files, you've got an uphill battle. However, Bridge does allow you to apply a metadata template to the files selected in the browser windows. Do the following:

1. Apply the metadata to a single file, and save the data to a separate metadata file (.../**File Info** > **Advanced** > **Save**).

2. In the file browser, select the files to which you want to apply this metadata.

3. To apply the saved metadata to the selected files, choose .../**File Info** > **Advanced** > **Append**, and then select the name of the previously saved metadata in the dialog box that appears. ❀

WORKING WITH XMP FILES

XMP files are Unicode text files. This means that you may view and edit them simply by opening the XMP file with an ordinary (Unicode-enabled) text editor. This feature allows you to create your own metadata templates to assign copyright information to photographs and even create your own customized File Info panel (see www.adobe.com/products/xmp/custompanel.htm) among other things. [⚡]

Photoshop, Bridge, and ACR offer two ways to store metadata that is not embedded in an image file:

- In the ACR database
- In a separate XMP file, called a **sidecar file** by Adobe

Both methods have their benefits and their pitfalls. One benefit to storing external metadata in the ACR database file is that the result will be a very compact, centralized solution. However, this database has two disadvantages:

- If you move your directory with picture files to a different computer, the connection between the picture file and its external metadata will be broken and will be difficult to re-create. On the other hand, if you rename it using the Photoshop file browser or Bridge, the association will be maintained. However, there is no function that will allow you to move a file or a complete directory of files within Bridge or the Photoshop CSI file browser (other than drag and drop).
- Storing metadata in an XMP sidecar file adds an additional XMP file (name.**xmp**) to each picture file. This file resides in the same directory as the RAW file, and it contains metadata as well as the RAW conversion settings for the image file. As long as you rename your image file or move it using the Photoshop file browser or Bridge, the sidecar file will be renamed, copied, or moved consistently. However, if you perform these operations using different tools, you must make allowances for the sidecar file.

We prefer the second method because it allows us to move whole folders, including the metadata information, as well as to archive a folder (a CD or DVD, for example), while easily including metadata within the folder. It is very similar to the other RAW converters and file browsers, although they use different file and folder names.

❀

NOTE:
*Use **Replace** instead of **Append** to replace all of your file metadata with the fields set in the template.*

⚡

NOTE:
When editing an XMP file, make sure you don't alter the file's basic structure. Make sure you observe the correct XML/XMP syntax (for more information see http://partners.adobe.com/public/developer/xmp/topic.html).

12.3: Retrieving Files by Searching for Metadata

One of the benefits of using metadata becomes apparent when you sort and retrieve photos. For example, with the Photoshop file browser or Bridge, if you call up the Find dialog box (Figure 12-6) via **Edit > Find** or via Ctrl+F (Mac: ⌘+F), you can include several metadata characteristics in your search criteria.

Once your search is complete, the files that meet your search criteria will be grouped in a temporary set and optionally shown in a new browser window. You may then save this set as a new collection, which will look like a virtual folder.

As of this writing, there is no similar metadata search function in RawShooter, Capture One, Bibble, Nikon Capture, or DPP. As an alternative, you may be able to use this metadata with DAMS (digital asset management system) software like ThumbsPlus, Extensis, or iView, provided you're able to include the specific metadata in their database when you import the image files.

Photoshop locates data by searching its cache or by reading the metadata section of the files. Asset management systems look it up in their database, a process that's usually a much faster way to handle a large number of files. Before importing your images into these systems, however, make sure that the DAMS database has fields defined for the metadata you intend to use for searching. (You may have to configure this when customizing your DAMS.)

FIGURE 12-6: The Find dialog in Bridge allows you to specify several lookup criteria.

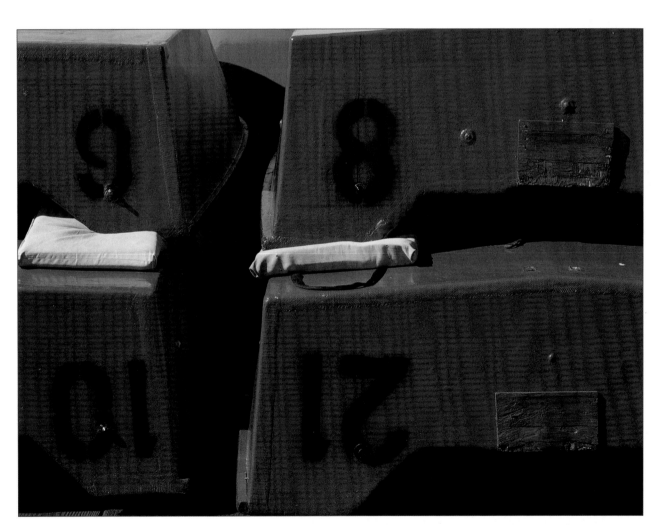

CAMERA: OLYMPUS E1

In Chapter 2, we emphasized the importance of using ICC device profiles and showed you how to create a monitor profile. We've assumed throughout this book that you'll use the generic camera profile included with the RAW converter software for your camera. All of the converters we've covered include good generic profiles for all DSLRs that they support. But for professionals who need the best results, custom profiling for digital cameras can be useful as well. Custom profiling is challenging, but this chapter will guide you.

You can use one of several packages for camera profiling, including the module Camera by GretagMacbeth (www.gretagmacbeth.com), inCamera by PictoColor (www.picto.com), and Profile Prism by Digital Domain (www.ddisoftware.com). This chapter will show you how to profile your camera with Camera and inCamera.

13.1: The Problem with Camera Profiles

When you profile a device, your first step should be to define the relevant parameters. Light is one of the most important ones. As input devices, cameras pose a particular challenge.

For example, when you profile a scanner, the light source remains the same (the profile only needs to distinguish between reflective prints and transparencies). With printers, D50 (daylight at 5000 K) is the standard light source used when evaluating and judging prints. Cameras, however, encounter varying light conditions, such as night shots, morning light, sun, clouds, and so on.

For this reason, a custom camera profile is practical only if you'll be shooting under a few different but well-controlled lighting conditions, such as in a studio. The scheme for profiling can be quite simple, and it is similar to that of profiling other devices:

1. Shoot a camera target (a ColorChecker or similar reference image with known color values) using the same lighting conditions you plan to use with your photographs. Use the same camera settings (resolution, white balance, exposure, and so on) that you plan to use later for shooting. Your target must have uniform lighting. The most difficult challenges are to get even lighting and to avoid the reflections that can occur with color targets that have glossy patches.

2. If you are shooting RAW, convert your target image using your standard RAW converter. Use your standard settings for this conversion. In some cases, it may be helpful to correct white balance.

3. Import the image of the camera target into your profiling software (be sure not to open it in Photoshop beforehand). Your profiling software will compare the colors in your image of the target with its known color values and calculate the camera ICC profile from that.

If you are shooting TIFFs or JPEGs, apply this profile to your photograph when you open the image in Photoshop. If you shoot RAW files, the RAW converter should accommodate custom camera profiles. RawShooter, Camera One, and Bibble accommodate custom profiles; Adobe Camera Raw, Canon Digital Photo Professional, and Nikon Capture do not. (Later in the chapter, we'll present an alternative for those tools.)

13.2: Camera Profiling with Eye-One Photo and ProfileMaker

GretagMacbeth's Camera package consists of a camera target and a software module called ProfileMaker 5. Camera is sold as a stand-alone package and as part of different Eye-One packages, such as Eye-One Photo. Gretag's Camera (which supports both Windows and Mac OS) includes a small (4 × 5 inch) camera target Mini ColorChecker, as shown in Figure 13-1.

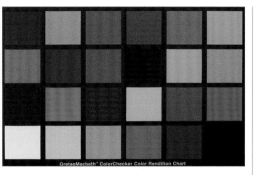

FIGURE 13-1: The GretagMacbeth Mini ColorChecker

FIGURE 13-2: GretagMacBeth's ColorChecker SG is an excellent camera target.

For serious camera profiling, however, you should consider purchasing ColorChecker SG, which can be ordered separately (see Figure 13-2) or comes as part of the extended package Eye-One Photo SG. It is larger than the Mini ColorChecker and has many more patches (color squares). It allows you to create better profiles. It isn't cheap, however (about 300 US dollars or Euros plus tax).

To justify the ColorChecker SG's price, it offers excellent color quality, it is quite robust, and the colors should not fade for a long time, even when used in bright light. The color patches show very little metamerism in varying lighting conditions.

To profile a camera using Eye-One Camera, follow these steps:

1. Photograph the target (ideally with ColorChecker SG), using the same lighting condition you'll use for a photo session. Continue shooting and profiling before you process the images from that session.

2. Convert your target image using the RAW converter's standard settings, and then convert it to a TIFF file. If you usually work with 16-bit TIFFs, convert the target image to a 16-bit TIFF, as well.

3. Start ProfileMaker 5, and select **Camera**. You should see the display shown in Figure 13-3.

4. From the **Reference Data** dropdown list, select the type of target used.

5. With **Photographed Testchart** selected in the dropdown list, click **Open** and then navigate to the image of the target shot.

FIGURE 13-3: The opening dialog of ProfileMaker 5.0

6. ProfileMaker will show the target image in a new window like the one shown in Figure 13-4.

 🔍 Carefully crop this image using the cross-hair cursor and the Zoom tool, as shown in Figure 13-4. (It's better to crop a bit too tightly than to include any surrounding black space. You can even crop into the target area if the image shows any perspective distortion.)

7. Compare your target image to that of the reference target (see Figure 13-3). If their orientation and pattern of patches are the same, click **OK** to proceed.

8. From the **Photo Task** dropdown menu in the main ProfileMaker window, select the type of picture you took. From the **Light Source** dropdown menu, select the type of lighting condition that was used for shooting.

9. If you need to tweak your profile for special lighting and color conditions, click **Photo Task Options** to display the window shown in Figure 13-5. (Only use the options here if you are experienced in profiling.)

10. Click **Start**, and ProfileMaker should begin generating the profile. You might see some messages advising that the image is over- or underexposed. Ignore them.

FIGURE 13-4: The target image open in ProfileMaker is ready to be cropped.

FIGURE 13-5: Several options allow you to adapt your camera profile to specific needs.

11. Provide a descriptive name for the profile, identifying the camera and lighting conditions, (e.g., Nikon-D70_Studio_D50).

That's it! You can use this as a camera ICC profile with Capture One, RawShooter, or Bibble. When using other RAW converters, you can assign it to a converted image using Photoshop.

13.3: A Custom Profiling Strategy for Adobe Camera Raw

We noted earlier that ACR, Canon Digital Photo Professional, and Nikon Capture do not support custom camera profiles. With those and similar RAW converters, the best approach is to convert your RAW files without performing much color correction in the converter and to then apply the generated profile to your converted TIFF or JPEG file using Photoshop. To do so, perform the following steps:

1. Open the converted image with Photoshop. Don't convert any profiles while you are opening the image.

2. Select **Image** > **Mode** > **Assign Profile** from the menu (In CS1: **Edit** > **Assign Profile**). From the Assign Profile dropdown menu (Figure 13-6), select the camera custom profile you generated using ProfileMaker for the lighting conditions you used when shooting.

If you checked **Preview** in the Assign Profile dialog box, you should see the effect of the selected camera profile even before you click OK. Click **OK** to assign the camera profile.

FIGURE 13-6: Assign your camera profile in Photoshop.

13.4: Camera Profiling with InCamera

InCamera is a Photoshop plug-in that allows you to create camera profiles. We recommend InCamera mainly for studio profiles in which you consistently control the light. To use it, just follow these steps:

1. Convert your RAW file with a RAW converter (such as RS) in the mode required to create camera profiles (see your documentation).

2. Open the converted file in Photoshop. When you see the Missing Profile warning dialog box (Figure 13-7), choose **Leave As Is (Don't Color Manage)** and click OK.

3. Run the InCamera plug-in, and adjust the grid to match the target (see Figure 13-8).

4. Click on **Check Capture**. InCamera will let you check for even lighting of your target (Figure 13-9). [❀]

NOTE:
Be prepared to reshoot the target if this check reveals any problems. Remember, providing good, even lighting is an art, and a good profile depends on shooting good target shots.

FIGURE 13-7: Ignore color management—for now.

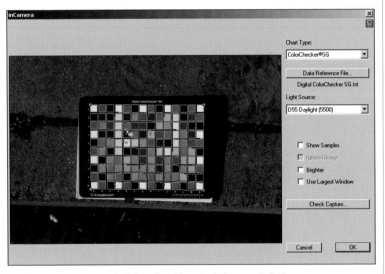

FIGURE 13-8: Adjust the grid to match the target in InCamera.

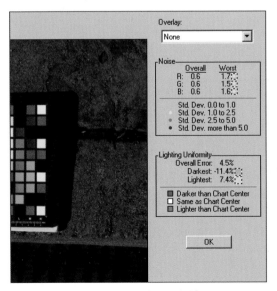

FIGURE 13-9: Check for even lighting.

5. Now, click **OK** and InCamera will save a ready-to-use camera profile.

═══

13.5: Shooting for a Neutral Gray

═══

One reason to profile is so that you can achieve a correct white balance, but correctness is not always what you want. For example, you may want to set up soft or colored lights within a studio to achieve a special mood. Also, when you're shooting under varying lighting conditions, as is usually the case when shooting outdoors or outside a studio, creating a custom ICC camera profile can be difficult. However, there are some ways to work around these problems.

There is an easy and universal solution to these challenges, although it may not achieve exactly the same color fidelty that you might get using a camera profile. You can use a color checker as a reference for your RAW converter's White Balance eyedropper tool. You saw previews of this technique in the workflow examples in Chapters 4 and 5, but here's a closer look at the technique. To use a color checker, just follow these steps:

1. Begin by shooting a color checker or gray card along with your subject.

2. Open the image with your RAW converter, such as Adobe Camera Raw, and activate the White Balance tab.

3 Pick up the eyedropper and select the gray patch on your color checker (with Mini ColorChecker, it is the second patch from the left in the bottom line, as shown in Figure 13-10). This sets your white balance, which should be nearly neutral by now.

4. Save this setting, and apply it to the other pictures taken with the same lighting conditions. You should get a good white-balanced result for all of them.

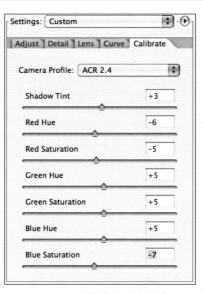

FIGURE 13-11: Profiling with Adobe Camera Raw's Calibrate tab

FIGURE 13-10: Shoot a color reference or a gray card with your first image and sample its neutral gray patch for white balancing. [⚡]

13.6: Calibrating Your Generic Camera Profile in Adobe Camera Raw

Although Adobe Camera Raw does not support custom camera profiles, it does provide controls and settings for special color corrections. These controls and settings will allow you to build special profiles (or something resembling custom profiles) for your camera. For example, if your camera tends to oversaturate red or cyan (more than other cameras of the same make and model), you might correct this in one image and then make it the default color setting for the camera. (You'll find these settings on the Calibrate tab, as shown in Figure 13-11.) [✿]

Use the sliders in the Calibrate tab with care, and closely watch their effects in the preview window. Also, be sure to use a correctly exposed photo for the calibration; it should show some neutral light gray areas where any color cast can be easily detected. One way to create those photos is to use a Mini ColorChecker.

 Set several measuring points with the eyedropper and try to obtain equal RGB values.

You can use these calibration settings as new camera defaults. ACR will use them for only a specific camera make and model. To use the settings as camera defaults, save them via **Save New Camera Raw Defaults** in the **Save Settings** menu, as shown in Figure 13-12.

FIGURE 13-12: Save your current settings as new camera defaults.

You can also save the settings as a file to be loaded again. You should probably save the Calibrate settings as a subset (**Save Settings Subset > Calibration**), as shown in Figure 13-13. Adobe Camera Raw stores the settings as **.xmp** files.

The default folder for calibrated settings is **C:\Documents and Settings\user\Application Data\Adobe\Camera Raw\Settings**. (For Mac OS users, it's **user/Library/Application Support/Adobe/Camera Raw/Settings**.) If you store your settings in that folder, they will be listed in the ACR Image Settings dropdown menu and may be recalled with a minimum of navigation.

FIGURE 13-13: ACR allows you to selectively save your settings.

—[⚡]—

NOTE:
Remember: RGB values are color space dependent! The RGB values given in the image shown are those of Adobe RGB (1998).

Going a step further, instead of simply judging a good gray color balance by eye, you can read the color values on your target using a spectrophotometer (such as Eye-One Pro), and set some color checkpoints with the ACR eyedropper at the color patches. If you don't have a spectrophotometer, use the patch values measured with our annotated Mini ColorChecker (see Figure 13-14).

Try tuning the calibration settings, so that the readouts achieve the target color values of the various patches. (This must be done iteratively, since changing one color will change other colors, and the process can get tedious.) Don't attempt to match all the patches; instead focus on the three or four patch colors that are important to you, (such as skin-colored patches or perhaps the blues). [⚡]

The results you achieve using this method will generally be better than those you would achieve by merely setting a neutral white/gray balance.

Lab: 39/14/15 RGB: 110/84/70	Lab: 66/17/18 RGB: 184/147/129	Lab: 50/-5/-22 RGB: 101/122/153	Lab: 43/-13/23 RGB: 95/107/67	Lab: 55/9/-24 RGB: 129/126/169	Lab: 70/-33/0 RGB: 128/128/169
Lab: 63/36/60 RGB: 202/124/51	Lab: 38/9/-43 RGB: 73/88/156	Lab: 51/48/17 RGB: 173/83/95	Lab: 30/20/-20 RGB: 83/62/101	Lab: 71/-22/56 RGB: 164/182/74	Lab: 72/20/69 RGB: 214/160/53
Lab: 29/18/-53 RGB: 52/64/148	Lab: 56/-38/33 RGB: 102/149/79	Lab: 41/56/29 RGB: 154/44/56	Lab: 82/5/79 RGB: 226/194/49	Lab: 51/50/-14 RGB: 167/82/144	Lab: 51/-29/-29 RGB: 60/135/167
Lab: 96/0/0 RGB: 243/243/243	Lab: 81/0/0 RGB: 200/200/200	Lab: 67/0/0 RGB: 162/162/162	Lab: 50/0/0 RGB: 118/118/118	Lab: 36/0/0 RGB: 85/85/85	Lab: 20/0/0 RGB: 52/52/52

FIGURE 13-14: Gretag's Mini ColorChecker annotated with the rounded Lab (L) and RGB (R) (Adobe RGB (1998)) patch color values

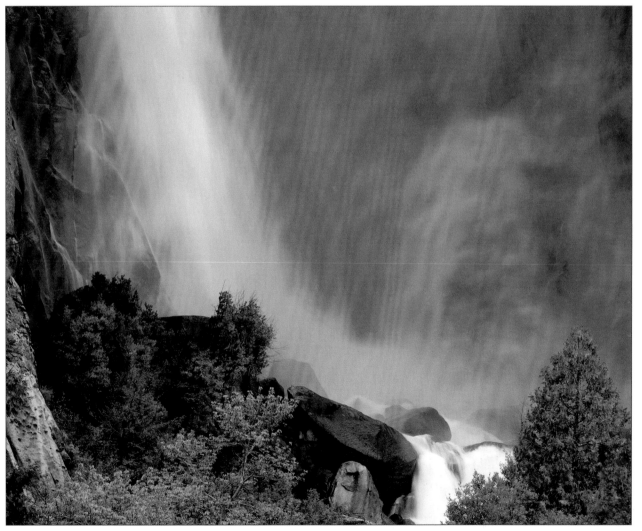

CAMERA: CANON 1DS

Because most people shoot in color, black-and-white (B&W) photography may seem to be a dying art. However, shooting in black and white is still viable and sometimes even superior in some instances.

To make a black-and-white photograph work well, your photograph must be highly abstract. Black-and-white photography lets you reduce your message to the most essential parts of the picture and to draw attention to those parts; you can force your viewers to focus their attention on shapes and contrast.

14.1: Turn Color Images into B&W

Although some digital cameras allow you to shoot in B&W, we recommend that you shoot in color and then use a RAW converter or Photoshop (or a similar image editor) to reduce the image to black and white. Converting color images to B&W has great potential, but merely converting an image from RGB mode to grayscale mode won't do the trick in most cases. A simple conversion will usuall result in a flat picture without much impact.

Shooting with B&W film has a long and well-established tradition, so let's compare the steps and elements of a traditional workflow (shooting with black-and-white film) to what's involved in shooting digital color and converting it to B&W with software. Table 14-1 presents the two workflows side by side. When you set up your digital color-to-B&W workflow, you should simulate these classic black-and-white techniques as much as possible.

14.2: B&W Workflow with ACR, Capture One, and RawShooter

We love the power of abstraction that black-and-white photography provides. You may have noticed that working in color and working in black and white require you to think very differently in order to achieve different feelings and effects. (See our color work at www.colors-by-nature.com.) In fact, when you are processing effective black-and-white photos, you can be distracted by the colors (especially in different versions of the same photo). For this chapter, we want you to think only in terms of black and white. To do that, you need to see the image exclusively in black and white.

SHOOTING WITH B&W FILM	CONVERTING DIGITAL IMAGES INTO B&W WITH PHOTOSHOP
The real world is in color.	*The real world is in color.*
The camera can utilize color filters (such as red, orange, yellow, and green).	*A digital color image can utilize different image formats (TIFF or JPEG from your RAW converter).*
B&W film is sensitive across the color spectrum.	*Photo filters can be used in Photoshop.*
B&W photography uses a negative and needs to be developed.	*Various techniques can be utilized to manipulate conversion, contrast, brightness, shadows, and highlights.*
B&W prints are produced utilizing different paper grades and dodge and burn.	*Dodge and burn is performed in Photoshop. Digital B&W prints are produced on digital printers.*

TABLE 14-1: Shooting with B&W film compared to converting digital images into B&W.

COLOR CONVERSION TECHNIQUES

The ways to convert color to B&W are nearly endless. Most of these methods are based on Photoshop:

- Using the Channel Mixer
- Desaturating the hue
- Using Photoshop plug-ins
- Converting to grayscale in the RAW converter (e.g., Adobe Camera Raw or Capture One DSLR)

All of these techniques are powerful, but they require switching from color to B&W, and thus detract from our pure B&W viewing process.

As alternatives, we have developed pure B&W workflows for Capture One, Adobe Camera Raw, and RawShooter. Our techniques differ for each workflow, but all allow you to view the thumbnails and previews in black and white. We'll begin with Capture One, which is the tool we prefer and the tool for which we developed a custom profile for B&W conversion.

B&W WITH CAPTURE ONE DSLR

 Capture One offers a very simple way to display images in grayscale. To switch to grayscale, click the button (on the top right of your screen). As you can see in Figure 14-1, the result is acceptable, but not very exciting.

FIGURE 14-1: Capture One in Grayscale Display mode

FIGURE 14-2: Capture One provides a generic grayscale profile.

Capture One can also convert your output to grayscale. You can find the Convert to Generic Grayscale option on the Develop tab, as shown in Figure 14-2.

This option creates a grayscale image with a gamma of 2.2. However, we prefer to work with a b&w image in RGB mode because using an RGB image allows us to perform further optimizations with Photoshop.

Within our workflow, our first step is to create a new profile that will convert color to black and white. To do this in Capture One DSLR Pro, we use the **Profile Editor** to desaturate the colors. Unfortunately, Capture One allows you to desaturate by only 30 percent in a single step. To save you from having to repeat the desaturation process several times, we have created a b&w camera profile, which you can download from www.outbackphoto.com/artofraw/raw_08/profile_BW.zip.

By using this tool, you can come close to achieving a 100 percent black and white workflow. Just follow these steps:

1. Select the new black-and-white profile as the default for your camera as shown in Figure 14-3. (Even the thumbnails will display in b&w.)

2. The Exposure, Contrast, Levels, and Curve tools in Capture One are very good for controlling b&w contrast and brightness (Figure 14-4). [❀]

3. You can use the WB control in Capture One (Figure 14-5) to modify the appearance of your image. Because the WB control was not designed to make black-and-white conversions, the underlying color image won't be very attractive at all. However,

our goal is to get a good black-and-white image, and in this context the colors are meaningless.

All three controls (Temperature, Tone Balance, and especially Color Cast) can affect the b&w

FIGURE 14-3: With Capture One DSLR, you can select a b&w profile as the default for your camera.

FIGURE 14-4: Use the Capture One Exposure, Contrast, and Curve tools to adjust your b&w image to suit your taste.

NOTE:
As an alternative to the profiling method we present here, you can use Photoshop's Channel Mixer to filter the color in an image to produce a b&w rendering.

FIGURE 14-5: You can use the WB tool in Capture One to control the look of the B&W image (which is still an RGB image).

FIGURE 14-6: A Canon 300D photograph converted in Capture One

conversion. You can also use Color Saturation to alter the B&W rendering, and you might even want to fiddle with the single RGB channels in the Levels tool. (Unfortunately, Curves in Capture One doesn't allow this feature yet.) Remember, too that you can save your settings.

Figure 14-6 shows an example of what you can achieve using Capture One for B&W conversion.

Working in Color and B&W

If you choose to work in both B&W and color, Capture One will limit you because it allows you to have only one type of settings and previews in your cache. As a workaround, we installed another instance of Capture One and stored it in a different folder to ensure that the cache is not shared (by default). To avoid a licensing hassle, when you install a second copy of Capture One, copy the *.lic file from the old installation root and insert it in the new installation root.

Example

We don't want the black-and-white photo to have too much contrast in Capture One. Later, we will open the file in Photoshop and apply some initial mild sharpening as a layer (see www .outbackphoto.com/workflow/wf_19/essay.html), which will allow us to improve the sharpening later on.

In Photoshop, we tweak the black (and if necessary) the white point in an Adjustment

layer (Figure 14-7) to get the final black-and-white snapshot. Figure 14-8 shows the result.

When you're done tweaking, save your image as a PSD file. ImagePrint 5.6 (see www .outbackphoto.com/printinginsights/pi.html) will open PSD files and print them using a custom ImagePrint gray profile.

CREATING B&W IMAGES WITH ACR

It's pretty easy to create B&W images with ACR. As shown in Figure 14-9, begin by setting the saturation to zero.

You can then manipulate the tonality using White Balance and calibration data. You can use the calibration data to change the colors of the underlying image to produce a different

FIGURE 14-7: Use a Levels Adjustment layer to tweak the white point of your image.

FIGURE 14-8: Canon 300D image converted with Capture One

black-and-white rendering. Very inaccurate colors can result in really nice grayscale representations.

Once you have converted a file and opened it in Photoshop CS, change it to Grayscale mode and open the **Shadow/Highlight** tool, as shown in Figure 14-10.

The Shadow/Highlight function provides the ultimate control for tweaking the tonality of your black-and-white images. For grayscale images, the **Color Correction** slider turns into a **Brightness** slider. You can use these controls to:

- Open up shadows
- Tone down highlights
- Enhance midtone contrast
- Optimize brightness

Canon EOS 10D: 10d_0000__0078.CRW (ISO 100, 1/320, f/9.0, 90 mm)

☑ Preview ☐ Shadows ☐ Highlights R: --- G: --- B: ---

Settings: Custom

Adjust Detail Lens Curve Calibrate

White Balance: As Shot

Temperature 5800

Tint +4

Exposure ☐ Auto +0.20

Shadows ☐ Auto 4

Brightness ☐ Auto 50

Contrast ☐ Auto +25

Saturation -100

26.2%

☑ Show Workflow Options

Space: Adobe RGB (1998) Size: 3072 by 2048 (6.3 MP)

Depth: 8 Bits/Channel Resolution: 240 pixels/inch

Save... Cancel

Open Done

FIGURE 14-9: Setting the Saturation to zero will display your images in black and white.

B&W Thumbnails and Previews

You can apply your saturation settings to all of the pictures you want to convert to black and white. As shown in Figure 14-11, even the thumbnails and the preview images will appear in B&W.

In the Preferences window (Figure 14-12), set the **Save Image Settings In** option to *Sidecar Xmp Files* to save your changes. Otherwise, any other color images with the same name might turn gray, too.

Use the **Preferences** tab to save this ACR setup as the default for black and white. While **Extended** is activated, display the triangle drop-down menu and choose **Settings** > **Preferences** (Figure 14-13).

FIGURE 14-10: You can optimize your image using Photoshop's Shadow/Highlight function.

FIGURE 14-11: Previewing images in black and white

FIGURE 14-12: Set your preferences to save your image settings in separate files so you don't overwrite a color version of the same image.

FIGURE 14-13: You can save your ACR settings as new camera defaults.

B&W WITH RAW SHOOTER

RawShooter also does a good job of converting color to black and white (see Figure 14-14), and allows you to use both of the techniques we discussed earlier. You can set the saturation to zero, as in ACR (usually the most convenient technique), or you can use a profile, as in Capture One. RawShooter will even let you use different color and B&W Snapshot settings.

The Fill Light, Shadow Contrast, and Highlight Contrast sliders are especially useful when you are optimizing the tonality of your B&W pictures. Hard contrast, which is sometimes very disturbing in color photos, looks just fine in black-and-white images. (When we work in black and white, we frequently use stronger positive settings for Shadow and Highlight Contrast than we do when we work with color.)

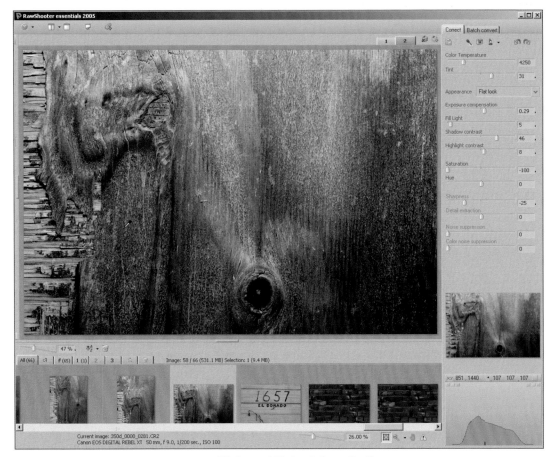

FIGURE 14-14: Working with black and white in RawShooter

FIGURE 14-15: RD offers six methods for B&W conversion

14.5: B&W Images with RAW Developer

RAW Developer offers several methods for B&W conversion and even provides a separate tab for it (see Figures 14-15 and 14-16). While most of its methods do not offer separate controls, **Custom Tone** and **Channel Mixer** do. You can use **Custom Tone** to give an image an additional hue, like sepia, or a small amount of cold blue, as shown in Figure 14-17.

The Channel Mixer is very flexible. It works much like Photoshop's Channel Mixer, which we discuss in Chapter 9. 📖

14.6: B&W Workflow with Aperture

Because black and white is increasingly used by professional photographers switching over from film, Apple includes a B&W conversion method, the **Monochrome Mixer**, in Aperture (see Figure 14-18).

The Monochrome Mixer is like the Channel Mixer in Photoshop and RAW Developer. To activate it, use the Adjustments tab. The default preset is Monochrome, but you may use other presets that simulate the traditional color filters used with film. (You may adjust the RGB controls with all presets.)

NOTE:
The result will always be an RGB image no matter which RAW Developer method you use. If you want a true grayscale image, you will have to convert your image in Photoshop.

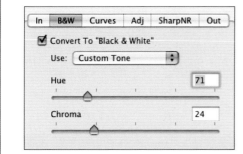
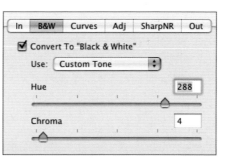
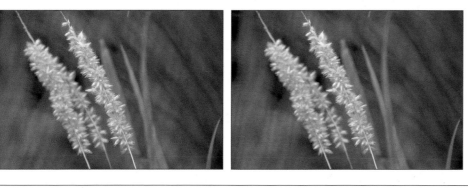

FIGURE 14-16: The same image converted with two different Custom Tone settings

Color: To add hue to a monochrome image, use either the **Sepia Tone** or the **Color Monochrome** control (see Figure 14-19). Click to bring up a color wheel where you may choose your basic hue. You can see a couple of example results in Figures 14-20 and 14-21.

As with all RAW converters, the result will still be an RGB image.

FIGURE 14-18: Aperture Monochrome Mixer.

FIGURE 14-19: You may add a hue either via Sepia Tone or Color Monochrome.

FIGURE 14-20: Original image *(left)* and B&W image *(right)* using Monochrome Mixer with preset Monochrome

FIGURE 14-21: B&W version using Monochrome Mixer and the preset
Orange Filter *(left)*; B&W image using Preset Monochrome and Sepia Tone at Intensity 0.7 *(right)*

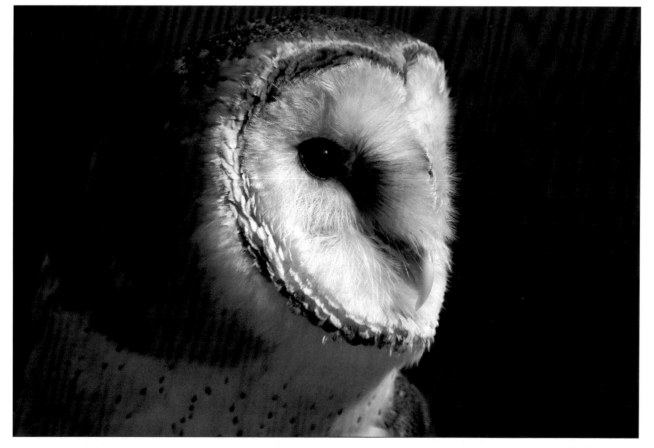

CAMERA: NIKON D100

AA filter Antialiasing filter. Used in digital cameras to spread incoming light slightly so that small points of white light will be recorded by more than one sensor element.

aberration Irregularities in an image, caused by some weakness of a lens. With digital photographs, there are two types of aberrations:

- **Chromatic aberrations** are caused by the fact that a lens refracts light differentially as a function of its wavelength (color). Good lenses compensate largely by combining several lens elements. Such a lens is called an **achromatic lens**. Chromatic aberrations (CA for short) usually show up as purple/green fringes that are more visible at edges within an image. Good RAW converters offer tools to reduce chromatic aberrations.
- **Spherical aberrations** are blurs in parts of an image.

absolute colorimetric *See rendering intent.*

ACR *See Adobe Camera Raw.*

Adobe RGB (1998) A color space defined by Adobe. It is well-suited for digital photographs, has a reasonably wide gamut, larger than sRGB, and includes most printable colors.

Adobe Camera Raw (ACR) The RAW converter provided as a plug-in by Adobe as part of Photoshop CS1 and CS2. Photoshop CS1 (aka Photoshop 8) ships with ACR 2.*x*, while Photoshop CS2 (aka Photoshop 9) has ACR 3.*x*. Photoshop Elements 3 provides a slightly stripped ACR 2.*x* interface.

aliasing Technically, any kind of false information generated by sampling a signal at too low a rate. In digital photographs, aliasing usually appears as "the jaggies," particularly visible at areas of high contrast.

artifacts Any undesirable effect visible when an image is printed or displayed, such as moiré patterns, banding, or compression artifacts. Compression artifacts (JPEG artifacts) may result from too severe JPEG compression. Oversharpening may also produce artifacts.

banding Noticeable jumps in tonal level between areas of an image where continuous tone levels would normally be. Banding is one type of **artifact**.

Bayer pattern An array of color filters placed in front of camera sensors that allow the camera to capture color information even though individual sensor elements can record only brightness. The Bayer pattern, in most cases, consists of a matrix of tiny green, red, and blue filter elements. The Bayer pattern algorithm (there are several others) interpolates RGB colors from individual gray levels for each pixel of an image.

blooming An effect that occurs when a CCD cell in a camera sensor receives too much light. Its electronic charge transfers to the next cell, producing an undesired "blooming" effect. Blooming is most visible at the edges of high contrast and highly saturated colors.

black point The density (or color) of the darkest black a device can reproduce. Black levels beyond that point in an image are clipped to the device's black point.

C1 Informal abbreviation for Capture One DSLR by Phase One. Because there is a trademark issue with C1, Phase One no longer uses this abbreviation, but instead uses "C0."

CA Chromatic aberration. *See aberration.*

calibration Adjusting the behavior of a device to a predefined state for accurate measurement. Calibration, in many cases, is the first step you take when **profiling** a device.

camera RAW format *See RAW.*

candela Unit of measurement for luminosity, or **luminance**. Luminosity is specified in candela per square meter (cd/m²).

CCD Charge-Coupled Device. An electronic element that accumulates an electronic charge depending upon the intensity of light (photons) perceived by the element. The photographic sensor in most present-day digital cameras consists of a matrix of CCDs. An alternative technology used in cameras sensors is the CMOS-based sensor.

cd *See candela.*

CF Compact flash. A type of data storage used in memory cards for digital cameras.

CIE Commission Internationale de l'Eclairage. The international scientific organization that defined the CIE LAB standard.

CIE LAB *See Lab.*

characterization *See profiling.*

CMM Color Matching Module. The internal color engine of a color management system. CMM translates the color from different source color spaces to the PCS (**Profile Connection Space**) and from the PCS to the output color space. Well known CMMs are Apple's **ColorSync** for the Mac and Microsoft's ICM (an integral part of Windows). Adobe provides its own CMM module with applications, such as Photoshop and InDesign. It's called ACE (Adobe Color Engine).

CMS Color Management System.

CMYK A subtractive color model used in print production and based on the four primary printing colors cyan, magenta, yellow and black. (Black is also called the **key color.**) Although many inkjet printers use CMYK inks (and often other additional colors), they make the conversion to this color model internally and present an RGB interface to the user.

CO Abbreviation for Capture One, the RAW converter of Phase One.

CRT Cathode Ray Tube. A component in monitors utilizing glass tubes for display.

clipping The loss of certain tonal values usually found at the color or tonal limits of a color space. Clipping occurs, for example, when converting images from 16-bit-mode to 8-bit or when converting from RGB to CMYK. In these cases, usually some saturated colors are clipped to become less saturated colors.

color gamut *See gamut.*

colorimeter An instrument used to measure the color of emitted light. Colorimeters are often used in profiling monitors.

color model The way colors are described by numbers as digital information. RGB, for example, uses a triple number, denoting the amounts of red, green, and blue. CMYK uses a quadruple number for the percentage of cyan, magenta, yellow, and black. There are other colors models, such as **Lab**, HSM, grayscale (a gray value), and bitmap (with pixel values of 0 or 1—white or black, respectively).

color space A range of colors available for a particular profile or color model. When an image resides in a particular color space, the range of colors available to that image is limited. The color space also defines how the color values of an image are to be interpreted. There are device-dependent color spaces (e.g., the color space used by scanners or printers) and device-independent color spaces (e.g., **LAB**, **Adobe RGB (1998)**, and **sRGB**).

ColorSync Apple's implementation of ICC-based color management (part of Mac OS 9 as well as Mac OS X).

color temperature A measure on the spectrum of the wavelength of white (light). The unit used is Kelvin (K). Lower color temperatures correspond to a red or yellowish light; higher temperatures result in a bluish tint. The term "temperature" stems from a "blackbody radiator" emitting (white) light when heated to a specific color temperature. See Figure A-1.

candlelight, fire	1000–1800 K	
tungsten	2600–2700 K	
halogen lamp	3400 K	
moonlight	4100 K	
D50 daylight illuminant	5000 K	
sunny and blue sky	5800 K	
D65 daylight illuminant	6500 K	
flash	6500 K	
cloudy sky	7000–8000 K	
neon light	8000–9000 K	
sunny mountain snow	up to 16,000 K	

FIGURE A-1: Examples of different color temperatures

color wheel A circular diagram displaying the available color spectrum at a particular brightness level.

chroma The technical term for **saturation**.

curves A tool in Photoshop that allows the user to manipulate the tonal values in an image. The curve diagram below represents the relationship between input and output. Modifying this curve changes the corresponding tonal values of the pixels in the image.

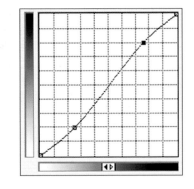

CS1, CS2 Informal abbreviation for Adobe Creative Suites 1 and 2. The full suite includes Photoshop, InDesign, Illustrator, GoLive, and Version Cue. The Premium suite includes Acrobat. CS2 also includes Bridge.

D50 Daylight at 5000 Kelvin. This is the standard light (*illuminant*) used in the printing industry (prepress) for evaluating colored prints.

D65 Daylight at 6500 Kelvin. This is the standard (*illuminant*) that is closer to the light emitted by CRT or LCD monitors.

device profile *See ICC profile.*

dithering A technique whereby dots are placed in a certain pattern to simulate many different colors and/or halftones with only a few primary colors. Viewed from an appropriate distance, the image is perceived as having continuous tones.

dot gain As ink spreads into paper, halftone dots grow slightly in size during the printing process. This increase is size is called **dot gain**. Different paper consistencies absorb different quantities of ink. Coated paper has a dot gain of 8–20 percent, and uncoated paper can have a dot gain up to 28 percent. Photoshop can compensate for dot gain by reducing dot size appropriately when outputting to printers.

dpi, DPI Dots per inch. Used as a measurement of print resolution for ink or toner dots on paper or printing plates. Most printing techniques (e.g., inkjet printers or offset presses) simulate a halftone value or a nonprimary color of a pixel using a pattern of tiny dots. With such printing techniques, the dpi value of a printing device must be considerably higher (by a factor of 4 to 8) than the **ppi** (pixel per inch) value of the image.

DSLR Digital Single-Lens Reflex. A standard type of professional and semi-professional digital camera.

ECI European Color Initiative. This organization focuses on defining standardized ways to exchange colors (color images) on the basis of ICC profiles. You can find some specific color profiles at their Internet home page (see www.eci.org).

ECI-RGB An RGB work space for images destined for prepress work in Europe. Its **gamut** is somewhat wider (slightly more green tints) than that of Adobe RGB (1998) and includes nearly all colors intended to be printed.

EPS Encapsulated PostScript. A standard file format for graphics, usually those containing vector graphics or a mix of vector graphics and bitmap images. Often, EPS files contain both the actual graphic information and additionally a preview image of that graphic.

EV *See exposure value.*

Exif, EXIF A standardized format for camera **metadata** describing how an image was captured (camera model, exposure value, focal length, etc.). This data is usually embedded in the image file and may be used for searching. PTLens, for example, uses the focal length value from EXIF data to correct lens distortions.

exposure value The exposure generated by an aperature, shutterspeed, and sensitivity combination. Doubling any of these parameters will double the exposure value. For example, f/8 × 1/125 s (shutter speed) at ISO 100 will result in the same EV as f/8 × 1/250 s at ISO 200 (both resulting in 13 EV). "+1 EV" halves the amount of light collected by a sensor, "-1 EV" doubles the amount of light collected by the sensor (e.g., f/5,6 × 1/250 s at ISO 100 would result in 12 EV).

Firewire IEEE 1394. A fast, serial interface for card readers, digital cameras, scanners, and other peripheral devices. Firewire allows transfer rates of up to 40 MB (1394a) or 80 MB (1394b).

gamma (1) The relationship between tonal values (or input voltage with a monitor) and perceived brightness. Two gamma values are in wide use:

· 1.8, the Apple standard for the Mac and preferred in prepress work.
· 2.2, the Windows standard. For photographs, we recommend using 2.2, (even on Macintosh systems) when calibrating monitors and profiling;

(2) The degree to which a **color space** or device is nonlinear in tonal behavior.

gamut The total range of colors (and densities) that an output device (e.g., a monitor or printer) can reproduce or that an input device (e.g., a scanner or digital camera) can capture. **Color gamut** is the range of colors a device can reproduce (or capture). **Dynamic range** refers to the brightness levels a device can produce or capture.

gamut mapping The way colors are remapped when an image is converted from one color space to another. If the destination space is smaller than the source space, color compression or color **clipping** will occur.

gray balanced A color space is **gray balanced** if equal values of the primary colors result in a neutral gray value. This situation is preferable for work spaces.

highlights Areas of an image with no color or gray level at all.

histogram A visual representation of tonal levels in an image. With color images, it is advantageous to see not only luminance levels but also tonal levels of each individual color channel:

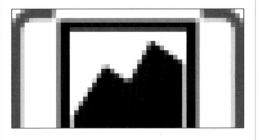

HSB, HSL Adaptions of the RGB color model. Colors are described by a **hue**, **saturation** of the hue, and **lightness** (HSL) or **brightness** (HSB).

hue Hue is normally referred to as "color tint."

ICC International Color Consortium. A consortium of companies that develop industry-wide standards for color management (e.g., ICC profiles). For more information, see www.color.org.

ICC profile A standardized data format used to describe the color behavior of a specific device. ICC profiles are the basis of color management systems. They allow CM systems to maintain consistent color impression across different devices, different platforms, and throughout a complete color-managed workflow.

ICM Image Color Management or Integrated Color Management. The Microsoft implementation of the color management module in Windows.

intent *See rendering intent.*

IT-8 A family of standard targets used by profiling devices such as scanners or digital cameras.

IPTC International Press Telecommunication Council. In photography, IPTC is a **metadata** format describing how an image can be used. It provides fields (e.g., for copyright notices, rights usage terms, a title [caption], and keywords).

JPEG Joint Photographic Experts Group. This ISO group defines a file format standard for color images. The JPEG format uses lossy compression, offering various trade-offs between high quality (at lower compression) and lower quality but smaller files resulting from higher compression.

Lab, LAB, L*a*b*, CIE LAB A perception-based **color model** defined by the CIE. Colors in this model are defined by L (**luminance**) and two color components, A and B. The A (or "a") ranges from red to green, and the B axis (or "b") ranges from blue to yellow.

LCD Liquid Crystal Display. A display technique used with flat panel monitors (TFT monitors).

lpi, LPI Lines per inch. The measure used to define printing resolution (or screen frequency) with typical halftone printing methods, such as offset printing.

luminance The amount of light (energy) emitted by a light source (e.g., by a monitor). The unit used with monitors is **candela per square meter (cd/m²)**.

metadata Data that describes other data objects. EXIF and ITPC data are examples of different kinds of metadata that can be included as part of digital photographs.

metamerism The phenomenon where two colors have the same color sensation under one lighting condition but do not have the same color sensation under a different lighting condition. This behavior may cause inconsistent results when the individual inks of a print have different metameric properties.

PCS Profile Connection Space. This is an intermediate color space used when converting colors from a source space to a destination space (say, from one profile to another). According to the ICC specification, it can be either CIE-LAB or CIE XYZ.

perceptual intent *See intent.*

PNG Portable Network Graphics. A flexible image file format that provides indexed color for up to 8 bits per channel and that allows transparency. This format, however, is not as flexible as TIFF.

ppi, PPI Pixels per inch. Used to specify the resolution of a digital image. See also **dpi**.

primary colors Those colors of a color model that are used to construct the colors of the pixels. Every color within a given color space is defined by the levels of the primary colors. For RGB, the primary colors are red, green, and blue. CMYK primaries are cyan, magenta, yellow, and black.

profile *See ICC profile.*

profiling The act of creating a device **profile**. Usually a two-step process, whereby the first step is to linearize the device. The second step measures the color behavior of the device and describes it with an ICC profile. The entire process is also called "characterization."

PS An informal abbreviation for Photoshop.

RAW (camera RAW format) Image data coming from the camera that mainly consists of the raw data read from the camera sensor and not yet processed and with no color interpolation (demosaicing). Today, almost all RAW image files use a

proprietary format, specific to the camera manufacturer and even the camera model. This raw data has to be converted by a RAW converter to be used in an image application such as Photoshop.

relative colorimetric *See rendering intent.*

rendering intent A strategy to achieve color space mapping when converting colors from a source to a destination color space. ICC has defined four different standard intents:

- **Perceptual** compresses colors of the source space to the gamut of the destination space (where the source space is smaller than the destination space). This is the intent recommended for photographs.
- **Relative colorimetric** does a 1:1 mapping when the colors in the source space are all present in the destination space. Out-of-gamut colors of the source are mapped (clipped) to the nearest neighbor of the destination space. This intent may be used for photographs if most of the colors in the source space are available in the destination space. In this case, most colors of the source are mapped 1:1 into the destination. The **white point** of the source space also is mapped to the white point of the destination space.
- **Absolute colorimetric** does a 1:1 mapping when colors in the source space are present in the destination space. Out-of-gamut colors of the source are mapped (clipped) to the nearest neighbor of the destination space. The *white point* of the source is maintained. This intent is used (only) for **soft proofing**.
- **Saturation**. This intent aims to maintain saturation of a source color, even when the actual color has shifted during the mapping. This intent may be used when mapping logos and diagrams, but it is not suitable for photographs.

resolution This term defines the depth of detail that an image can reproduce. Resolution is measured in dots per inch (**dpi**) or pixels per inch (**ppi**).

RGB Red, Green, Blue. These are the primary colors of the standard additive color model. Keep your photographs in RGB mode as long as possible, and use RGB for archiving your images.

RIP Raster Image Processor. A module, either part of a printer or a software application, that converts page information into a raster image or dot pattern for printing.

RS, RSE Informal abbreviations for RawShooter Essentials, a good RAW converter freely provided by Pixmantec.

saturation (1) Defines the purity of color. Saturation can vary from none (which is gray) via pastel colors (some saturation) to pure colors (full saturation) with no gray; (2) One of the four rendering intents. *See rendering intents.*

spectrophotometer An instrument that measures the color of emitted and reflected light. It usually is used for profiling printers and measuring the color (light spectrum) of a print or other surface.

soft proofing Using the monitor as a proofing device. For example, Photoshop can simulate on the monitor the colors that a picture will have using a different output method, such as printing.

sRGB A standard color space for monitors. It is intended for images presented on monitors or on the Internet.

tagged images Images with embedded color profile.

TIFF **Tagged Image File Format**. A file format for images. TIFF acts as an envelope format for a lot of different image formats and allows several different compression modes—most of them lossless (e.g., LZW, ZIP, Runlength encoding, uncompressed). It allows an image to store different color depths (from 1 to 32 bits per channel) and to embed comments, profiles, and other metadata as well as layers and alpha channels. It is well suited as an archival format for images.

unsharp masking A method of sharpening an image by increasing the contrast of edge pixels. The term stems from a traditional film-composing technique

USB Universal Serial Bus. A computer device interface for peripherals such as card readers, cameras, scanners, or external disks. There are two versions of the USB bus. USB 2 (high speed) is much faster (up to 60 MB)than USB 1.*x* (up to 1.2MB).

USM Informal abbreviation for **unsharp masking**.

vignetting An effect where some areas of a photograph are less illuminated than others. Most camera lenses exhibit "optical vignetting" to some degree (mostly at the outer edges but stronger when an aperture is wide open). "Mechanical vignetting" can occur if a lens hood is too small or not properly attached. See Figure A-2.

wide gamut RGB A large color space that covers almost all of RGB. There is no physical device that can reproduce all of the **wide gamut** colors. This color space is sometimes used for archival purposes when the output will be produced for photographic printers or transparent recorders.

white balance Adjusting the color temperature and color tints in an image so that there is no color cast and the gray areas show no color tint.

white point (1) The color of "pure white" in an image. On a monitor, it is the brightest white that the monitor can display. In photo prints, it usually is defined as the color of the blank paper; (2) The color of a light source or lighting conditions in terms of **color temperature**; (3) The color "white" in a color space. For example **Adobe RGB (1998)** and **sRGB** have a white point of 6500 K (**D65**), while **ECI-RGB**, **Color Match RGB**, and **Wide Gamut RGB** have a white point of 5000 K (**D50**). Most CMYK color spaces have a white point of D50.

white point adaption When a color mapping has to take place and the source and the destination spaces have different **white points**, with some **intents** (e.g., **relative colorimetric**) colors are adapted relative to the new **white point**.

working space A device-independent color space (profile). It defines the color **gamut** available to the image using this working space. For photographers, **Adobe RGB (1998)** or **ECI-RGB** (in Europe) are the recommended working spaces.

FIGURE A-2: Slight vignetting *(left)*; very strong vignetting *(right)*

RESOURCES

B

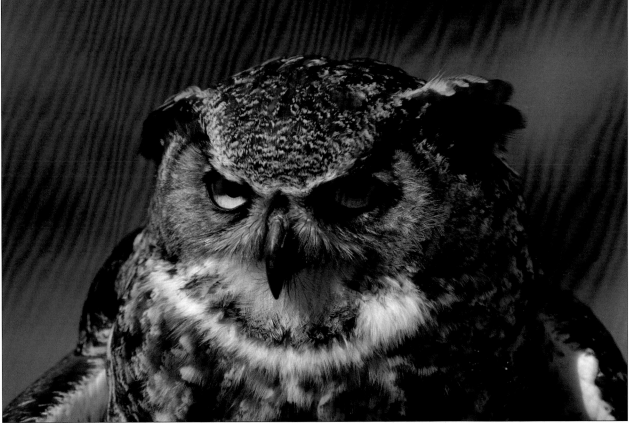

CAMERA: NIKON D100

Here you'll find all the references cited (with bracketed numbers) throughout the chapters and the Glossary. All the information here is current as this book goes to press. Remember, however, that Internet addresses may change or vanish over time. To help us keep this information up to date, please let us know if you find a link that no longer works, at artofraw@outbackphoto.com or art_of_raw@outbackphoto.com.

B.1: Recommended Books

Color Confidence: The Digital Photographer's Guide to Color Management by Tim Grey (Sybex Inc., San Francisco, CA 2004). Tim Grey gives an easy to understand introduction to color management, focused on those points that are relevant to photographers.

Real World Color Management. Industry-Strength Production Techniques. Second Edition by Bruce Fraser, Chris Murphy, Fred Bunting (Peachpit Press, Berkeley, CA, 2004). If you really want to plunge deeper into color management, this should be the right book for you.

Photoshop CS2. Up to Speed by Ben Wilmore (Peachpit Press, Berkeley, CA, 2005). This book will bring you up to speed with Photoshop CS2, assuming, that you are familiar with Photoshop CS1.

B.2: Useful Resources on the Internet

INFORMATION AND INSPIRATION

Uwe and Bettina Steinmueller's website at www. outbackphoto.com is a tremendous resource of information for photographers and there are updates almost daily. The following links are just a few examples mentioned in this book.

Outback Photo The home page of Bettina and Uwe Steinmueller, with lots of information on digital photography: www.outbackphoto.com

Colors by Nature Some of the color works by Bettina and Uwe Steinmueller: www.colors-by-nature.com

Uwe Steinmueller *A Profile for B&w conversion*: www.outbackphoto.com/artofraw/raw_08/profile_BW.zip

Digital Outback Photo *Our Tonality Tuning Toolkit*: www.outbackphoto.com/workflow/wf_61/essay.html

Digital Outback Photo *Digital Photography Essentials #5: Improving "Presence" in Digital Images*: www.outbackphoto.com/dp_essentials/dp_essentials_05/essay.html

Digital Outback Photo *Digital Photography Essentials #4: Noise*: www.outbackphoto.com/dp_essentials/dp_essentials_04/essay.html

Digital Outback Photo *Using Actions and Filters in Layers*: www.outbackphoto.com/workflow/wf_19/essay.html

Digital Outback Photo *Printing Insights*. An essay on printing from digital files: www.outbackphoto.com/printinginsights/pi.html

Workflow Technique #25 *Noise Ninja*. A description of this noise removal tool, with links to purchase it (): www.outbackphoto.com/workflow/wf_25/essay.html

Workflow Technique *Uprezzing in Photoshop #60* by Jack Flesher: www.outbackphoto.com/workflow/wf_60/essay.html

EasyS Sharpening Toolkit www.outbackphoto.com/workflow/wf_66/essay.html

Bettina and Uwe Steinmueller *Digital photography workflow handbook*: www.outbackphoto.com/booklets/dop2000/DOP2000.html

RAW CONVERSION SOFTWARE AND HARDWARE

For most RAW converters and Photoshop plug-ins you will find a trial version, downloadable from the Internet. The trial version may in most cases be used for 30 days. There is no trial version of Adobe Camera Raw, as it is part of Photoshop CS1/CS2. However, you will find a trial version of Photoshop CS1 and CS2 on Adobe's website.

GretagMacbeth *ColorChecker* and several profile packages (e.g., Eye-One Match and Eye-One Photo): www.gretagmacbeth.com

ColorVision Color Management Tools (e.g., *ColorPlus*, *Spyer2Pro*, *ProfilerPlus*, *PrintFIX*): www.colorvision.com

Monaco Systems (now part of X-Rite) Color management tools and profiling packages (e.g., *Monaco OPTIX* for monitor profiling): www.xritephoto.com

Digital Domain Inc. *Profile Prism*. An ICC profiling tool for cameras and scanners: www.ddisoftware.com/prism/

Pixmantec *RawShooter Essentials* (🖳). A RAW converter for a broad range of DSLRS: www.pixmantec.com

Phase One *Capture One DSLR* (🖳 🍎). A RAW converter for a broad range of DSLRS: www.phaseone.com

Bibble Labs *Bibble* (🖳 🍎). A RAW converter for a broad range of DSLRS: www.bibblelabs.com

Canon *Canon Digital Photo Professional* (🖳 🍎). A RAW converter for various Canon DSLRS: www.canon-europe.com/Support/Patches/dpp/

Nikon *Nikon Capture* (🖳 🍎). A RAW converter for most of Nikon's DSLRS: http://nikonimaging.com/global/products/software/capture4/

PictoColor *inCamera* ICC profile software for digital cameras and scanners: www.picto.com

PTLens (🖳). A correction program for lens flaws (Photoshop plug-in): http://epaperpress.com/ptlens

LensFix and PanoTools Lens distortion correction and image remapping plug-ins for Mac OS. www.kekus.com

Neat Image Noise removal tool (🖳 🍎): www.neatimage.com

Noiseware Noise removal tool (🖳 🍎): www.imagenomic.com

Helicon Filter Pro (🖳). A freeware set of filters to remove red eye, reduce noise, and to do sharpening and color tuning (🖳): www.shareup.com/Helicon_Filter_pro_download-21227.html

Debarrelizer Used for correcting barrel distortions (🖳 🍎): www.theimagingfactory.com/data/pages/products/products1.htm

Focus Magic (🖳) A sharpening tool: www.focusmagic.com

FocusFixer (🖳 🍎) A sharpening tool: www.fixerlabs.com

Digital Domain, Inc. *Qimage RIP* (🖳) and *Profile Prism* (🖳). Profiling software for printers, digital cameras, and scanners: www.ddisoftware.com

DxO Optics Pro (🖳 🍎) Corrects distortions and lateral chromatic aberrations and vignetting: www.dxo.com

Exifer for Windows (🖳) Used to manage EXIF/ITPC metadata: www.friedemann-schmidt.com/software/exifer/

ACD Systems *ACDSee* (🖳) Photo management software: www.acdsystems.com

Cerious Software *ThumbsPlus Pro* (🖳). Simple-to-use digital asset management system: www.cerious.com

Rname-it (🖳) A free and flexible renaming utility: www.outbackphoto.com/handbook/cameratocomputer.html

Renamer4Mac (🍎) A free renaming utility for Mac OS X. http://mac.softpedia.com/get/Utilities/Renamer4Mac.shtml

Helmut Dersch *Panorama-Tools* (🖳). Tool for digital panoramas. Used as the basis for PTLens: www.ptgui.com

Downloader Pro () A utility to download and rename image files from a memory card or from a camera. The page on our Digital Outback site includes a review of the product and a link to purchase it: www.outbackphoto .com/computers_and_more/veit_downloader_ pro/essay.html

Photorescue () A utility used to extract image files from a corrupted memory card: www.outbackphoto.com/handbook/usingdslr .html#photorescue

ADOBE RESOURCES

As the developer of Photoshop, Camera Raw, Bridge, the XMP metadata format, and other digital imaging tools, Adobe plays a leading role in the processing of RAW data.

Paper on XMP customizing www.adobe.com/ products/xmp/custompanel.html

New versions of Adobe Camera Raw www .adobe.com/support/downloads/

Free Adobe DNG converter www.adobe.com/ products/dng/

OTHER ONLINE RESOURCES

Tips & Techniques for Photoshop CS2 by Dr. Russell Brown. Dr. Brown's Services 1.0 make this whole process much easier (check out the movie): www.russellbrown.com/tips_tech.html

International Color Consortium (ICC) This is the organization that defined the ICC profile standard. You will find some useful information on ICC profiles including an in-depth introduction and information on enhanced versions of the standard: www.color.org

European Color Initiative (ECI) You can find the ECI-RGB ICC profile here and useful information on profiles and offset printing. This will be most applicable for members of the European prepress industry: www.eci.org

INDEX